Artists
of the
Middle Ages

ℰ

LESLIE ROSS

Artists of an Era

GREENWOOD PRESS

Westport, Connecticut • London

Library of Congress Cataloging-in-Publication Data

Ross, Leslie, 1956–
 Artists of the middle ages / Leslie Ross.
 p. cm. — (Artists of an era, ISSN 1541–955X)
 Includes bibliographical references and index.
 ISBN 0–313–31903–0 (alk. paper)
 1. Art, Medieval. 2. Artists, Medieval. I. Title. II. Series.
N5975.R684 2003
709′.2—dc21 2002035211

British Library Cataloguing in Publication Data is available.

Library of Congress Catalog Card Number: 2002035211
ISBN: 0–313–31903–0
ISSN: 1541–955X

First published in 2003

Greenwood Press, 88 Post Road West, Westport, CT 06881
An imprint of Greenwood Publishing Group, Inc.
www.greenwood.com
Printed in the United States of America

The paper used in this book complies with the
Permanent Paper Standard issued by the National
Information Standards Organization (Z39.48–1984).

10 9 8 7 6 5 4 3 2 1

#50645769

To my students

Contents

Acknowledgments

Greenwood Press is first of all to be thanked for inviting me to contribute this volume to the Artists of an Era series. I have profited greatly from the assistance of numerous friends and colleagues, and wish especially to thank Victoria Sheridan, Jody Hoppe, and Sister Barbara Green for their excellent suggestions on portions of the text. For assistance with research, my thanks go to Victoria Sheridan and Karen McGuinn. I am also deeply grateful to Geoffrey Fisher of the Courtauld Institute of Art in London for his generous help with picture research. My students in Medieval Art History at Dominican University of California during the fall 2001 semester offered their enthusiasm and support of this project, and I am extremely grateful for our discussions. Great thanks are due also to Dominican University for support of faculty research projects. There is no doubt that this project could not have been completed without the generous patience, enthusiasm, and support of my parents.

Timeline

1107–1118	The Liège baptismal font attributed to Rainer of Huy
1115	Foundation of monastery at Clairvaux by Saint Bernard
1125	Saint Bernard of Clairvaux, *Apologia* to William of Saint Thierry
1125–1135	The Last Judgment tympanum at Autun
1130	Theophilus's treatise on *The Various Arts* (*De Diversis Artibus*)
1135	The Bury Bible by Master Hugo
1140	Guide for pilgrims to Santiago de Compostela
1140–1144	Rebuilding of abbey church of Saint Denis under Abbot Suger, west front and east end
1147–1148	Second Crusade
1150	Chartres cathedral, west portals
1154	The Stavelot Triptych
1155–1160	Laon cathedral begun
1160	The Eadwine Psalter
1170	Archbishop Thomas Becket murdered in the Canterbury cathedral
1174–1184	Canterbury cathedral choir begun by William of Sens after fire of 1174
1180–1200	The *Hortus Deliciarum* of Herrad of Hohenbourg
1181	The Klosterneuberg altarpiece by Nicholas of Verdun
1189–1192	Third Crusade
1194	Fire at Chartres cathedral; subsequent reconstruction
1202–1204	Fourth Crusade
1210	Reims cathedral begun
1230	The sketchbook of Villard de Honnecourt
1240	The *Chronica Majora* of Matthew Paris
1243–1248	The Sainte-Chapelle, Paris
1277	Facade of Strasbourg cathedral designed by Erwin von Steinbach
1285	The *Rucellai Madonna* by Duccio
1308–1311	The *Maestà* Altarpiece by Duccio
1325–1328	Book of Hours for Jeanne d'Evreux by Jean Pucelle
1348–1349	The Black Death sweeps through Europe
1363–1434	Christine de Pisan
1370	Byzantine painter, Theophanes the Greek, settles in Russia
1373	Apocalypse tapestries designed by Jean Bondol
1375	The *Parement de Narbonne*
1390	Cennino Cennini, *The Craftsman's Handbook* (*Il Libro dell'Arte*)
1400	Westminster Hall, London remodeled by Henry Yevele
1403	*Book of Famous and Notable Women* by Boccaccio illuminated for the Duke of Burgundy
1408–1427	The *Trinity* icon by Andrei Rublev
1413–1416	The *Très Riches Heures* of Jean de Berry by the Limbourg Brothers
1453	Capture of Constantinople by the Ottoman Turks; fall of the Byzantine empire

Introduction: The Medieval Artist— Questions and Considerations

Name an Artist—Any Artist

Let's begin with a little experiment. Take a few minutes and see if you can come up with the names of three or four really famous artists from any period in history. These famous artists might be painters, sculptors, architects, photographers, or printmakers—any artists who work in any field of the visual arts.

Most people, when asked to do this, can usually come up with a fairly predictable set of artists' names, such as: Leonardo da Vinci (1452–1519) (everyone knows the *Mona Lisa*) and Michelangelo (1475–1564) (for the Sistine Chapel ceiling and the great marble sculpture of *David*). Both Leonardo and Michelangelo lived during the Italian Renaissance period in the late fifteenth and early sixteenth centuries. They are certainly among the most famous artists in western art history.

How about some more modern artists? Yes, Pablo Picasso (1881–1973). Many people think Picasso is one of the all-time greatest artists of the twentieth century. He certainly produced a lot of art in his lifetime and went through a number of different "styles." He had a "blue period," a "rose period," a "cubist period," and so on.

Most people have heard of Vincent Van Gogh (1853–1890) as well. The story of his life is so tragic in many ways. His art was virtually unappreciated during his lifetime but in recent decades several of his paintings have sold for astoundingly high prices. There have been a couple of movies made about Vincent Van Gogh: *Lust for Life* (1956) is based on a book by Irving Stone, and *Vincent and Theo* (1990) is based on the copious correspondence between Vincent and his brother Theo (who was one of the very few fans of Vincent's art during the artist's lifetime).

Actually, movies have been made about quite a few artists in recent years. The film *Pollock* (2000) has certainly made the influential mid-twentieth-century American artist, Jackson Pollock (1912–1956), even more well known. So, when asked to name a famous artist, some people might also cite Jackson Pollock.

Well, we can go on and on. We forgot about Paul Gauguin (1848–1903) and Henri Matisse (1869–1954) and Paul Renoir (1841–1919) and Claude Monet (1840–1926). All of these artists are popular and well known. The Impression-istic landscapes and scenes of relaxed people painted by Renoir in the late nine-teenth century are favorites for posters and greeting card reproductions today. Everyone loves Monet's paintings of water lilies. The brightly colored and ex-otic scenes Gauguin painted when he lived in Tahiti are also favorite art repro-ductions. And you can find designs by Matisse used for gift-wrapping paper and fabrics as well.

From Michelangelo to Matisse, Picasso, and Pollock, however, most of the names that people think of, when asked to come up with a list of famous artists, are those from the Renaissance period and onward into the nineteenth and twen-tieth centuries. But what about art and artists before the Renaissance period? Before the fifteenth century? Can we think of any famous artists from the me-dieval period? Can we name any artists *at all* from the eleventh, twelfth, thir-teenth, or fourteenth centuries?

Many people, even people with some background in art history, would be very hard pressed indeed to come up with the name of a medieval artist, let alone three or four names of artists from the Middle Ages. Why is this? Were there no particularly great artists during medieval times? Are there no medieval artists worth remembering for their innovations, style, and influence on other artists? Are there no really famous works of medieval art that everyone knows and loves? What types of artwork were produced in the Middle Ages?

Most people, when asked to think about examples of medieval art (rather than names of medieval artists), have much less difficulty citing examples. The beautiful Gothic cathedrals and stained glass windows spring to mind immedi-ately; one may also think of castles and tapestries and colorful hand-painted manuscripts with scenes of aristocratic and courtly life. In fact, reproductions of medieval art (on greeting cards, wrapping paper, posters, fabrics, etc.) are very common and popular, too. But the people who can name Michelangelo and Leonardo and Vincent Van Gogh as famous artists might not immediately think of the "Master of the Morgan Leaf" (late twelfth century) or the Limbourg broth-ers (early fifteenth century) or Villard de Honnecourt (mid-thirteenth century) as medieval parallels to the famous Renaissance and modern masters.

Have There Been No Great Medieval Artists?

Were there no famous artists during medieval times? A similar question was posed several decades ago by the art historian Linda Nochlin who wrote an ex-tremely influential article titled, "Why Have There Been No Great Women

Artists?" This article appeared in the early 1970s[1] and served to bring attention to the fact that, at that time, relatively few women artists were included in traditional art history books. The standard survey texts of art history up to that time covered very few women artists, even though, as Nochlin pointed out in her article, women artists have been active throughout the history of art and some women artists were considered quite "great" and "famous" in their own times, as well. Why were these women artists excluded from the basic texts on art history? Nochlin's influential article—and her provocative question—ultimately inspired many other scholars to take a closer look at the status and importance of women artists through the ages. Standard art history texts now customarily include many more women artists. Books have been written, and popular movies recently made, about a number of individual female artists. The social and cultural factors that contributed to the previous so-called neglect of women artists have also been explored and discussed by numerous writers. The biographies of many previously unstudied women artists have been uncovered. As a result, great advances in scholarship have taken place in reinstating women artists into the overall history of art.

The question posed here ("Have there been no great medieval artists?") is also designed to be thought provoking. Many of the scholars who have devoted attention to the so-called rediscovery of women artists through the ages have been interested in discussing these artists as distinct individuals—with personalities, life experiences, influences, and contributions. The lives and thoughts of these women artists, how they saw themselves, their position and role in society, and how they have been treated (or ignored) in past scholarship are all topics frequently covered now. Is it possible—or appropriate—to want to do the same for artists of the medieval era? Should scholarly attention be devoted to uncovering the names and reconstructing the biographies of previously neglected medieval artists? Are there great artistic personalities from the Middle Ages who have been ignored? Are there medieval artists still waiting to be discovered? Are there medieval artists whose names should be known and who should be given their rightful position in the history of art? These are not easy questions to answer and, much the same as Nochlin's provocative question about female artists back in the early 1970s, it depends upon how one looks at things.

The Idea of the Artist and Artistic Fame

It would seem enormously argumentative for anyone to disagree with the statement that works of art are created by artists. After all, the paintings and sculptures that we see today in public spaces or museums or galleries were all either thought up, designed by, if not actually made by specific people. The paintings and sculptures which are displayed in the world's art museums and the architecture which has been created to house these artistic creations can all be credited to particular individuals. We visit the Louvre Museum in Paris in order to see the *Mona Lisa*, which was painted by Leonardo da Vinci in the early

sixteenth century. We may journey from long distances indeed to see this fa-
mous painting by such a famous Renaissance artist. It almost feels like a pil-
grimage—an important thing to do (or recount that one has done). We may be
especially interested to see, for ourselves and in person, the famous "smile" of
this very famous woman. And so, when we come face to face with the original
painting in the Louvre Museum, we may be reluctant to admit if we perhaps are
disappointed in any way. We may find that the painting is smaller than we
thought and maybe even a bit less interesting than we imagined. Why did this
painting (and the *Mona Lisa*'s "smile") ever become so famous?

Much of the continued fame of this particular work of art and many other
works of art from the Renaissance period can be traced back to the writings on
art and artists done by the Italian artist and scholar Giorgio Vasari (1511–1574).
Vasari's descriptions of the *Mona Lisa* and her "smile" are included in his famous
treatise concerning the *Lives of the Most Excellent Italian Architects, Painters and
Sculptors from Cimabue to Our Own Day*. First published in 1550 and appearing
in a revised second edition in 1568, Vasari's *Lives* has a stellar position in the
history of art history and remains an incredibly important source of informa-
tion (as well as misinformation).

Vasari was not, by any means, the first person to ever write about art or artists.
He was inspired by earlier authors and drew from previous sources. But his work
has the distinction of being the first really systematic approach to the classify-
ing and attributing of works of art to specific artists. His book contains chap-
ters (biographies) of all the artists (all Italian) who he considered to be the most
eminent and important from around 1300 to his own time. He also (in his sec-
ond edition) included chapters on artists living and working during his life-
time—artists he had met personally. Altogether, Vasari wrote about 160 "lives."
Vasari is sometimes considered to be the "Father of Art History"—certainly he
was the "Father of Artistic Biography." Indeed, "no subsequent collection of
artists' biographies has ever matched his example."[2]

Vasari was interested in the *lives* of artists—in their artistic personalities. His
book contains detailed information about a great number of artists: where and
when they were born and died, who their teachers were, where they traveled
and worked, and what, in his opinion, were their major accomplishments (as
well as their failures). Apart from his painstaking and lengthy descriptions of a
great number of works by his selected artists, he also wrote about events which
happened in the lives of these artists; he discussed their dreams and goals, their
virtues, vices, and personality quirks. Reading the biographies written by Vasari,
one gets the impression that he is "bringing to life the human stories of indi-
vidual artists . . . [recording] often the interesting human detail that would help
to make vivid the painter not as artist but as [human]."[3] Many of Vasari's biog-
raphies are full of little anecdotes which are chosen "to reveal the essential per-
sonality of the subject."[4] We sense that he is describing "real people"—sharing
their thoughts and concerns with the reader. Vasari was also quite clear about
what works of art and what artists he thought were the "best" among all the "ex-

cellent" ones he chose to include in his book. "Vasari was bumptious, expansive, optimistic, opinionated, and . . . never at a loss for words. He knew what he knew."[5] And, he devotes the *greatest* length to the biographies of artists he thought were the *greatest*. Vasari's favorite artist was Michelangelo (his biography is by far the longest in Vasari's book) and he often judges other artists' work by the high standards that he felt were set by Michelangelo.

This biographical approach to the world's great artists, as exemplified by Vasari, was incredibly influential on many, many later authors and continues to influence much art history scholarship today. The fashion for discussing the history of art in terms of the achievements of individual artists has continued, to a greater or lesser extent, to influence all later art history writing. Naturally, one wants to know about the lives of artists—the people responsible for the great works of world art. And the most famous artists become even more famous the more that is known about their lives and the more that is written about them. However, we might be very wise to be somewhat cautious about this Vasari-style approach to the history of art, especially when we realize that Vasari actually invented many of his stories about artists.

Truth or Tall Tales?

Although a primary source for Italian Renaissance art studies, Vasari's text is also full of gossipy details, inaccuracies, highly opinionated statements, and sections of sheer fantasy. In fact, a great many of the stories Vasari tells about events in the lives of the artists he includes in his book cannot have happened and certainly never did happen. He writes, for example, a poignant description of the death of the great artist Leonardo da Vinci in 1519. Leonardo, according to Vasari, died in the arms of his last patron, Francis I, the king of France. Yes, Leonardo certainly did spend his final years working as an artist at the court of France and we know the date of Leonardo's death. We also know from historical documents that the king of France was not in residence when Leonardo passed away.[6] Did Vasari know this? Or had Vasari himself been misinformed on these events? Whether Vasari was aware of the facts or not, the tale of Leonardo's final moments with Francis I makes a wonderful story. In fact, this story has been a subject depicted in later art![7]

Many of Vasari's *Lives* include similar fictitious descriptions, and although art historians are well aware of this tendency on Vasari's part, the inherent appeal of his text and the fact that his good stories were repeated by many later authors who copied from him makes us somehow want to believe that there are more grains of truth than pure fiction in Vasari's *Lives*. "This acceptance of Vasari at face value is fairly typical of art history, notwithstanding the fact that art historians otherwise correct his attributions and inaccurate dates."[8] Certainly we also need to understand that Vasari was, to a large extent, using certain formulas in his biographical compositions.[9] His *Lives* follow particular patterns and se-

quences of information, and he emphasized specific themes, such as the bene-fits of hard work, to provide "practical lessons in profitable genius-conduct."[10] If Vasari's own goals and agenda inspired him to invent missing details or em-bellish others, we need to understand his own motivations for doing so as well.

However, apart from inventing appealing and interesting stories about artists, Vasari also invented artists who probably never existed at all! Vasari also very much enjoyed wordplay and puns. His chapter on the life of the artist Morto da Feltro is a case in point. *Morto* in Italian means "dead." In his chapter on this artist, Vasari plays with words and phrases which emphasize that the fame of this artist, though he is deceased, "lives on" in his works. But, there are no works of art that can be convincingly attributed to the artist Morto, probably because he was always dead—in other words, he never lived at all. Vasari simply in-vented him and enjoyed the literary wordplay and other complex references and implications which might well have been much better recognized and under-stood by readers in his own time versus later art historians reading his biogra-phy of Morto as "fact."[11]

Biographical writing, in general, has an exceedingly long tradition. Ever since history began to be recorded in written documents, the lives, deeds, and sig-nificant contributions of major figures have been topics for many authors. Vasari's *Lives* of artists are to a large extent based on earlier models—writings about the achievements of important rulers, politicians, military leaders, heroes, and saints. "Biography is . . . a sister discipline to history, and it is historical nar-rative which claims to represent 'reality.' "[12] It is always important to realize that history and biography are written by historians and biographers whose own per-sonal or contemporary concerns, ideals, understandings, theoretical perspec-tives, and visions of the world are reflected in their writings. "Even the most empirical and non-speculative biography is inseparable from the intellectual and social structures within the period of the subject. . . . The documents that sur-vive are themselves products of a specific set of circumstances and assumptions that determine what is and what is not within the document."[13]

Medieval Artists and Biography

Although Vasari, in composing his *Lives* of artists, may have "created" quite a bit of his information, the very fact that he (a prominent artist himself) con-sidered writing about individual artists to be a useful, interesting, and viable en-deavor says a lot not only about Vasari himself but also about his time period. There are no similar documents in terms of artistic biographies for the medieval period. The type of information that Vasari included in his book about Renais-sance artists is lacking for the medieval period. No author during the Middle Ages was inspired to write about specific medieval artists in the way that Vasari wrote about individual artists of the Renaissance period. Biographies of impor-tant people were indeed written during the Middle Ages, but there is no study of specific artists comparable to Vasari's for the medieval era.

The biographical (and even autobiographical) documents that survive from the Middle Ages were generally not written by or about artists. There are many medieval documents which describe works of art and mention the names of artists—but there are no biographies of medieval artists to which researchers can turn when trying to reconstruct the lives, careers, personalities, or thoughts of medieval artists. In fact, scholars of medieval art are often quite stymied by the lack of information about specific artists—even those many medieval artists who signed their works or whose names are otherwise recorded. Although we know the names of hundreds of medieval artists, most of the information we have about medieval artists is not "biographical" in the Vasarian sense. Information about specific medieval artists comes to us largely in a shorter and non-biographical form: brief documents recording contracts between artists and patrons, records of payment to artists, artists' signatures and self-portraits, and mentions of artists in various inscriptions, chronicles, annals, and building accounts.[14] Sometimes these documents provide information about the nationality of the artists mentioned as well as references to and praises of their skills in various media. Much information about medieval art techniques and working methods is available in several "handbooks for artists" written during the Middle Ages (see chapter 5). Stories about art and artists also occur in medieval tales of saints' lives and art was certainly discussed in various religious treatises from the Middle Ages.

Even so, the documents that survive about artists from the medieval period are thus rather scanty in comparison to the relatively greater amount of information available about the lives and careers of artists from later centuries. Medieval authors who wrote about art—and there are many examples—generally weren't interested in the personalities of individual artists. "It is rarely possible in the study of the Middle Ages to make the associations between names, personalities, and reputations—the kind of incidental biographical information that fascinate people and that in later centuries has, in one way or another, contributed to artists' reputations."[15] It would be tempting to surmise from this—as has been occasionally done—that medieval artists themselves weren't at all interested in their own fame or reputations, that medieval artists were generally humble and pious figures who subordinated any sense of personal achievement or desire for individual fame to the larger goals of their patrons—especially the medieval church. As works of art created for religious purposes do indeed dominate artistic production during the major portion of the Middle Ages and the names (if not biographies) of so many medieval artists remain unknown, the idea of the "anonymous artist" working for the "greater glory" of the church is certainly a logical concept.

Thus, when scribes such as Eadwine in the mid-twelfth century described himself (or someone in the period described him) as the "Prince of Scribes" (see chapter 3) and names such as Gislebertus appear prominently in the early-twelfth-century sculpture at Autun (see chapter 1), art historians have been challenged by these apparent evidences of medieval artistic "personalities." Because we know nothing more about Eadwine (apart from the fact that his portrait ap-

pears in a famous manuscript written and illustrated at Canterbury), any attempts to construct his biography remain purely speculative. Similarly, the debates surrounding the "Gislebertus" inscription at Autun (was he the artist of the sculpture? the patron of the building?) are indicative of the continuing challenges in studying and interpreting medieval art.

"Art has always been produced by individuals and a lack of literary information about them does not mean that they had no individuality."[16] However, our modern concept of "artistic individuality"—about the aims, goals, and behavior patterns of artists generally—may also be conditioned by our post-Vasarian time. We simply may expect to know more about the lives of medieval artists than the documentary evidence permits. This may also be because our own modern ideas of "art" and "artists" are to some extent different from the medieval concepts. In the Middle Ages, "artists were regarded socially as artisans, below the rank of merchants in the towns, and, depending on their precise skills, at the upper end of the rank of peasants in the countryside."[17] Artists during the Middle Ages were appreciated (if not, in some cases, also highly regarded) for their skills—just the same as all other craftspeople were during the time who also performed their jobs. Certainly, the most talented artists during the period were also highly sought after by patrons and kept very busy with commissions, such as the artists (some of whom remain anonymous) working for European royal courts in the late medieval period (see chapter 10). But, the ability to be an artist or create art during the Middle Ages appears not to have been considered any sort of an abnormally special gift that necessarily gave the artist a high level of regard in medieval society. Artists were considered to be professional craftspeople who learned their trades through practical training and apprenticeships—quite often with other family members with whom they carried on family businesses and traditions. Artists appear not to have been, during the Middle Ages, considered as grand and heroic figures—or in any way especially more interesting personality types whose struggles, trials, and tribulations were worthy of "gossip about them as individuals."[18] The modern concept of the "artistic personality"—the idea, for example, "that artists are, and always have been, egocentric, temperamental, neurotic, rebellious, unreliable, licentious, extravagant, obsessed by their work, and altogether difficult to live with"[19]—is not a concept which applies comfortably to artists during the Middle Ages, not only because we have so little information to go on from the medieval period but also because this notion appears to be a construct of "artistic biography" in general.

No doubt the changing social status of artists in the Renaissance period contributed to and was also enhanced by the creation of artistic biography as a literary form.[20] When the lives of artists began to be composed in the Renaissance period—when the interest in the "artistic personality" began—more artists appear to have considered themselves to be independent entrepreneurs and social climbers. Certainly this is the case with Vasari himself who also made up a fiction regarding the conversations with his elite and wealthy patrons about their initial ideas and interest for his book about artists.[21] Just as eager as a medieval

artist, one presumes, to "get work," Vasari in his different approach directed attention to "the artist" in general as someone worthy also of psychological interest and consideration—not just a skilled and trained crafter of artworks but a "hero" and "genius" as well.

Although there is little documentary evidence to show that these attitudes about art and artists can be confidently applied to (or read back into) the art of the medieval period, it is extremely intriguing to see how these notions have continued to influence the study of medieval art. The lack of documentary evidence of artistic "personalities" from the Middle Ages has not prevented any number of scholars (in Vasari fashion) to create "biographies" of medieval artists where none exist. This has not simply involved the logical and often necessary creation of "names" (e.g., "The Master of . . . ") for otherwise anonymous medieval artists whose styles can perhaps be more or less confidently identified by formal analysis. Indeed, the impulse to create medieval artistic personalities and/or to expand the minimal documentary details that are available has led to a number of intriguing scholarly inventions in the form of mythological or semi-mythological medieval masters (see especially chapters 4 and 9) whose lives and careers often reveal much more about modern scholarship than about medieval art history.

Medieval Artists and History

The acknowledgment of the fact that "Historians . . . cannot escape from looking at the past with the eyes of their time"[22] has provided an overall guiding theme for the chapters in this book. Medieval artists (anonymous, named, or invented) are discussed in a series of chapters which are primarily organized according to different media (various forms of painting, sculpture, architecture, and metalwork) rather than following a strictly "biographical" format. Because the documentary information about specific medieval artists varies widely, some individual artists are discussed only briefly whereas others are given greater coverage. Where information exists on the lives and careers of specific artists, this data has been woven into larger considerations of the types and techniques of art produced during the medieval era. The reader will find information about medieval society and religion as well as medieval art and artists.

Most of the chapters concentrate on art produced in western Europe from the eleventh through fourteenth centuries, especially during the "High Middle Ages"—or the eleventh- and twelfth-century Romanesque period and the twelfth- and thirteenth-century Gothic period. The medieval era (postclassical, pre-Renaissance) is not a precisely defined time span by any means. "The difficulty with setting . . . precise starting and ending dates for the Middle Ages is related to the problems of determining (or agreeing), for example, exactly when the Renaissance began (generally understood to be earlier in Italy than in northern Europe) and exactly when the classical period can be said to have con-

cluded."[23] Historians of medieval art thus may range into the early years of the fifteenth century (normally considered the Renaissance period) for a discussion of "International Gothic" style (chapter 10) and appropriately also away from western Europe and into the important and influential realms of Byzantine art (chapter 8).

Female as well as male artists (and art patrons) are included in this book as well as information about the history of medieval art history. The materials covered should, in conclusion, assist with not only answering but also in better assessing the questions and challenges raised with the little exercise proposed at the very beginning of this introduction. When asked to "Name an Artist—Any Artist," perhaps a few candidates from the Middle Ages should come to mind.

Notes

1. Linda Nochlin, "Why Have There Been No Great Women Artists?," *Art News* 69, no. 9 (January 1971): 22–39, 67–71; also in E. Baker and T. Hess, eds., *Art and Sexual Politics* (London: Collier Macmillan, 1973).

2. Udo Kultermann, *The History of Art History* (Pleasantville, N.Y.: Abaris Press, 1993), 20.

3. Michael Levy, *The Painter Depicted: Painters as a Subject in Painting* (London: Thames and Hudson, 1981), 47.

4. Catherine Soussloff, "*Lives* of Painters and Poets in the Renaissance," *Word and Image* 6, no. 2 (1990): 161.

5. Reed Whittemore, *Pure Lives: The Early Biographers* (Baltimore, Md.: Johns Hopkins University Press, 1988), 71.

6. Richard Turner, *Inventing Leonardo* (New York: Alfred A. Knopf, 1993), 55.

7. Levy, 46–47.

8. Paul Barolsky, *Why Mona Lisa Smiles and Other Tales by Vasari* (University Park: Pennsylvania State University Press, 1991), 119.

9. Catherine Soussloff, *The Absolute Artist: The Historiography of a Concept* (Minneapolis: University of Minnesota Press, 1997).

10. Whittemore, 74.

11. See Barolsky, 58–60.

12. Thomas Heffernan, *Sacred Biography: Saints and Their Biographers in the Middle Ages* (New York: Oxford University Press, 1988), 12.

13. Martin Kemp, "Lust for Life: Some Thoughts on the Reconstruction of Artists' Lives in Fact and Fiction," *XXVIIè Congrès International d'Histoire de l'Art: L'Art et les Revolutions,* ed. Sixten Ringbom (Strasbourg: Société Alsacienne pour le Developpement de l'Histoire de l'Art, 1992), 167–168.

14. Useful sources include the "sources and documents" volumes by Caecilia Davis-Weyer, *Early Medieval Art 300–1150* (Toronto: University of Toronto Press, 1986), and Teresa Frisch, *Gothic Art 1140–c1450* (Toronto: University of Toronto Press, 1987).

15. Veronica Sekules, *Medieval Art* (Oxford: Oxford University Press, 2001), 40.

16. Rudolf and Margot Wittkower, *Born Under Saturn: The Character and Conduct of Artists: A Documented History from Antiquity to the French Revolution* (New York: Random House, 1963), 42.

17. Sekules, 46.

18. Umberto Eco, *Art and Beauty in the Middle Ages* (New Haven, Conn.: Yale University Press, 1986), 114.

19. Wittkower, xix.

20. See Bruce Cole, *The Renaissance Artist at Work* (New York: Harper and Row, 1983), especially 13–29: "The Social World of the Artist."

21. See Kultermann, 12.

22. Wittkower, 283.

23. Leslie Ross, *Medieval Art: A Topical Dictionary* (Westport, Conn.: Greenwood Press, 1996), xi.

Bibliography

Barker, Emma, Nick Webb, and Kim Woods, eds. *The Changing Status of the Artist.* New Haven, Conn.: Yale University Press, 1999.

Barolsky, Paul. *Why Mona Lisa Smiles and Other Tales by Vasari.* University Park: Pennsylvania State University Press, 1991.

Cole, Bruce. *The Renaissance Artist at Work.* New York: Harper and Row, 1983.

Davis-Weyer, Caecilia. *Early Medieval Art 300–1150.* Toronto: University of Toronto Press, 1986.

Eco, Umberto. *Art and Beauty in the Middle Ages.* New Haven, Conn.: Yale University Press, 1986.

Egbert, Virginia. *The Medieval Artist at Work.* Princeton, N.J.: Princeton University Press, 1967.

Frisch, Teresa. *Gothic Art 1140–c1450.* Toronto: University of Toronto Press, 1987.

Heffernan, Thomas. *Sacred Biography: Saints and Their Biographers in the Middle Ages.* New York: Oxford University Press, 1988.

Kemp, Martin. "Lust for Life: Some Thoughts on the Reconstruction of Artists' Lives in Fact and Fiction." In *XXVIIè Congrès International d'Histoire de l'Art: L'Art et les Revolutions,* edited by Sixten Ringbom. Strasbourg: Société Alsacienne pour le Developpement de l'Histoire de l'Art, 1992.

Kris, Ernst, and Otto Kurz. *Legend, Myth, and Magic in the Image of the Artist: A Historical Experiment.* New Haven, Conn.: Yale University Press, 1979.

Kultermann, Udo. *The History of Art History.* Pleasantville, N.Y.: Abaris Press, 1993.

Levy, Michael. *The Painter Depicted: Painters as a Subject in Painting.* London: Thames and Hudson, 1981.

Martindale, Andrew. *The Rise of the Artist in the Middle Ages and Early Renaissance.* New York: McGraw-Hill, 1972.

Nochlin, Linda. "Why Have There Been No Great Women Artists?" *Art News* 69, no. 9 (January 1971): 22–39, 67–71.

Ross, Leslie. *Medieval Art: A Topical Dictionary.* Westport, Conn.: Greenwood Press, 1996.

Rudolph, Conrad. *The "Things of Greater Importance." Bernard of Clairvaux's "Apologia" and the Medieval Attitude Toward Art.* Philadelphia: University of Pennsylvania Press, 1990.

Sekules, Veronica. *Medieval Art.* Oxford: Oxford University Press, 2001.

Soussloff, Catherine. *The Absolute Artist: The Historiography of a Concept.* Minneapolis: University of Minnesota Press, 1997.

———. "*Lives* of Painters and Poets in the Renaissance." *Word and Image* 6, no. 2 (1990): 154–162.

Turner, Richard. *Inventing Leonardo.* New York: Alfred A. Knopf, 1993.

Whittemore, Reed. *Pure Lives: The Early Biographers.* Baltimore, Md.: Johns Hopkins University Press, 1988.

Wittkower, Rudolf, and Margot Wittkower. *Born Under Saturn: The Character and Conduct of Artists: A Documented History from Antiquity to the French Revolution.* New York: Random House, 1963.

CHAPTER 1

The Romanesque Sculptor: Gislebertus?

Site, Setting, and Significance

Over the main entrance to the cathedral of Saint Lazare in the Burgundian French city of Autun is a monumental sculpture of the Last Judgment. This complex and magnificent sculpture, carved from numerous blocks of limestone, appears in the tympanum (the semicircular space above the door) and measures about fifteen by twenty feet. The work is traditionally dated to about 1125–1135 and is, in form and subject matter, a type of sculpture which became very popular in the Romanesque and Gothic periods.

Economic prosperity and urban growth during the eleventh and twelfth centuries in Europe resulted in a building boom—especially of religious architecture—so much so that one writer, the early-eleventh-century monk, Raoul Glaber, described his sense that the earth had become clothed in a "white garment of churches."[1] The cathedral at Autun, which was begun in the 1120s and dedicated in 1132, is one among many of these newly constructed or enlarged religious buildings of the Romanesque period and, like many other medieval churches, it also served as a center for pilgrimage.

Pilgrims traveled to Autun to see the relics (in this case, bones) of Saint Lazarus who, according to the biblical accounts, had been miraculously raised from the dead by Jesus (John 11, 12:1–11). Various extremely convoluted stories from the medieval period describe how Lazarus himself, or his physical remains, later arrived in France. Although several French churches claimed to possess his relics, the construction of the cathedral at Autun in the 1120s to house his tomb was surely intended to settle these disputes. The relics of Lazarus were formally enshrined in the cathedral in a grand ceremony in 1146–1147.

The tradition of constructing buildings containing the burial places of holy

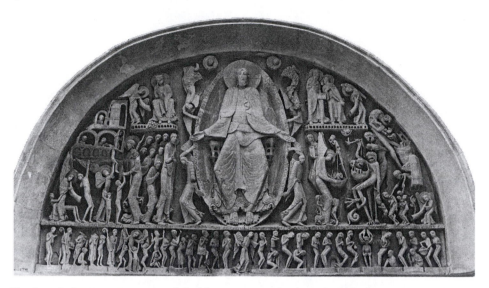

The Last Judgment tympanum of Gislebertus, west portal, Cathedral of Saint Lazare, Autun, France, c1125–1135. (Courtesy of the Conway Library, Courtauld Institute of Art, London)

people has a very lengthy history in Christianity and in many other religions as well. The practice of marking sacred sites where important religious events took place, or where significant holy figures are buried, is a characteristic feature of many of the world's religions, as is the tradition of pilgrimage to these sacred sites.[2] A pilgrimage is a "journey to a distant sacred goal."[3] Pilgrims may undertake these journeys "in order to worship, seek spiritual aid or physical healing, or to fulfill a vow or obligation."[4]

In the history of Christianity, the identification of and travel to specific sites associated with the birth, deeds, death, and resurrection of Jesus became especially widespread after the journey of the empress Helena (c255–c330; the mother of the first Christian Roman emperor, Constantine [c280–337]) to the Holy Land in the early fourth century. In the following centuries, and throughout the Middle Ages, many pilgrims traveled to Jerusalem especially, as well as to other centers of early Christianity and sites associated with numerous early Christian holy figures. The city of Rome, with the great church dedicated to and enshrining the tomb of the apostle Saint Peter, was another major pilgrimage destination. Other significant pilgrimages during the Middle Ages were made to sites such as Santiago da Compostela in northern Spain, where the church contained the relics of the apostle Saint James, and, from the late twelfth century onwards, to Canterbury Cathedral in England, which contained the tomb and relics of the murdered archbishop Thomas Becket (1118–1170).

Relics may be the actual physical remains, such as the body, skull, bones, or hair of a holy figure, or objects owned by or associated with the holy person, such as items of clothing. "Relics serve as memorials of the dead, objects for remembrance, affection, and veneration and are also believed to possess powers

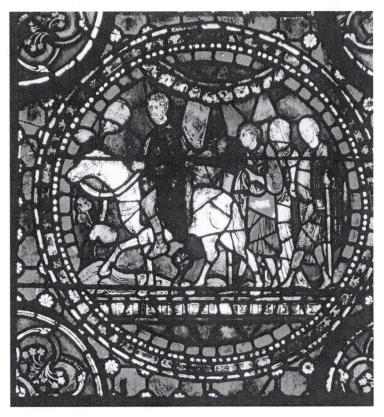

Pilgrims making the journey to Canterbury, detail from window c1280. (The Art Archive/Canterbury Cathedral/Dagli Orti)

to perform healings and miracles."[5] Relics in medieval churches were frequently enclosed in lavish shrines (reliquaries) made of precious metals. Viewing and praying before these impressive holy objects was the goal of medieval pilgrims.

Relics and pilgrimages were enormously significant for medieval society— both in religious and in economic terms. Pious travelers visiting holy places in the Middle Ages, just like modern-day tourists and sightseers, of course expended money on food, accommodations, and souvenirs. A city or town with an important sacred site that contained famous or especially powerful relics would attract more pilgrimage traffic than a town lacking any such notable shrine or relics. Important relics provided prestige and potential economic prosperity for medieval towns. Thus, there was a certain amount of rivalry and competition among medieval towns in terms of relic possession. The discoveries, appearances, disappearances, reappearances, relocations, and even thefts of relics during the Middle Ages involve many fascinating stories.[6]

There are a number of different stories from the medieval period describing how and when the relics of Saint Lazarus arrived in France and specifically to the town of Autun in Burgundy. Before the construction of the saint's shrine at

Autun in the twelfth century, several other places also claimed to have "at least some of the relics"[7] of this extremely important biblical figure who was raised from the dead by Jesus himself. Great prestige was certainly associated with these relics. "By constructing a monumental structure in Lazarus's honor . . . Autun enforced its assertion that it was the official abode of the first-century holy man's body. The new structure established the authority of that site and no other."[8]

Subjects and Symbols

People visiting the cathedral of Saint Lazare at Autun in the present day usually enter the church through the front portal, passing beneath the monumental sculptured tympanum depicting the Last Judgment. In the twelfth century, it appears that the original "main" entrance to the church was a large side doorway (transept portal) which was also enriched with impressive sculpture. Only fragments of sculpture from the transept portal survive, however, as much of it was destroyed in additions and renovations to the building in later centuries. Scholarly attention to the exterior sculpture at Autun has thus tended to concentrate primarily on the Last Judgment tympanum of the front door.

The subject of the sculpture is based largely upon biblical descriptions and commentaries by medieval theologians about the end of time when Jesus Christ will return to judge humankind. According to these traditions, the wicked will be cast down into hell and the blessed will enter the kingdom of heaven. Prominently placed in the center of the composition is the huge figure of Christ with arms outstretched. He is enclosed in a *mandorla* (a full-body halo) and is surrounded on either side by several tiers of smaller figures including saints and angels. The Virgin Mary is depicted seated on the upper left side. Below Mary on the left side of Christ can be seen an elongated figure of Saint Peter holding a huge key which symbolizes the key to the kingdom of heaven. Saint Peter is assisted by angels in his role of welcoming tiny figures—the souls of the blessed—into heaven. One angel is shown actually pushing a small soul up into the heavenly architectural space. Other angels are blowing trumpets on both sides of the composition.

The right side of the sculpture includes an intriguing group of figures around a pair of scales. This depicts the weighing of the souls (*psychomachia*) with an angel (Saint Michael) on one side and a grotesque demon on the other side. The demon is attempting to pull down the scales and send a soul down into hell. Other souls awaiting their own judgments huddle around the feet of the archangel; one little soul even seems to be trying to hide in Saint Michael's robe. The lowest tier of the sculpture (the horizontal lintel) shows many small figures including pilgrims (recognizable by the scallop-shell emblems on their knapsacks as pilgrims to the shrine of Saint James at Compostela in northern Spain), clerical figures such as bishops (identifiable by their *croziers* or curled staffs), additional angels, and little naked figures again representing souls. One group of little figures appears to be dancing gleefully around a welcoming angel. Their

happiness and exuberance is not shared, however, by the figures on the right side on the lintel. Here we see sorrowful and downcast figures being pushed away by the central sword-bearing angel. These represent the wicked and sinful people who will go to hell rather than to heaven. Further along on the bottom right of the lintel we see little figures who are being tortured by snakes and huge demonic gripping hands.

This type of artistic subject matter with significant religious messages is extremely characteristic of a great deal of art produced during the Middle Ages. Although many examples of nonreligious art survive from the medieval period, a very large percentage of medieval art is religious in nature. The Middle Ages has often been called "the age of faith" due to the dominant role of religion in society. Many medieval works of art were created for religious contexts and settings, such as the sculpture over the entrance to the church of Autun. Given the setting, it is logical then that the subjects and symbols depicted would be religious in nature—designed to convey specific and clear messages to medieval churchgoers. In that sense, subjects such as the Last Judgment are extremely appropriate for positioning over a church entryway. People entering the church are reminded of the importance of virtuous behavior and the salvation promised by their Christian faith. They are also warned, by frightening images, of the punishments awaiting the wicked. As the churchgoers enter the religious structure, they pass from the secular world into a holy space. Subjects such as the Last Judgment could serve to direct their thoughts to spiritual concerns appropriate for attendance at church services—as well as reinforce the powerful role of the church in their lives.

The tympanum sculpture at Autun conveys its messages very clearly and effectively. Even modern-day viewers unfamiliar with the biblical subjects can easily recognize that a significant event is being depicted, and that this event is presided over by one huge figure who is centrally placed in the composition. It is also clear that "good" as well as "bad" things are happening on either side of this central figure. The small figures on the left side appear to be happy; they are smiling and jumping with glee. The figures on the lower right side of the sculpture are obviously not happy at all. They are weeping, cringing, and falling down. They hang their heads in distress. The figures are all extremely expressive. Their poses and gestures convey their emotions and the overall theme of the sculpture extremely well.

It is also quite clear that the huge figure in the center of the composition is the most important character. He is many times larger than the other people, so we know that this figure is the most important because he is bigger than anybody else. We might criticize this sculpture for its "lack of scale" or "unrealistic proportions"; however, the difference in the relative sizes of the figures is actually a very effective device. Quite often in medieval art, "what *looks* important *is* important."[9]

Medieval art in general makes use of a great deal of symbolism. These repeated symbols assist viewers in identifying the subjects shown in the art. Of course, a viewer needs to be familiar with what the symbols are and what they

mean. However, the same symbols are repeated over and over again and this repetition of conventional forms is like a form of visual shorthand. One needs to learn the symbolic language used in medieval art and this does require some study and patience. "But the patience will be well-rewarded . . . once one knows how to read the clues. And the clues (as in any good mystery story) are always quite obvious, in retrospect."[10]

A number of standard symbols—visual clues—can be seen in the tympanum sculpture at Autun. Angels are identifiable because they have wings. Saint Peter holds the key to heaven. The Virgin Mary is seated on a throne up in heaven and she is wearing a crown. She is the queen of heaven. In the horizontal lintel, the bishops are recognizable because they hold crook-staffs or croziers and the pilgrims are identifiable by their travel bags bearing scallop-shell emblems. These motifs are repeated throughout medieval art. Christ bears a scallop-shell pilgrimage badge in another Romanesque sculpture. What figures wear or what they carry, what colors are used, and the relative size of figures are all aspects of the visual symbolic shorthand of medieval art.

This medieval interest in symbolism and in narrative clarity—getting the message across—makes a lot of practical sense because so much medieval art was intended to teach and inspire people. There would be very little point indeed in a medieval artist creating something "personal" which no one else could understand. Also, because a large percentage of medieval people could not read, it has often been said that medieval art—especially the art created for churches—could effectively have been used to teach or help people visualize stories from the Bible and saints' lives. As Pope Gregory the Great (c540–604) is said to have written, "What Scripture is to the educated, images are to the ignorant, who see through them what they must accept; they read in them what they cannot read in books."[11]

Even so, for the benefit of the literate members of medieval society, a great many medieval artworks also include writing on them.[12] Figures are sometimes identified by name, sometimes words will be shown issuing from the mouth of a figure indicating their speech, and, as in the case with the tympanum at Autun, written words on the sculpture are used to reinforce the visual messages.

Style and Signature?

Apart from all the expressive and active figures sculpted in this impressive composition, the tympanum at Autun also includes writing. Inscriptions are carved on the edges of Christ's *mandorla* and a long inscription can be seen running across the lintel. The writing is in Latin and reinforces the visual themes of judgment, punishment, and rewards. For example, directly over the figures of the damned and tortured souls the inscription reads: "Here let fear strike those whom earthly error binds, for their fate is shown by the horror of these figures." The inscription on Christ's *mandorla* reads: "I alone dispose of all things and crown the just, those who follow crime I judge and punish." Above the figures

of the blessed, the inscription says: "Thus shall rise again everyone who does not lead an impious life, and endless light of day shall shine for him." All of these inscribed words clearly relate directly to the subjects shown in the sculpture: the compositional dominance of the enlarged figure of Christ as judge, the heavenly happiness awaiting the virtuous people, and the hellish horrors which the damned must suffer. The written inscriptions reiterate the visual subjects and restate, in words, the major themes of the sculpture. The words reinforce what the viewer can see in the sculpture.

There are, however, three more words inscribed on the tympanum at Autun which convey additional information beyond the themes shown in the sculpture. Directly in the center of the lintel, right below the feet of Christ, an inscription reads: *Gislebertus hoc fecit*. This Latin phrase has customarily been translated as "Gislebertus made me." An enormous amount of scholarly attention has been devoted to the interpretation of this one short inscription at Autun, which appears to be the signature of the medieval sculptor responsible for this impressive work. Or, is it?

The story of Gislebertus, "sculptor of Autun," is one of those especially fascinating chapters in the history of medieval art history. Many scholars have interpreted the inscription naming him at Autun to be an indication of his so-called authorship of the work, whereas other scholars have argued that Gislebertus may not be the name of the artist at all but rather the name of an important earlier patron of the church—a tenth-century count of Burgundy who caused the later church to be "made" due to his original donation of the land. The debates about this issue continue to the present day and primarily evolve from the fact that, in general, very little biographical or documentary evidence exists about the majority of named or anonymous medieval artists. In other words, we have no information at all about "Gislebertus" (as an artist) apart from his name on the tympanum at Autun. We do not know who he was, where he was born, what he did, why his name appears in such a prominent position on this building, what actual connection he had with the church or city of Autun, where he went later, or when and where he died. In such cases, scholars can only base their speculations on the visual evidence itself, for example, comparing the style and appearance of the sculpture at Autun to other contemporary examples.

The exterior sculpture above the entrance to the cathedral at Autun, as impressive as it is, represents only a small portion of the vast sculptural program that continues on the interior of the church. Visitors passing beneath the sculptured tympanum and entering the church will find, as typical of many medieval churches, that the interior of the cathedral at Autun is also highly enriched with sculpture, primarily in the form of carved capitals (tops of columns and piers) in the nave (main body of the church), choir (area where church services are performed, between crossing and apse), and apse (traditionally the east end). There are dozens and dozens of carved capitals inside the church at Autun which depict various biblical stories as well as decorative devices. The majority of these carvings exhibit the same style as seen in the tympanum. The figures are highly expressive and frequently appear to be very lively and animated. They are

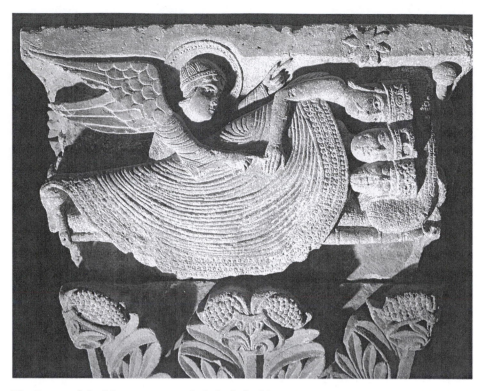

The Dream of the Magi, nave capital, Cathedral of Saint Lazare, Autun, France, c1125–1135. (The Art Archive/Autun Cathedral France/Dagli Orti)

clothed in garments which have drapery folds carved in close parallel lines. These linear folds of drapery are often rendered in curving and swirling patterns. It seems clear that the artist responsible for the exterior tympanum sculpture was also the same artist who carved a great deal of the interior sculpture at Autun.

The rather distinctive "multi-linear" style of the sculpture at Autun has also been identified by scholars at several other French Romanesque churches located relatively close to Autun. Although the evidence is largely fragmentary, specialists have identified echoes and traces of the Autun sculpture style at the church of Sainte Madeleine (Mary Magdalene—identified in legends as the sister of Lazarus) at the nearby city of Vézelay, as well as at the very important and powerful Burgundian monastery of Cluny. Based on a formal comparison of styles as well as some shared ornamental and figurative details, some scholars believe that the career of "the Autun sculptor" (Gislebertus?) can be traced from Cluny (where he served as chief assistant to the master sculptor there around 1115) to Vézelay (where he worked for a time around 1120), from whence he was called to create the sculptures at Autun.

The type of painstaking analysis that is required in order to pinpoint the work of individual medieval sculptors involves extremely high levels of visual train-

ing to identify the often very minute stylistic details.[13] Art historians who use such methods will often concentrate on very small details that more casual viewers might not even notice. They will scrutinize aspects such as the shape and patterns of drapery, looking to see if the sculptor has carved these as tubular, flat-topped, or sharp-edged plates. Sculptors may have distinctive ways of rendering facial features, such as eyelids, earlobes, or nostrils. The details of an individual artist's style may be like the particular characteristics of the handwriting of different people. A careful analysis may thus reveal the "hand" of particular artists in their otherwise "unsigned" works.

Of course, the fact that artists sometimes change their styles, or that their styles may grow and evolve through their artistic careers, also needs to be taken into consideration. Gislebertus's style at Autun may represent his "mature" work—the peak of his career—after his "early" work elsewhere.

Individuals and Teams

The interest in tracing the styles and careers of particular medieval sculptors through their work at different geographic locations is a very logical approach because medieval sculptors, like many other types of artists in the Middle Ages, certainly moved around from job to job, not only as individuals but also as teams. Thus, scholars often speak of "schools" of medieval sculpture, not indicating art academies or schools in the modern sense but shared style characteristics of, for example, a particular region where it seems clear that the same teams of artists worked together. There were no official art schools to attend in the Middle Ages and so we assume that medieval sculptors would learn their craft by first serving as apprentices to a master sculptor. Presumably, they would serve as members of a workshop or atelier while developing their own skills with the aim of eventually becoming masters themselves and heading up their own workshops. In such a system, the master sculptor would serve as overall director and overseer of the workshop, allocating various tasks to the team members depending upon their level of skill and experience. The simpler carving tasks and rougher work would be performed by the beginners, while the master sculptor would take responsibility for the more sophisticated work, perhaps with help from one or two chief assistants.

Unfortunately, however, there is not a great deal of documentary evidence about the division of labor and the specific procedures involved with the creation of the extensive sculptural programs of medieval churches. The amount of work required certainly involved teamwork and collaboration on the part of many craftspeople, though many questions still remain about exactly how these teams of artists were organized and supervised. Also, we cannot "presume that the same kinds of creative and labor practices continued unchanged for generations."[14]

It does seem clear, however, that the work of the sculptors took place, certainly in both the Romanesque and Gothic periods, at the building sites. De-

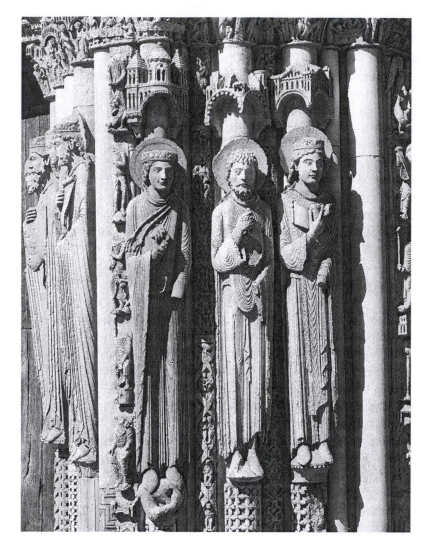

Cathedral of Notre Dame, Chartres, France, c1145–1170, west façade, portal sculpture. (The Art Archive/Dagli Orti)

pictions in medieval illustrated books show sculptors working outside in fair weather and also indicate that enclosed workshop areas were constructed for indoor work during inclement weather. Although finishing details may have been done on occasion from scaffolding, most of the work of carving was done on ground level and the sculptured blocks were then placed in position as the work of church construction progressed. The tympanum at Autun, for example, consists of about twenty-nine separate blocks of limestone which were carefully pieced together again when the tympanum was installed on the church front.

With the medieval church building boom of the Romanesque and Gothic periods, and the increased interest in exterior as well as interior sculpture, the craft of stone carving was in ever-higher demand. It could be claimed that the art of stone sculpture was actually revived during the eleventh century because monumental stone carving was not at all common in the earlier Middle Ages and not since classical (Greek and Roman) times do we see stone carving on such a grand scale as gradually reappears in the medieval period.[15] The extremely elaborate cathedrals of the Gothic era, for example, definitely show sculpture in massive scale and amount. Ultimately deriving from the taste developed for exterior and interior sculpture in the Romanesque period, these later Gothic buildings often have multiple entrances with many tympana depicting narrative and symbolic scenes, rows upon rows of arches (archivolts) above the tympana also filled with sculpture, full-length standing figures grouped around the sides of the portals (jamb sculptures), as well as carved figures in the middle of the large doorways supporting lintels (trumeau figures). The majority of the subjects and scenes represented are derived from the Bible and the lives of saints, although subjects such as the signs of the zodiac and the labors of the months were also popular as aspects of the all-encompassing cosmic program of medieval Christianity. Some Gothic cathedrals also have deep porches filled with additional jamb figures and niches filled with sculpture also depicting biblical figures and saints on the upper levels of the exteriors as well. Gargoyles (drain spouts) carved as ferocious monsters also become popular in the Gothic period. The interiors of Gothic cathedrals become increasingly elaborate in terms of stone sculpture as well, with carved capitals, bands of foliage, figures in niches, and decorative designs on wall surfaces.

All of this vast amount of sculptural work throughout these centuries obviously involved thousands of artisans—the majority of whom remain unnamed. We do, however, know the names of more than a few medieval sculptors and there are actually quite a number of artists' signatures (and presumed signatures) on medieval sculptures. An inscription *Unbertus me fecit* ("Unbertus made me") on a carved stone capital on the French church of Saint-Benoît-sur-Loire dates probably to the 1080s; a sculptor named Bernardus Gelduinus signed his late-eleventh-century work at the church of Saint Sernin at Toulouse in France; Wiligelmo signed his early-twelfth-century work at Modena Cathedral in Italy, to cite just a few examples.[16] In the case of unnamed artists, art historians have invented titles such as the "Cluny Master," the "Headmaster of Chartres," the "Naumburg Master,"[17] and so on.

The fact that the work of these medieval sculptors—named and unnamed— is in some cases often so distinctive and impressive and recognizable as being by the "hand" of individual master carvers (about whom we know so few biographical details) doubtless explains the flurry of initial excitement in the mid-twentieth century and the continued controversy about the inscription naming Gislebertus at Autun.

The Creation of Gislebertus

In the early 1960s, a beautifully illustrated book appeared titled *Gislebertus, Sculptor of Autun.* The book was coauthored by several scholars (Grivot and Zarnecki) who had spent years studying the sculpture of Autun. Fascinated by the distinctive style of the work and eager to give credit to a previously unrecognized medieval French artist, the authors interpreted the inscription naming Gislebertus at Autun to be the signature of the artist himself. Reviews of the book and subsequent photographic exhibitions and articles enthusiastically described the "re-discovery" of the master sculptor of Autun: Gislebertus. He was described as a preeminent artist whose work was apparently held in such high esteem in the early-twelfth century that he was "allowed" to place his name in a most prominent position on the sculpture above the church doorway. He was described as bold and "audacious" and as an important artist whose position in the history of medieval art needed to be reestablished.[18] "The work of Gislebertus is of the highest quality,"[19] wrote one important scholar soon after the publication of Grivot and Zarnecki's volume. Gislebertus has "re-emerged as one of the great artists of Western Europe,"[20] stated another author in 1963. In the following decades, the name of Gislebertus and the importance of his signature at Autun continued to captivate scholarly attention. His inscription at Autun was described as bearing "witness to the fact that he had an author's consciousness of sorts and was proud of his work."[21] Indeed, "it is the inscription of the name that has attracted the most attention. . . . [S]cholarship on the church regards the name Gislebertus as both the carving's and the building's most compelling element."[22]

Indeed, until the publication of Grivot and Zarnecki's book in the early 1960s, very few people apart from specialists had ever heard of Gislebertus. In fact the sculptures at Autun had been covered up by plaster in the late eighteenth century and thus hidden from view until the middle of the nineteenth century when interest in medieval art generally was undergoing a revival. The portal was cleaned up and restored in the mid-nineteenth century by Viollet-le-Duc (1814–1879), the preeminent architect, archaeologist, and restorer of many French medieval monuments. When the tympanum sculpture was plastered over in the eighteenth century, the head of Christ was removed because it projected too far. It wasn't until 1948 that a previously unidentified detached head in a local museum was reunited with the tympanum sculpture. It was at this point also that additional research was undertaken, eventually resulting in the publication of Grivot and Zarnecki's book.

All of these details also indicate the importance of how changing tastes through the ages have a decided influence on how people perceive art from the past and remind us of how our own tastes and perceptions may be shaped by our own times and motivations. This also serves as an extremely useful reminder that there may, inevitably, be hidden agendas in scholarship. The rediscovery of Gislebertus, a medieval French master sculptor, seemed cause for celebration and publicity indeed in the mid-twentieth century. The research of Grivot and

Zarnecki has ultimately resulted in the name of Gislebertus becoming more widely known. Most books about medieval art published in the second half of the twentieth century thus name the artist of the sculpture at Autun as Gislebertus and describe his distinctive and innovative personal style. Students of medieval art need to learn the name of Gislebertus when they study French Romanesque sculpture. The name of Gislebertus has thus been entered into the list of master artists from the medieval period and his career (especially preceding but also after his work at Autun) has been traced by stylistic analysis of similar sculptural work at other locations.

But if the name "Gislebertus" isn't actually that of the artist of the sculpture at Autun but rather that of an earlier noble benefactor who granted land to the church (as has recently been argued by Linda Seidel), does this influence our perceptions of the sculpture? Do we better appreciate the style and understand the subject matter of the sculpture at Autun if we are able to attribute the work to a named artist? Or, is our knowledge of the historical context as well as the subject matter of the sculpture increased if we are able to perceive indications of the ongoing power and territory struggles between the medieval clergy and nobility of the region? In rethinking how we perceive art of the past we are also reminded of our own biases and points of view. The constructing (and deconstructing) of an artistic career for Gislebertus of Autun remains and will continue to be a fascinating and controversial chapter in medieval art history.

Notes

1. Caecilia Davis-Weyer, *Early Medieval Art 300–1150* (Toronto: University of Toronto Press, 1986), 124.

2. See Simon Coleman and John Elsner, *Pilgrimage: Past and Present in the World Religions* (Cambridge, Mass.: Harvard University Press, 1995).

3. Richard Barber, *Pilgrimages* (Woodbridge, Suffolk: Boydell Press, 1991), 1.

4. Leslie Ross, *Medieval Art: A Topical Dictionary* (Westport, Conn.: Greenwood Press, 1996), 199.

5. Ross, 214. See also Benedict Ward, *Miracles and the Medieval Mind: Theory, Record and Event, 1000–1215* (Aldershot, England: Wildwood House, 1987).

6. See Patrick Geary, *Furta Sacra: Thefts of Relics in the Central Middle Ages* (Princeton, N.J.: Princeton University Press, 1990).

7. Linda Seidel, *Legends in Limestone: Lazarus, Gislebertus and the Cathedral of Autun* (Chicago: University of Chicago Press, 1999), 60.

8. Seidel, 60.

9. Leslie Ross, "Reading Medieval Art," in *The Thread of Ariadne*, ed. P. Umphrey (Fort Bragg, Calif.: QED Press, 1988), 108.

10. Ross, "Reading Medieval Art," 108.

11. Davis-Weyer, 48.

12. Calvin Kendall, *The Allegory of the Church: Romanesque Portals and their Verse Inscriptions* (Toronto: University of Toronto Press, 1998).

13. For excellent recent examples of this approach, see C. Edson Armi, *The "Head-*

master" of Chartres and the Origins of "Gothic" Sculpture (University Park: Pennsylvania State University Press, 1994) and C. Edson Armi, *Masons and Sculptors in Romanesque Burgundy: The New Aesthetic of Cluny III* (University Park: Pennsylvania State University Press, 1983).

14. Armi, *Headmaster,* 105.

15. Millard Hearn, *Romanesque Sculpture: The Revival of Monumental Stone Sculpture in the Eleventh and Twelfth Centuries* (Ithaca, N.Y.: Cornell University Press, 1981).

16. See Kendall, especially chapter 13: "Artists in Pursuit of Fame," 171–184, and for the Italian examples, see Christine Verzar, "Text and Image in North Italian Romanesque Sculpture," in *The Romanesque Frieze and Its Spectator,* ed. Deborah Kahn (London: Harvey Miller, 1992), 121–140.

17. Kathryn Brush, "The Naumburg Master: A Chapter in the Development of Medieval Art History," *Gazette des Beaux-Arts* 6 (1993): 109–132.

18. E. M. Polley, "The Sculptor of Autun," *Artforum* 1, no. 8 (1963): 24.

19. C. R. Dodwell, review of *Gislebertus, Sculptor of Autun* by D. Grivot and G. Zarnecki, *The Burlington Magazine* 104 (1962): 544.

20. J. D. de la Rochefoucauld, "The Rediscovery of Gislebertus," *Connoisseur* 152 (1963), 90.

21. Aaron Gurevic, "The West Portal of the Church of St. Lazare in Autun: The Paradoxes of the Medieval Mind," *Peritia* 4 (1985): 251.

22. Seidel, 12.

Bibliography

Armi, C. Edson. *The "Headmaster" of Chartres and the Origins of "Gothic" Sculpture.* University Park: Pennsylvania State University Press, 1994.

————. *Masons and Sculptors in Romanesque Burgundy: The New Aesthetic of Cluny III.* University Park: Pennsylvania State University Press, 1983.

Barber, Richard. *Pilgrimages.* Woodbridge, Suffolk: Boydell Press, 1991.

Brush, Kathryn. "The Naumburg Master: A Chapter in the Development of Medieval Art History." *Gazette des Beaux-Arts* 6 (1993): 109–132.

Coldstream, Nicola. *Masons and Sculptors.* Toronto: University of Toronto Press, 1991.

Coleman, Simon, and John Elsner. *Pilgrimage: Past and Present in the World Religions.* Cambridge, Mass.: Harvard University Press, 1995.

Davis-Weyer, Caecilia. *Early Medieval Art: 300–1150.* Toronto: University of Toronto Press, 1986.

Denny, Don. "The Last Judgment Tympanum at Autun: Its Sources and Meaning." *Speculum* 57, no. 3 (1982): 532–547.

————. "The Meaning of 'Sculptor' in the Romanesque Period." *Romanesque and Gothic: Essays for George Zarnecki,* edited by Neil Stratford. Woodbridge, Suffolk; Wolfeboro, N.H.: Boydell Press, 1987.

Dodwell, C. R. Review of *Gislebertus, Sculptor of Autun* by D. Grivot and G. Zarnecki. *The Burlington Magazine* 104 (1962): 544–546.

Geary, Patrick. *Furta Sacra: Thefts of Relics in the Central Middle Ages.* Princeton, N.J.: Princeton University Press, 1990.

Grivot, Denis, and George Zarnecki. *Gislebertus, Sculptor of Autun.* New York: Orion Press, 1961; reprinted New York: Hacker Art Books, 1985.

Gurevic, Aaron. "The West Portal of the Church of St. Lazare in Autun: The Paradoxes of the Medieval Mind." *Peritia* 4 (1985): 251–260.

Hearn, Millard. *Romanesque Sculpture: The Revival of Monumental Stone Sculpture in the Eleventh and Twelfth Centuries.* Ithaca, N.Y.: Cornell University Press, 1981.

Kendall, Calvin. *The Allegory of the Church: Romanesque Portals and their Verse Inscriptions.* Toronto: University of Toronto Press, 1998.

Petzold, Andreas. *Romanesque Art.* New York: Harry N. Abrams, 1995.

Polley, E. M. "The Sculptor of Autun." *Artforum* 1, no. 8 (1963): 24–26.

Rochefoucauld, J. D. de la. "The Rediscovery of Gislebertus." *Connoisseur* 152 (1963): 90–93.

Ross, Leslie. *Medieval Art: A Topical Dictionary.* Westport, Conn.: Greenwood Press, 1996.

———. "Reading Medieval Art." In *The Thread of Ariadne,* edited by P. Umphrey. Fort Bragg, Calif.: QED Press, 1988.

Seidel, Linda. *Legends in Limestone: Lazarus, Gislebertus, and the Cathedral of Autun.* Chicago: University of Chicago Press, 1999.

Stoddard, Whitney. *The Sculptors of the West Portals of Chartres Cathedral.* New York: Norton, 1987.

Verzar, Christine. "Text and Image in North Italian Romanesque Sculpture." In *The Romanesque Frieze and Its Spectator,* ed. Deborah Kahn. London: Harvey Miller, 1992.

Ward, Benedict. *Miracles and the Medieval Mind: Theory, Record and Event, 1000–1215.* Aldershot, England: Wildwood House, 1987.

CHAPTER 2

The Master Metalworkers:
Rainer of Huy, Godefroid de Claire,
Nicholas of Verdun, and Company

Magnificent Metalwork

Among the many amazing and beautiful types of artworks produced during the Middle Ages, a very special position must be given to the objects created of metalwork. The surpassing skill with which medieval artists shaped and decorated magnificent works in gold, silver, and bronze make these objects today amongst the most admired examples of medieval art production. These costly objects, created of precious materials with meticulous techniques, often glittering with gems and colorful enamels, were certainly designed to impress and inspire awe in the medieval viewers. Modern-day viewers of these works are similarly filled with appreciative amazement in their presence as well.

Although the modern viewers of these medieval works may indeed be filled with admiration for the beauty of these objects, it is wise to remember that these works were not designed to be seen—as they so often are today—in museum collections. A true appreciation for these glorious objects needs to take into account that these works were originally designed to serve specific functions. One needs to visualize these objects placed and used in their original contexts and settings. Many of the magnificent objects of medieval metalwork displayed today in art museums were originally located in churches. These objects were used in religious services and played specific roles in medieval worship and devotional practices. Doubtless it is due to their supreme significance in medieval religious ceremonies that the utmost care was taken in crafting these objects into glowing and vibrant expressions of medieval spirituality.

Many other types of beautiful, secular (nonreligious) objects of metalwork survive from the Middle Ages also. These include jewelry (rings, brooches, necklaces), crowns, belt buckles, and decorative mounts for belts, saddles, reins, and

hunting horns, as well as objects of tableware such as platters, cups, plates, salt cellars, ewers, goblets, spoons, knives, and saucers. The wealthy and aristocratic classes in medieval society certainly enjoyed owning, using, and displaying these luxurious objects as symbols of their social position. Coins and seals were also among the important objects produced by medieval metalworkers.

Although both secular and religious objects of metalwork survive from the Middle Ages, the need for religious (or liturgical) pieces represents a significant demand on medieval metalworkers. These liturgical artifacts are also the ones most often displayed in museums and church treasuries today.[1]

Liturgical Art

There were many different types of liturgical objects created during the medieval period. All of these religious objects were designed for specific functions. From *aquamanilia* to monstrances, croziers to reliquaries—the list of names and terms associated with these objects is lengthy. Some familiarity with the rites and ceremonies of the medieval Christian church is helpful in understanding how these objects were used, although many of the objects have modern counterparts which are used in Catholic and some Protestant church services today.

A great number of the metalwork objects that survive from medieval churches were displayed or used on the altar during the celebrations of the Mass. The Mass is the crucial church service, which, in Christian practice, commemorates the death and resurrection of Jesus Christ. The ceremony of the Mass takes place on an elevated table or altar. The altar—what takes place on it, and what objects are used—provides the focal point for the Mass in physical as well as symbolic terms. The priest or bishop celebrating Mass (the celebrant) partakes of and may distribute to the congregation special holy bread (wafers, also known as the Host) and wine. These two elements of the Eucharist, in Christian teaching, symbolize and are transformed into the body and blood of Jesus Christ. Special containers were created to hold these critical elements of the Eucharist. Chalices are cups or goblets that hold the sacred wine; patens are circular dishes used to hold the wafers. Additionally, the holy wafers may be stored in covered containers known as ciboria, and the wafers may be displayed in containers called monstrances.

Candlesticks and crucifixes were often displayed on church altars and altars were often elaborately decorated with screens or panels on their front sides. These are called altar frontals or antependia. Small "portable altars" also survive in some numbers from the Middle Ages; these could be moved to different locations for celebrating Mass.

An important part of church services involves burning incense. Censers or thuribles are the objects used for this. The celebrant also washes his hands with holy water at a certain point in the Mass; *aquamanilia* are vessels with pouring spouts used for this purpose. Holy water may also be sprinkled with a long-handled rod known as an aspergillum. The religious books used in the Mass

during the Middle Ages were often enriched with beautiful and elaborate gem-studded metal covers as well.

In preparation for the Mass, monstrances and special long-handled crosses (known as processional crosses) were often carried in processions to the altar. Bishops, abbots, and abbesses carry staffs with crooked tops (like shepherds' crooks); these are known as croziers. Elaborate rings were also worn by arch-bishops at especially grand church ceremonies.

Apart from the objects used specifically for the Mass, several other types of objects were regularly found in medieval churches. Little statuettes of impor-tant holy figures such as the Virgin Mary were extremely popular. Of extreme significance also were the elaborate containers for relics. Relics are the physical remains of, or objects associated with, holy figures such as saints. During the Middle Ages, relics were customarily enshrined in impressive containers known as reliquaries. These were created in a variety of different shapes and forms. Some, known as *chasses*, are shaped like little churches or houses. Others are more simple box-like containers (often called reliquary caskets); others actually have the shape of the relic they contain (a saint's arm bone or head, for exam-ple.) Relics were the great treasures of medieval churches and reliquaries are amongst the most impressive examples of medieval metalwork to survive. Reli-quaries were displayed in churches on or above altars or in other prominent lo-cations and/or kept in special chapels or the crypt (underground area). These objects were eagerly viewed and venerated by medieval churchgoers and pil-grims and were often visual focal points in church layout and arrangement.

Materials and Techniques

Various materials and techniques were used by medieval artists to create these metalwork objects.[2] Gold, silver, and bronze were used—often in combination. Designs and scenes could be engraved (or incised) or stamped or punched into the flat surfaces; sheets of metal could be laid over a shaped base (say, of wood) and carved or molded to form three-dimensional elements. This is also known as embossing. Raised designs were also created by hammering metal from the back side; this is known as repoussé. Three-dimensional forms could also be created by the process of casting metal. This involves using a mold to duplicate an original clay or wax model; melted metal is poured into the mold and al-lowed to cool.

Medieval metalworkers were also great masters of several enameling tech-niques. Enamel is colored glass that is melted and fused to a metal base. Enam-eling is a very ancient art form "producing a glistening, magical effect and satisfying the human love of ornament."[3] There were two primary methods of enamel work used in the early Middle Ages: cloisonné and champlevé. Cloi-sonné enamel is created by placing colored ground glass into little cells (or cloi-sons) made by thin threads of metal raised from a surface. Champlevé enamel involves placing the colored ground glass into hollows dug out of a metal sur-

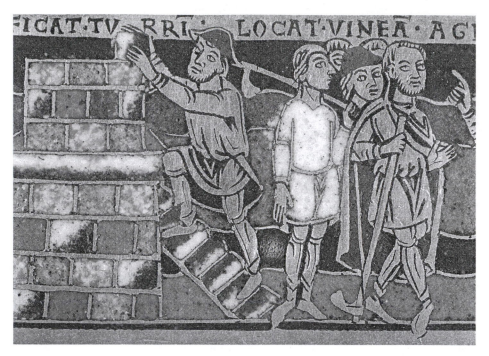

Constructing a tower, from the parable of the "Workers in the Vineyard," plaque in gold and enamel, 1160. (The Art Archive/Museo del Bargello Florence/Dagli Orti)

face. In both techniques, the pieces are then fired (baked) and the glass melts and fuses to the metal. Sometimes these two techniques were combined, although the champlevé technique became the most commonly used in western Europe from the eleventh through thirteenth centuries and the cloisonné technique was more characteristic of Byzantine art during the medieval period.

Another enameling technique, known as *basse-taille*, or translucent enamel, was developed in Europe in the late thirteenth century. This involves carving the metal surface into a variety of depths before the enamel is applied. Enamels done in this technique show greater variation in color tones due to the depth or thickness of the enamel. Painting on enamel was another technique that developed, especially in the very late medieval period.[4] An awareness of and ability to recognize these different techniques can assist in localizing and dating objects of enamel work from the Middle Ages.

Many objects of medieval metalwork are gilded; this means they have been covered with very, very thin sheets of gold known as gold leaf. There were several different processes used for gilding. Niello is another technique often used by medieval metalworkers to create black lines and designs on a metal surface. The niello technique involves filling in incised lines on an object with a combination of lead, silver, copper, and sulphur. Another common technique was filigree work, which involves the careful laying down of a series of beads of melted gold.

Gems, jewels, and pearls were frequently also fixed onto medieval metalwork objects. The sources for the precious and semiprecious gems and stones used in medieval metalwork range widely. Rubies, sapphires, emeralds, and turquoise came from regions such as India, Persia, Egypt, and Russia. Opals, garnets, rock crystal, pearls, amber, and coral were obtained in Europe, the British Isles, and various Mediterranean regions. The art of cutting stones into sharp planes of faceted surfaces develops later in the Middle Ages (the fourteenth and fifteenth centuries). Before then, the stones and gems mounted into metalwork objects and jewelry were simply cut into ovals, squares, and circles and then highly polished. These unfaceted stones are known as cabochons. Again, it is often possible to date medieval objects on the basis of their use of cabochons or cut gemstones.

The stunning combination of costly materials and meticulous, complicated methods makes us marvel at the skill of these medieval artists and their refined techniques.

All of the techniques mentioned above—and many, many more—are described in full detail in a very intriguing manuscript that survives in numerous copies from the Middle Ages. This is the treatise on *The Various Arts (De Diversis Artibus)* which was written in the first half of the twelfth century by a German Benedictine monk who called himself "Theophilus" (see chapter 5). This how-to manual contains a wealth of information about a vast number of medieval art techniques and includes especially detailed coverage of metalworking processes. Many scholars who have studied this work have been extremely tempted, and with good reason, to identify the pseudonymous "Theophilus" with a named and famous medieval metalworker, Roger of Helmarshausen.

Roger of Helmarshausen (Early Twelfth Century)

The identification of the author Theophilus with Roger of Helmarshausen is largely based on the facts that one of the earliest surviving copies of the treatise on *The Various Arts* includes a note identifying "Rogerus" as the author, and also that a goldsmith Roger is named in a document of c1100 which records his creation of a portable altar for Bishop Henry of Werl of Paderborn. The goldsmith Roger, who worked at the abbey of Helmarshausen, thus seems likely to have been "the same Roger the author of the *De Diversis Artibus,* written by a monk and priest Theophilus whose name in religion was Roger."[5]

The portable altar that Roger created for Bishop Henry of Werl is a beautiful object of silver and gilt bronze with niello panels, pearls, and gems. It survives today and is a prized possession of the treasury of Paderborn Cathedral. The top includes a green marble slab surrounded with niello plaques. An embossed (raised) figure of Christ surrounded by wire filigree appears on the front. Although Roger did not sign this specific work (or any other works of art), it cer-

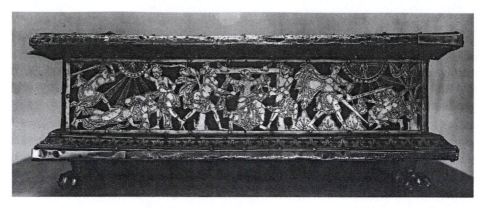

Portable altar from Abdinghof Abbey by Roger of Helmarshausen, c1100. Paderborn, Franciscan Church. (Courtesy of Bildarchiv Foto Marburg)

tainly seems likely that the Paderborn portable altar displayed in the Paderborn museum today is the one mentioned in the document as having been created for Bishop Henry of Werl by Roger of Helmarshausen.

Working from this evidence, art historians have concentrated on identifying other works of art that Roger might have produced during his career as a metalworker in the early twelfth century. The engraved niello panels on the Paderborn portable altar, which depict figures of apostles as well as Bishop Henry of Werl, exhibit a rather distinctive style in the depiction of drapery. The garments of the figures are rendered in what art historians have termed the "nested V-fold" style; that is to say, folds in the drapery are indicated by series of little V-shaped lines nested into groups. This particular way of showing drapery folds "may be seen as one of the aspects of a general tendency throughout Europe around 1100 to learn that the representation of the human figure would gain in solidity and sculptural presence if the drapery patterns revealed rather than concealed the figure beneath them."[6] This artistic convention was used to imply a sense of three-dimensionality to forms shown on otherwise flat surfaces, such as Roger's engraved niello panels on Bishop Henry's portable altar. This nested V-fold style, along with some other distinctive elements in the drapery patterns, has been identified as the signature style of Roger and, although various earlier sources for his drapery style have also been traced, this particular style seems to appear in really full-blown form in Roger's work of c1100.

Lacking any other documents or any works actually signed by Roger requires very detailed style analysis of other works of art in order to establish an artistic career for Roger. Based on style analysis, several other works have been attributed to Roger, including another portable altar made for the abbey of Abdinghof (today also in the museum in Paderborn). This object, "undoubtedly also the work of Roger,"[7] displays beautiful panels of gilded openwork bronze depicting scenes from the lives and martyrdoms of several saints. Episodes from saints' lives were extremely popular in all medieval art media. These saintly (hagiographic) subjects, along with stories from the Bible, form an important core

of subject matter for medieval art generally.[8] The particular saints depicted on the Abdinghof portable altar include the patron saints of the abbey.

The nested V-folds can certainly be seen here on the Abdinghof portable altar and the style compares very well with the previous altar attributed to Roger. "The figure style, although in a more lively narrative version . . . is identical with Bishop Henry's altar: the same carefully articulated figures, the same severe heads and at times contorted poses occur."[9] Whether or not Roger made this altar before or after the other one is a matter of dispute, however. The Abdinghof altar is undated and there are no documentary references to it that would assist in determining its date.

Apart from these two portable altars, Roger has also been credited with creating a magnificent metal book cover for a manuscript of the Gospels. This object, today in the cathedral library in Trier, includes raised and gilt copper depictions of the animal symbols of the Four Evangelists, cloisonné enamel pieces with decorative designs, gems, pearls, and filigree details. Scholars have noted that the filigree work here is exactly similar to that found on the Paderborn altar, thus indicating Roger's "hand." Two other works of art—an altar cross and a crucifix figure—have also been described as being "very close to Roger's style and may well be by his hand."[10]

Clearly, we would expect, hope, and deeply desire to be able to attribute (or securely attribute) a few more pieces to the master metalworker, Roger. If indeed he was "Theophilus," the author of the important treatise on medieval art techniques mentioned above, his skill and expertise with a huge variety of metalworking methods seems beautifully, but incompletely, reflected in the relatively few works of art actually associated with his name.

Rainer of Huy (Early Twelfth Century)

Roger of Helmarshausen is credited with developing a distinct and influential style in German Romanesque art and there are several other metalworkers who are also famous for their style and influence. Rainer of Huy, who worked in the Mosan region (parts of present-day Belgium and Germany), is traditionally credited with creating a magnificent bronze baptismal font for the church of Notre Dame at Huy. The font (used for the ceremonies of baptism—the traditional rite of formal entry into the Christian church) is about twenty-three inches tall and about thirty-one inches in diameter. This work was commissioned by Abbot Hellinus and is dated between 1107–1118. The font is displayed today in the church of Saint Bartholomew in Liège, Belgium, and is one of the most famous monuments of medieval bronze-casting art.

The Liège baptismal font was cast in a single piece and was originally supported by twelve figures of bronze oxen. Ten of the (half-length) oxen survive. They are extremely charming creatures who are shown twisting and turning their heads with a sense of powerful but free and easy movement. This sense of freedom, ease, and naturalism permeates the raised relief sculptures on the font it-

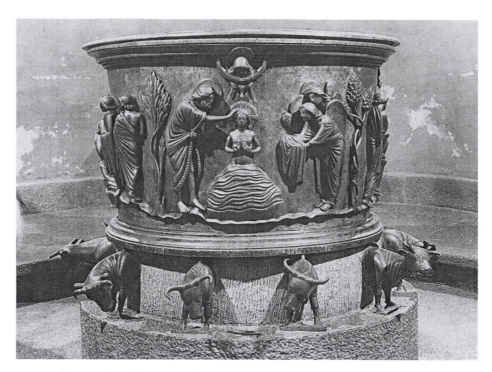

Baptismal font attributed to Rainer of Huy, c1107–1118. Church of Saint Barthélemy, Liège, Belgium. (Courtesy of the Conway Library, Courtauld Institute of Art, London)

self. Appropriately, various baptism scenes are shown on the bowl of the font, including the scene of the baptism of Jesus by Saint John the Baptist. All of the many figures depicted on the font seem calm and serene; they are not crowded, but move around the font in a relaxed and gentle manner. The figures are soft and smooth. Many of them are wrapped in long robe-like garments and the drapery rests comfortably on the figures. The bodies are realistically proportioned and the drapery reveals the three-dimensionality of the forms beneath. Altogether, the smoothness, ease, and naturalism here seems very classical (like the realistic figure styles in ancient Greek and Roman art), and the Liège baptismal font is an excellent example of the classicizing trend in German medieval art of the early twelfth century.

There are other examples of artworks produced in the Mosan region and elsewhere during the medieval period which exhibit these classical-style qualities. And, just like using the nested V-fold treatment to attempt identification of specific works of Roger of Helmarshausen, there are a couple of other pieces that have been attributed to Rainer of Huy based on comparison with the Liège baptismal font. A small cast bronze figure of Christ from a crucifix (in Cologne) and a small bronze censer (in Lille) have been identified as the work of Rainer, or very close to his style. Many other works of art have been described as being "influenced" by Rainer's style. Indeed the "classicizing" style was extremely prevalent throughout the twelfth century, especially in the Mosan region.

It is difficult, however, to credit this style tendency purely to the work of Rainer of Huy, especially because the name of the artist who created the Liège baptismal font is not actually certain. Scholars have found it convenient to describe it as a work by Rainer of Huy, but this attribution is highly speculative and based on rather slim and confusing documentary evidence. The name "Reinerus" (an alternate spelling?) appears in a legal document of c1125 from the church at Huy, and although this "Reinerus" (Rainer?) is described as an "artist," the document unfortunately does not actually refer to any of his specific art. The beautiful font was also described in another document but in this further document, the artist's name is not stated. It is only in the fifteenth century that a chronicle from Liège states that the artist "Rainer of Huy" made the baptismal font and—at this date, several centuries later—it is far from certain that this information is accurate. Again, the traditional attribution of works of art to specific named artists in the medieval period poses many challenges, but should by no means prevent us from admiring the beauty of the surviving works.

Godefroid de Claire (Mid-Twelfth Century)

Godefroid de Claire is another intriguing case of a named artist whose skill in metalworking is lavishly praised in several medieval documents but whose actual surviving works appear to be few. In this case, the separation of legend and myth from documentary records is especially challenging. A letter does survive from 1148 written by the famous and important art patron, Abbot Wibald of Stavelot (1098–1158), to "Dear Son 'G,' goldsmith." In this letter (one of over 400 surviving from his copious correspondence), Abbot Wibald asks "G" to quickly complete all the objects he had previously ordered and he urges him not to accept any other commissions until he has completed this work. The abbot writes, "Know, that our desire is impatient and pressing and that we want quickly what we want."[11] A letter from "G" replying to Wibald also survives in which the artist assures his patron that he will complete his commissions as soon as possible; he adds, "But it is not always in the power of him who promises to fulfill these promises."[12] This fascinating interchange of letters between Wibald and the goldsmith "G" has naturally inspired scholars to want to learn more about "G's" life, work, and personality.

There are other documents—from the twelfth, thirteenth, and fourteenth centuries—which have been called into play here to create the artistic personality: Godefroid de Claire. The death of a Godefroid is noted in the register of a nearby monastery in the late twelfth century. In the thirteenth century someone added more information in this document, stating that Godefroid was a citizen of Huy who was a surpassing metalworker. An even later thirteenth-century document states that two magnificent shrines were created in the late twelfth century by the goldsmith Godefroid. And, by the fourteenth century, the artist Godefroid was described by a chronicler as "the finest goldsmith in the world."[13]

The problems here are obvious. Although it may be accepted that there was

a famous goldsmith named Godefroid who worked in the area around Huy in the mid and late twelfth century, there is no real certainty at all that this same Godefroid was actually the artist "G" who worked for and corresponded with Abbot Wibald of Stavelot. Nevertheless, scholars have tended to concentrate on the surviving works commissioned by Abbot Wibald as pieces that are potentially attributable to the goldsmith Godefroid.

And here, even more challenges arise. Abbot Wibald was an extremely important figure in twelfth-century politics and religion. He traveled widely throughout Europe, accompanied the German emperor Conrad III on the Second Crusade, served as imperial ambassador, advisor, and counselor to several other emperors, and was a major patron of the arts. He commissioned (c1145) a gilt silver and enamel reliquary of the head of Pope Alexander and a magnificent shrine and altar screen for his monastery at Stavelot. His patronage has also been connected with an elaborate gilded bronze and enamel reliquary triptych (three hinged folding panels), created to contain some smaller Byzantine reliquaries which he may have acquired during his travels to Constantinople.

The head reliquary and the reliquary triptych survive, but the shrine and altar screen were dismantled and exist today only in fragments. Although both the head reliquary and the triptych exhibit magnificent examples of enamel work, the styles used are rather different. Although these objects may have been produced in the "same workshop," the head reliquary "appears to be by a different hand" than the triptych.[14] There is, in any case, no documentation to support the attribution of either of these two specific works to the artist Godefroid de Claire. In fact, the only works directly mentioned (in thirteenth-century documents) as being creations of the goldsmith Godefroid (two reliquary shrines for Saints Domitian and Mangold) contain no enamels and survive today in a highly restored and so altered state that art historians have been unable to actually identify a distinctive style of this artist. So, "on the whole, the introduction of the personality of Godefroid has often hindered rather than helped our understanding of the development of the Mosan style in this vital period."[15]

Again, the lack of secure attributions—in the form of artists' names to connect to specific medieval works of art—really should not diminish our appreciation of these objects and their importance for medieval society and religion. The Stavelot triptych, for example, now in the Pierpont Morgan Library in New York, is an extremely impressive example of the art of medieval metalwork. It exhibits a glittering array of enamels set in a gilded copper framework and includes precious gems, miniature silver columns, and silver pearls. Although the object itself is only about nineteen inches tall and twenty-six inches wide, it impresses all the more by its small scale and extremely fine detail.

The two side panels on hinges attached to the central panel show six round champlevé enamel plaques which depict scenes from the lives of the first Christian Roman emperor, Constantine, and his mother, the empress Helena. The overall format of the triptych resembles the two smaller Byzantine reliquary triptychs contained within it. These Byzantine objects exhibit smaller cloisonné enamels and they contain precious relics including fragments of the True Cross (the cross upon which Jesus was crucified).

The emperor Constantine is celebrated for his official toleration of the Christian religion within the Roman Empire in the early fourth century, thus bringing to an end the previous persecutions of Christians. The empress Helena is credited with having made an important pilgrimage to the Holy Land in c326. On this journey she identified a number of sites associated with the life, death, and resurrection of Jesus. These holy places continued to serve as sites of Christian pilgrimage all through the medieval period.

The fascinating medieval legends regarding Helena's discovery of the True Cross during her pilgrimage to Jerusalem are partially illustrated in the three champlevé enamel plaques on the right side of the Stavelot triptych. The tales recount that three buried crosses were excavated under her direction. Jesus had been crucified along with two other people and so it was important to determine which one of the three crosses was the True Cross. The True Cross was identified "when it alone revived a dead youth,"[16] just as is shown in the top right enamel scene of the Stavelot triptych. As fragments of the True Cross are displayed in the triptych's center, these enamel scenes appropriately reinforce the importance and validity of these relics. It should be noted, of course, that "pieces of the True Cross were among the most sought after and the most abundant of medieval relics."[17]

Whether or not the Stavelot triptych can be securely credited to a particular named artist (Godefroid de Claire?) may be of much less interest, in the long run, than what we can learn from the object about medieval interests, values, and beliefs.

Nicholas of Verdun (Late Twelfth/Early Thirteenth Century)

With the three artists mentioned above—Roger of Helmarshausen, Rainer of Huy, and Godefroid de Claire—we have names but no absolutely secure attributions, or attributions but really no surviving works. With Nicholas of Verdun however, we have two securely documented works, magnificent pieces of metalwork, signed by the artist himself. One work dates to 1181 and the other to 1205. Thus, art historians have felt much more confident about discussing the artistic career of this esteemed and influential master metalworker of the Mosan region.

The first piece attributed to Nicholas is one of the very most impressive monuments of medieval enamel work and medieval symbolism. Originally a pulpit for the Augustinian abbey of Klosterneuberg, the enamel panels were rearranged (after a fire in the fourteenth century) to create an altar screen in triptych form. At this point (c1331), six additional enamel plaques were added to the original forty-five. The enamels are done in the champlevé technique and are arranged in three horizontal rows.

A myriad of subjects from the Bible are represented in these enamel plaques, carefully arranged according to a complex system of symbolism known as ty-

The Klosterneuberg altarpiece by Nicholas of Verdun, 1181. Stiftsmuseum, Klosterneuberg, Austria. (Erich Lessing/Art Resource, NY)

pology. Events from the life of Jesus Christ appear in the middle register while scenes from the Old Testament and New Testament appear on the registers above and below. Additional scenes relating to the end of time and the Last Judgment also appear on the right-hand wing of the triptych. The subjects and stories are carefully matched up to be read vertically and in groups. Events from the Old Testament (Hebrew scriptures) which prefigure events from the New Testament (Christian scriptures) are aligned according to their similarities and theological significance. For example, the Old Testament story of Jonah (who spent three days in the belly of a whale) is matched with the image of the Entombment of Jesus. According to Christian tradition, Jesus spent three days in his tomb before his resurrection. The typological analysis of scripture has a very long history in Christian theological writings and was especially popular with authors in the twelfth century. These writings were extremely influential on the development of religious illustration programs in medieval art, such as seen in the Klosterneuberg altarpiece.

Apart from the fine enamel plaques, the Klosterneuberg altarpiece is also lavishly covered with inscriptions, including one naming the patron, the artist, and the date of completion (1181). The inscription reads: "Nicholas of Verdun made this work." Of course, we have no other biographical information about Nicholas—where he received his training in the art of metalworking or where he worked before he arrived to complete this important commission at the abbey of Klosterneuberg. Clearly, to receive such a significant commission, Nicholas

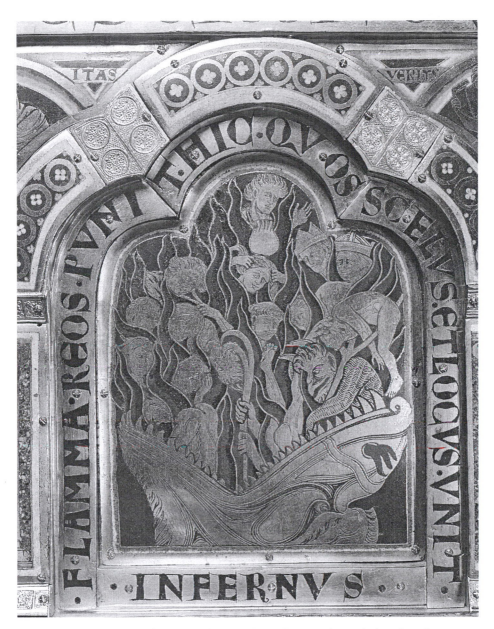

The Mouth of Hell, detail from the Klosterneuberg altarpiece by Nicholas of Verdun, 1181. Stiftsmuseum, Klosterneuberg, Austria. (The Art Archive/Klosterneuberg Monastery, Austria/ Dagli Orti)

must have already been an artist of high regard. Scholars estimate that he probably worked on this large piece (with careful directions from his patron about the choice and arrangement of subjects) for at least two years, so he must have arrived at Klosterneuberg around 1178.

Like Rainer of Huy and Roger of Helmarshausen, Nicholas of Verdun is also credited with developing a highly distinctive style which was to influence many

other artists. The key elements of Nicholas's style are also exhibited in his manner of handling human figures and drapery. The relatively sharper and more geometric nested V-fold style of Roger is here combined with much of the softness and ease of Rainer's classical style. In Nicholas's work (much later in the twelfth century than either of the two earlier artists) drapery flows around the figures in loose and curving patterns. The drapery swoops and falls in naturalistic folds that reveal the shape and movement of the figures. Specifically distinctive are the grooves and trough-like patterns he employs. Art historians have named this style the *muldenstil*: the "trough fold" or "softly grooved" style. Some art historians like to credit Nicholas with the invention or creation of this style, which quickly became the standard for many works of art produced around the year 1200 all across Europe.

The only other securely attributed and precisely dated work of Nicholas is a piece he produced about twenty-five years after his work at Klosterneuberg. This is a small but exquisite house-shaped reliquary shrine of Saint Mary (in the treasury of Tournai Cathedral) made of gilded silver and bronze and set with enamel pieces, gems, and pearls. An inscription on this piece also states that it was made by Nicholas and completed in 1205. The raised figures and scenes under arcades on the sides on the shrine also exhibit a highly fluid and expressive handling of drapery, evident of Nicholas's mature and late style.

The lengthy chronological gap between the Klosterneuberg altarpiece and the Tournai shrine has naturally led scholars to attempt to reconstruct Nicholas's career in the intervening years. With no other documents or inscriptions, but using careful stylistic analysis, art historians have attributed a number of other beautiful works from the late twelfth century to the "hand" of Nicholas of Verdun, either in whole or in part. An esteemed master artist such as Nicholas would doubtless have worked with assistants and would have trained younger artists in his techniques and style. Thus, a number of other works have been partially attributed to Nicholas and partially to his workshop assistants. Nicholas himself however, remains regarded as one of the truly "great creative personalities"[18] of the Middle Ages who played a prominent role in the development of a style which marks an important transition between the Romanesque and Gothic eras.

Anonymous Artists

The traditional identification of the "hands" or "personal styles" of the artists discussed above should not cause us to neglect the fact that these named artists and the works which are more or less securely attributed to them represent just a very small sampling of the vast wealth of medieval metalwork production. Certainly it is tempting to see "the imprint of three of the greatest artist personalities of the Romanesque period: Rainer of Huy . . . Godefroid de Claire . . . and Nicholas of Verdun" on the history of twelfth-century art.[19] However, a number of important pieces by other named artists could also be included here, such as the extremely impressive golden altar produced, in the ninth century, for the

church of Sant'Ambrogio in Milan by a Master Wolvinus, or, the twelfth-century work of Eilbertus of Cologne who is also credited with a distinctive style.

There are, however, countless other examples of beautiful liturgical objects which were produced during the Middle Ages by artists whose names are unknown. The many examples of (largely anonymous) enamel work objects produced in the Limoges area of France during the twelfth through fourteenth centuries are impressive examples of medieval enameling techniques in this region as well. Enamel production was a specialty in this area throughout the Middle Ages.

Perhaps it is, in the long run, most profitable to approach all of these works of art as expressions of their time and context, without neglecting the contributions of special and creative individual artists, of course. In other works, writing the history of medieval metalwork with an emphasis on named artists only may tend to downplay or gloss over the many, many contributions of the hundreds of other anonymous medieval artists. These artists—along with their named counterparts—also contributed their skills to the enrichment of medieval churches, as well as wealthy households, with functional and devotional objects of magnificent metalwork.

Curiously enough, this uneasiness of approach—the very natural tendency of scholars to want to fix names to objects during a time period when so much art production was anonymous—is also reflected in some concern about exactly what to call the arts of medieval metalwork. The fabulous shrines, golden and enamel reliquaries, altar frontals, book covers studded with precious gems, and pearl-strewn chalices, as well as the many stupendous examples of secular objects of medieval metalwork, have often been categorized under the designation: "minor arts," "decorative arts," or "applied arts." In this way, they are contrasted with the "major" or "monumental arts" of architecture, sculpture, and painting and may, by implication, be seen as lesser forms of art. This terminology—separating the "minor" and "monumental" arts—largely developed during the nineteenth century and reflects a very nonmedieval distinction as well between "art" and "craft." More recent scholarship in the twentieth century has argued very convincingly for a reassessment and recognition of "the greatness of the so-called minor arts"[20] and their monumental significance in medieval society.

Notes

1. John Cherry, *Goldsmiths* (Toronto: University of Toronto Press, 1992), 36.
2. Cherry provides an excellent short introduction to medieval metalworking methods.
3. Klaus Wessel, *Byzantine Enamels from the Fifth to the Thirteenth Century* (Greenwich, Conn.: New York Graphic Society, 1967), 11.
4. Marie-Madeleine Gauthier and Madeleine Marcheix, *Limoges Enamels* (London: Paul Hamlyn, 1962).

5. Peter Lasko, *Ars Sacra: 800–1200* (New Haven, Conn.: Yale University Press, 1972, 1994), 163.

6. Lasko, 164.

7. Lasko, 165.

8. Leslie Ross, *Text, Image, Message: Saints in Medieval Manuscript Illustrations* (Westport, Conn.: Greenwood Press, 1994).

9. Lasko, 166.

10. Lasko, 166.

11. Caecilia Davis-Weyer, *Early Medieval Art: 300–1150* (Toronto: University of Toronto Press, 1986), 171.

12. Davis-Weyer, 172.

13. Lasko, 192.

14. William Voelkle, *The Stavelot Triptych: Mosan Art and the Legend of the True Cross* (New York: Pierpont Morgan Library, 1980), 10–11.

15. Lasko, 194.

16. Leslie Ross, *Medieval Art: A Topical Dictionary* (Westport, Conn.: Greenwood Press, 1996), 253.

17. Ross, 253.

18. Lasko, 262.

19. Hanns Swarzenski, *Monuments of Romanesque Art: The Art of Church Treasures in Northwestern Europe* (Chicago: University of Chicago Press, 1967), 29.

20. William Wixom, "The Greatness of the So-Called Minor Arts," in *The Year 1200,* vol. 2, ed. F. Deuchler (New York: Metropolitan Museum of Art, 1970), 93.

Bibliography

Cherry, John. *Goldsmiths.* Toronto: University of Toronto Press, 1992.

Davis-Weyer, Caecilia. *Early Medieval Art: 300–1150.* Toronto: University of Toronto Press, 1986.

Forsyth, William. "Around Godefroid de Claire." *The Metropolitan Museum of Art Bulletin* XXIV (1966): 304–315.

Gauthier, Marie-Madeleine, and Madeleine Marcheix. *Limoges Enamels.* London: Paul Hamlyn, 1962.

Lasko, Peter. *Ars Sacra: 800–1200.* New Haven, Conn.: Yale University Press, 1972, 1994.

Ross, Leslie. *Medieval Art: A Topical Dictionary.* Westport, Conn.: Greenwood Press, 1996.

———. *Text, Image, Message: Saints in Medieval Manuscript Illustrations.* Westport, Conn.: Greenwood Press, 1994.

Swarzenski, Hanns. *Monuments of Romanesque Art: The Art of Church Treasures in Northwestern Europe.* Chicago: University of Chicago Press, 1967.

Voelkle, William. *The Stavelot Triptych: Mosan Art and the Legend of the True Cross.* New York: Pierpont Morgan Library, 1980.

Wessel, Klaus. *Byzantine Enamels from the Fifth to the Thirteenth Century.* Greenwich, Conn.: New York Graphic Society, 1967.

Williamson, Paul. *The Medieval Treasury: The Art of the Middle Ages in the Victoria and Albert Museum.* London: V&A Publications, 1986, 1998.

Wixom, William. "The Greatness of the So-Called Minor Arts." In *The Year 1200,* vol. 2, edited by F. Deuchler. New York: Metropolitan Museum of Art, 1970.

CHAPTER 3

The Prince of Scribes: Eadwine

Portraits and Self-Portraits

A very intriguing picture can be found on one of the back pages of a beautifully illustrated manuscript that was produced in Canterbury, England in the middle of the twelfth century (Cambridge, Trinity College MS R.17.1, folio 283v). Here we see a person who appears to be at work writing a book. He is seated in a fancy chair and is turned to the left leaning over an open book that is displayed on a desk or bookstand. In one hand he holds a quill pen and his other hand holds a knife, for correcting mistakes. He is dressed in an elaborately flowing robe with a hood and he has a monk's hairstyle (tonsure). The whole image is enclosed within a giant arch and further enframed with a decorative border of foliage scrollwork that mirrors some of the patterns on the man's garment. The bearded figure is wide-eyed and very intent on his work.

During the Middle Ages, all books (manuscripts) were handwritten and hand-painted, and so the person we see in this picture might be a medieval monk at work in the monastic scriptorium (book copying and producing center) of Canterbury in England. Perhaps this is a portrait (or a self-portrait?) of the person who devoted what would have been a great deal of time to the writing and illustrating of this manuscript. This particular manuscript includes text (several different versions of the Psalter from the Bible), myriads of pictures, and decorated initials. Such a large project would be a grand undertaking indeed during the Middle Ages and often was a group effort involving several scribes (writers) and painters working together.

Although this portrait of Eadwine is one of the most well known and most often reproduced illustrations of a medieval scribe, "perhaps the most famous portrait of its kind from medieval Europe,"[1] the full-page illustration includes

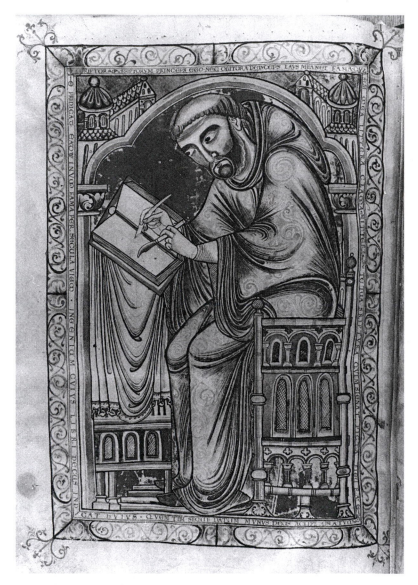

The scribe, Eadwine, from the Eadwine Psalter, c1160–1170. Cambridge, Trinity College MS R.17.1, folio 283v. (Courtesy of Masters and Fellows of Trinity College Cambridge/The Conway Library, Courtauld Institute of Art, London)

some puzzling elements and raises some interesting questions. The identity of the figure depicted is known because of the lengthy Latin inscription that appears on the frame surrounding the image. The inscription is phrased in terms of a conversation between "the scribe" and "the letter." The scribe states: "I am the prince of scribes, and neither my praise nor my fame shall die; shout out, oh my letter, who I may be." The letter replies: "By its fame your script proclaims you, Eadwine, whom the painted figure represents, alive through the

ages, whose genius the beauty of this book demonstrates. Receive, O God, the book and its donor as an acceptable gift."

Clearly, Eadwine played a major role in the creation of this lavish manuscript (which is known today as the Eadwine Psalter) but exactly who he was and precisely what he did still remain issues for much scholarly debate and discussion. Although it was not at all uncommon for medieval scribes and book illustrators to sign their works—and even include small self-portraits—the monumental scale (full page) of the "Eadwine portrait" as well as the tone of the inscription make this a rather unique example.

In the majority of other instances when medieval manuscript painters and scribes have signed their works or included self-portraits, these tend to be relatively more diminutive and certainly rather less aggrandizing than Eadwine's portrait and accompanying inscription. For example, several late-eleventh-century manuscripts from northern France include artists' self-portraits, such as the painter Robert Benjamin who is shown kneeling in the lower section of an illustrated initial in a manuscript now at Durham Cathedral library in England, and the artist Hugo who included small pictures of himself in two different manuscripts.[2] A German nun and painter named Guda included a small picture of herself within an initial letter in a manuscript, which dates to the second half of the twelfth century,[3] and, quite charmingly, small figures of the scribes Florentius and Sanctius are depicted "toasting" each other with raised goblets, celebrating each others' work and thanking God for their completion of a large Bible manuscript from tenth-century Spain.[4] An illustration on the back page of another tenth-century Spanish manuscript shows a view of the tower at the monastery of Tábara with the scribe Emeterius, and his assistant Senior, busily at work.[5] The names of a great many medieval scribes, artists, and book owners are also known simply through inscriptions, especially those at the conclusion of manuscripts.[6]

Portraits of authors and owners of books also occur frequently in medieval manuscripts in several different formats. Sometimes dedication or presentation pages at the beginnings of books depict the owner of the book solo, or show the owner with the author, or with the artist, or in some cases with the person who gave the book as a gift to the owner. Generally speaking, however, when such dedication pages depict book owners along with donors, authors, scribes, or artists, the figure to whom the book was given or to whom the book was dedicated has greater prominence in the illustration than donor/author figures. These figures are usually shown in a lesser role indicated by their kneeling or bowing down before the patron/owner. Many variations on such themes can be found throughout the history of medieval manuscript illustration, with varying formats and emphases depending upon the time period when the book was produced.

The tradition of author portraiture also has a very lengthy history in medieval book illustration. Ultimately derived from depictions of writers and philosophers found in the classical period, medieval manuscripts of the Bible, for example, often include illustrations of the four authors of the gospels: Matthew,

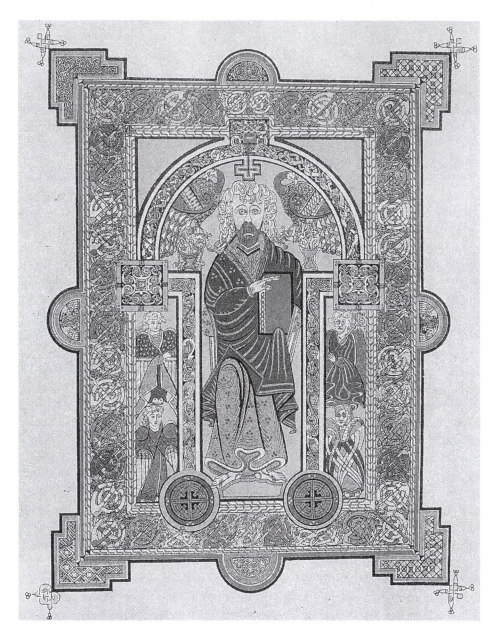

Saint Matthew from the Book of Kells 750–800 A.D. Hiberno-Saxon. (The Art Archive/The Art Archive)

Mark, Luke, and John. These four evangelists are often depicted at work writing their gospels, much as Eadwine is portrayed. The biblical figure of King David, the composer of the Psalms, was often included at the beginning of Psalter manuscripts. Books composed by early Christian authors, such as Saint Augustine (354–430) and Saint Jerome (342–420), may also include author portraits.

So, in some senses, there are actually plenty of pictorial precedents for the

Eadwine portrait, but several "interpretative difficulties are posed by the sheer size of the painting and by the size of Eadwine within it."[7] Eadwine could not have been the owner of the book. Medieval monks were not allowed to have personal property and certainly not lavishly illustrated manuscripts. Besides, the inscription states that the manuscript was a gift to God. The manuscript contains the text of the Psalms from the Bible. Eadwine did not compose the text, so he cannot "be regarded as an author in the modern sense of the term but, by stretching a point, he might conceivably have been seen as such in the Middle Ages."[8] In addition, the inscription clearly describes Eadwine as the scribe of the manuscript, not the author. But because no other portraits or self-portraits of medieval scribes are as grand as this picture of Eadwine and accompanied by such praises of "genius" and descriptions of "fame," scholars remain rather perplexed by this image.

Some researchers have speculated that perhaps the portrait of Eadwine is a later addition to the manuscript—not a self-portrait done by Eadwine himself but a portrait by a later artist in honor and memory of the famous Eadwine. Unfortunately, there are no other records at all which tell us anything about Eadwine.

Manuscripts with Many Makers

In cases like this, art historians need to carry out important detective work—looking very carefully at the existing evidence for clues. The Eadwine Psalter is a large manuscript and a careful study of the script and illustrations reveals that (not uncommonly) there were several "hands" involved with the production of this volume. Specialists in identifying styles of handwriting (paleography) have identified the work of several different scribes in this manuscript. A careful analysis of the painting style of the many illustrations in the book has similarly led scholars to identify the work of at least five different artists involved with illustrating and decorating the manuscript. Although the "hands" (or styles) of these different scribes and artists are not so incredibly divergent as to present really glaring or dramatic contrasts, careful study makes it clear that a number of different people were involved with the creation of this book. This was fairly typical of manuscript creation during the Middle Ages, especially for large books with extensive text and many pictures.

Paleographical study of the Eadwine Psalter has concentrated on the different pen handling and letter formations of the several scribes responsible for writing the lengthy texts, and the "hand" of at least one of these scribes has been noted in other contemporary manuscripts. The various artists as well tended to organize their compositions in slightly different ways in terms of picture space, grouping, and size of figures. There was one major artist responsible for most of the 166 colored ink outline and ink wash pictures illustrating the Psalms. This major artist as well was responsible for the over 500 fully painted enlarged initial letters signaling beginnings of text sections. Another artist had a quite dis-

tinctive manner of depicting drapery folds and the work of this artist can be seen in another very important manuscript of the same time period.

Is it reasonable to suppose that Eadwine, the "prince of scribes" was responsible for some of the most skillfully written sections of text in the manuscript? If so, as seems likely, he could thus be identified as one of the otherwise anonymous "hands" among the text writers. Can we imagine that Eadwine may also have, in some capacity, overseen the complete production of this lavish volume—giving directions to the other scribes and to the artists?

Copies and Originals

That directions and guidance would be necessary for a work of this size and scale is quite clear, especially given the fact that the Eadwine Psalter was a highly complex production. The manuscript contains more pictures than found in any other English manuscript from the twelfth century and also, quite importantly, represents a stylistically updated copy of a much earlier manuscript which was brought from France to England about a century and a half earlier. This earlier manuscript—the early-ninth-century "Utrecht Psalter"—was written and illustrated at or near the monastery at Reims during the Carolingian period and appears to have been brought to Canterbury around the year 1000. In the early eleventh century, a copy of the Carolingian Utrecht Psalter was also produced at Canterbury. This "first copy" of the Utrecht Psalter (now in the British Library and known by its shelf mark: Harley 603) was then followed, in the mid-twelfth century, by the Eadwine Psalter and was later followed (around 1180) by yet another copy (now in the Bibliothèque Nationale in Paris). The relationships between all of these manuscripts—the Utrecht Psalter (early ninth century), Harley Psalter (early eleventh century), Eadwine Psalter (mid-twelfth century), and Paris Psalter (late twelfth century)—have provided masses of questions and material for scholarly research as art historians have attempted to unravel the sources for the illustrations and the relative roles each later manuscript may have played in the creation of these further copies of the Carolingian original.

These four manuscripts, in spite of their unclear relationships as direct or indirect models for one another, provide an excellent mini-lesson in some of the changes of artistic style in medieval manuscript painting from the early ninth to the late twelfth century. The ninth-century manuscript shows a distinctive style typical of a particular school of Carolingian art. The ink drawings in the manuscript are lively and calligraphic. The figures have a great sense of energy and vibrancy and they are all done in the same dark-brownish color of ink.

The first (Anglo-Saxon) copy of this manuscript, produced at Canterbury in the early eleventh century, also shows ink drawings with a great deal of liveliness and energy. But in this manuscript, different colors of ink (such as green, red, purple, and blue) were also used. There seem to have been about six different artists involved with this painting, some of whom obviously preferred certain colors of ink. The many colors of ink used for the illustrations make these

pictures rather different from the Carolingian original. The pictures are extremely carefully copied however, and retain the sketchy and calligraphic quality of the illustrations in the earlier manuscript.

The third version, the Eadwine Psalter, uses even more colors of ink and the illustrations, although done "in jewel-like colours that tumble over the page in . . . exuberance"[9] generally lack the ragged edges and broken outlines more typical of either of the two previous versions. The illustrations in the Eadwine Psalter are also enclosed in frames or borders which separate the pictures from the text on the pages. Overall, the styles of the artists involved with the Eadwine Psalter illustrations tend to be more precise and more geometrically patterned and controlled than the Carolingian and Anglo-Saxon versions.

The final and total transformation of style comes in the late-twelfth-century version, which is distinctively different from the previous three. The pictures in this manuscript—although many of the exact same subjects as the previous versions—are fully colored paintings rather than colored ink drawings. The compositions are framed and their backgrounds are created with gleaming areas of gold leaf. There are no spaces left empty or unfilled with colors. All of the figures have distinct dark outlines and their drapery patterns indicate volume and depth by variation in tones and lines. The vibrant sketchy style of the Carolingian and Anglo-Saxon versions with their sense of "airy spaciousness"[10] and the lively linearity of the Romanesque Eadwine Psalter is now translated into a more typically Gothic style with sumptuous and bright colors and figures with a sense of "substance and weight."[11]

The painting style in this fourth copy of the manuscript looks so incredibly different from any of the previous versions that it hardly seems like a copy at all, by modern standards. However, the medieval and modern understanding of what constitutes a copy is doubtless very different. There are examples of medieval buildings, which were designed as copies of other buildings, that really bear only vague resemblances to their architectural models. It was, in any case, clearly not the intention of the late-twelfth-century artists responsible for the illustrations in this final copy of the Psalter to make an exact replica of any previous version.

The exact procedures and techniques which medieval artists and scribes used to copy texts and pictures is another fascinating topic about which tantalizing little is known. Scribes copying a written text would presumably do so with the original book right in front of them, painstakingly duplicating the letters and words one by one. Instances where scribal attention wandered, where words were left out, misspelled, or misunderstood are quite common however. Sometimes this has had very great repercussions indeed for texts—when entire meanings have been changed.

Artists copying illustrations from a previous manuscript might also have done so simply "by eye," carefully looking at the original and duplicating it as carefully as they could or as carefully as they felt was appropriate. On the other hand, there is also some evidence that medieval artists also made use occasionally of some mechanical aids to copying, such as tracing paper and a technique

known as "pricking and pouncing." In this latter technique, small pinpricks were made largely around the outlines and major details of illustrations and, if another piece of parchment was inserted beneath the pricked image, this in turn could be used as a pattern for duplicating the design. Chalk dust in a little bag could be "pounced" against this pattern, and dust particles would duplicate the pattern onto the desired new surface. Of course, this technique damages the original a great deal because the original ends up full of little pinholes. Even so, there are some medieval manuscripts that do show evidence of this technique having been used.

Materials and Methods

That manuscripts (both texts and pictures) were copied during the Middle Ages is a critical point. We need to remember that before the invention of the printing press and moveable type in the fifteenth century (let alone the modern Xerox machine), the process of book creation was very arduous and extremely time consuming. Manuscripts were written on vellum or parchment—the specially prepared skins of animals such as sheep, cows, or goats. Preparing the parchment, cutting it to size, ruling the sheets with lines for the text, writing the text and painting the illustrations, gathering and sewing together groups of folded sheets, and eventually binding the book between wooden boards and a leather cover—all of these different stages in the creation of a medieval book represented a significant output of time and energy.[12]

All of the materials required for writing and illustrating books in the Middle Ages—the pens, brushes, inks, and paints—all needed to be manufactured by hand as well. Pens were made from bird feathers (quills) and animal hairs were used to create brushes. Paints or pigments were made from various mineral and vegetable extracts, which were ground up and mixed with water and other substances such as glair (egg white), honey, and even urine and earwax. Inks for writing were made from oak gallnuts and carbon. Many medieval manuscripts are enriched with thin sheets of gold (gold leaf) and have details done in golden and silver paint. This is partly why medieval manuscripts are often described as "illuminated" and their pictures are called illuminations, though strictly speaking, not all illuminated manuscripts use gold. Recipes and directions for the creation of many materials used in medieval painting generally can be found in the early-twelfth-century how-to manual written by the monk Theophilus (see chapter 5). All of the processes were time-consuming and required great skill and patience. "During the early Middle Ages, scribes and/or illuminators ground and prepared their own pigments, perhaps with the aid of an assistant, but with the growth of specialized, more commercial production around 1200, they often purchased their ingredients in prepared form from a stationer or an apothecary."[13] Regardless of whether the materials had to be prepared by the artists themselves or could be purchased to some extent ready-made, all of the procedures involved with manuscript creation during the Middle Ages made medieval books very precious and highly regarded objects.

Texts and Illustrations

All medieval manuscripts were written by hand (the term manuscript means handwritten) but not all medieval manuscripts were decorated or illustrated with pictures. The amount and format of illustrations in medieval manuscripts varies widely according to the dates and purposes of the books. Naturally, manuscripts made for wealthy and important people, such as members of the royalty, tended to be more lavish productions than books created for the use of monks or students.[14] Some very late medieval manuscripts, such as one early-fifteenth-century prayer book made for Jean de Berry (1340–1416), the brother of the French king, are incredibly elaborate. Jean de Berry's "Very Rich" book is filled with page after page of full-page illustrations done by the very top artists of the time (see chapter 10).

Apart from illustrations that take up full pages, pictures in medieval manuscripts occur in a variety of other formats. Especially characteristic of the Romanesque period are manuscripts with enlarged initial letters—like huge capital letters signaling the beginnings of text sections—which are either decorated with designs or which include figures and scenes relevant to the text of the book. Scholars have developed a number of terms to describe these different sorts of enlarged initial letters. "Decorated" initials may have geometric and foliage designs, as well as fanciful figures of people and animals. "Zoomorphic" initials are composed largely of animal forms, while "zoo-anthropomorphic" letters show weird combinations of people and animal forms often in a state of metamorphoses. There are also "gymnastic" initials, which show humans and/or animals clambering and cavorting about as if they were performing acrobatic stunts. "Inhabited" initials also include people and/or animals, sometimes entwined in foliage and geometric patterns.

In terms of text illustration (versus decoration) however, the most important category is the form known as the "historiated" initial. These are enlarged letters that contain pictures or scenes which relate directly to the text of the manuscript itself. Historiated initials are especially characteristic of Romanesque manuscripts, though examples of the form can be found earlier.

The historiated initial form continued to be used well into the Gothic period while even further formats for page layout, decoration, and illustration continued to evolve. Half-page and full-page illustrations were quite common in earlier medieval manuscripts (such as seen in the Eadwine Psalter) and also were used frequently in Gothic manuscripts. Generally speaking, the illustrations in Gothic manuscripts tend to become more and more detailed—almost like independent miniature panel paintings placed within the text.

An awareness of the history and evolution of different styles and formats of illustration is extremely useful in dating medieval manuscripts. It is actually not terribly difficult at all to tell if a manuscript is from the Carolingian, Romanesque, or Gothic period once one knows the differences between the styles typical of these different times. The stylistic differences between the successive copies of the ninth-century Psalter manuscript, including the Eadwine Psalter, are excellent examples.

Types of Manuscripts

During the earlier Middle Ages, the majority of books were produced and used in monasteries. Naturally, these religious establishments primarily had use for religious books, such as the Bible (or more often, sections of the Bible, such as the Gospels, Psalter, and selected readings or lections that would be produced in individual volumes) and the writings about and commentaries on the Bible produced by the early church theologians such as Saint Augustine and Saint Jerome.

There were actually quite a number of different types of specialized manuscripts commonly produced and used during the medieval period. This list of liturgical manuscripts includes Antiphonals (which contain the music and words sung at the daily church services in medieval monasteries), Benedictionals (containing blessings and prayers recited by bishops during the Mass), Breviaries (containing the daily prayers recited in monasteries), Choir books (with music and songs for church services), Homiliaries (lessons and discussions of scripture), Lectionaries (selected readings), Missals (with various texts necessary for the Mass), Pontificals (used by popes and bishops for special services), and Sacramentaries (containing prayers recited by priests during Mass), to name just a few.

The contents and arrangements of these liturgical manuscripts changed and evolved during the Middle Ages as well. So it is often possible for specialists to date and localize a medieval liturgical manuscript purely on the basis of the texts included and how they are arranged. Personal prayer books used by non-monastic people became especially popular in the later Middle Ages (see chapter 10).

Stories recounting the lives of saints were also highly popular during the Middle Ages, and readings from the lives of saints were customarily delivered in monastic communities. Manuscripts containing saints' lives are known as Passionaries or Martyrologies. The readings in these manuscripts are arranged according to the yearly church calendar of saints' "feast days" (death dates). Passionary manuscripts often have illustrations of saints and specific events in their lives, or scenes of their deaths. Sometimes monasteries dedicated to a specific saint, or whose relics were enshrined in their church, would have a manuscript completely devoted to text and illustrations of their saint's life, good deeds, death, and miracles.[15]

Selected ancient pre-Christian (classical) writings were also copied when available and were thus preserved during the Middle Ages. Treatises on medicine, the identification of and medical usages of plants and herbs (herbals), and books containing descriptions of animals (bestiaries) were all also frequently produced during the medieval period.

Monasteries eager to build up their library collections, let alone have books available for the daily prayer services and oral readings, needed to borrow manuscripts in order to copy them. And, at least in the early Middle Ages, most of the copying of manuscripts appears to have been done by monks who were specially trained (or exhibited ability and competence to do so) in monastic scriptoria.

Monoceros, a mythical beast with a unicorn head and paws and a horse's
body, from a thirteenth-century English Bestiary. Oxford, Bodleian Library,
MS Bodley 764 folio 22r.

Thus, the portrayal, in the Eadwine Psalter, of Eadwine as a monastic scribe
(with appropriate tonsure and albeit somewhat fancy hooded robe) seems to suit
this picture of book production in the early medieval period quite perfectly. On
the other hand, at the very period (the mid-twelfth century) when the Eadwine
Psalter was being produced at the monastery of Christ Church Cathedral in Can-
terbury, scholars have noted more than increasing documentary evidence of non-
monastic artists being employed as scribes and book illustrators at medieval

monasteries. In fact, it may be the case that all of the several painters involved with the illustrations and decoration of the Eadwine Psalter may have been secular (non-monastic) artists, such as the documented "Master Hugo" who is recorded as having worked in various artistic capacities at the monastery of Bury Saint Edmunds in England in the twelfth century.

The Multitalented Master Hugo (Mid-Twelfth Century)

Master Hugo appears to have been an itinerant artist who was skilled in a variety of artistic media including sculpture, metalwork, and painting. Documents exist which tell that he carved a wooden crucifix for the monastery, created the bronze entrance doors for the church, cast a large bell, and painted the illustrations for a substantial Bible (identified as the c1130–1140 "Bury Bible" now in the library of Corpus Christi College, Cambridge, MS 2). Monastic records from Bury Saint Edmunds also record payment to a scribe for this same large Bible painted by Master Hugo, so again, secular craftsmen were frequently involved with the manuscript production of medieval monasteries. Records also tell that the vellum for this large Bible was purchased from Ireland.

Although Master Hugo has been described as "one of the great international artists of the twelfth century"[16] he, like Eadwine, lacks a biography in the modern sense. Apart from the written records describing his works and the beautifully painted Bible from Bury Saint Edmunds attributed to him, there is no information about his life otherwise. There is no doubt, however, that the painting style of the Bury Bible illustrations was the work of a highly skilled artist. In particular, his manner of handling drapery in an extremely sophisticated style "combining curvilinear elegance with a feeling of weight" has been described as "graceful but statuesque, free-flowing but deliberative"[17] and extremely influential on later Romanesque painting. "Indeed," it has been said, "many of the great manuscript paintings over the rest of the century bear some impress from his style."[18]

Although we know virtually nothing about Eadwine and very little about Master Hugo, there are some medieval manuscript artists whose lives and works are better documented.

Matthew Paris (c1200–1259)

One notable exception to the picture of little-documented medieval artists is Matthew Paris, a monk of the English monastery at Saint Albans who lived during the first half of the thirteenth century. Matthew Paris was an artist as well as an author who became quite famous in his own lifetime for both his writing and painting. He has been described as "one of the most compelling personalities of the Middle Ages."[19]

Most of what we know about Matthew Paris comes from his own writing. Although we do not know where he was born or where he received his early education, he entered the monastery at Saint Albans in 1217 and around 1236 became the official chronicler and historian for the monastery until his death in 1259. During these years, he produced a great number of manuscripts (written in both Latin and French) including historical works, saints' lives, and accounts of events particularly relevant to his monastic home. He illustrated many of these manuscripts himself with often very lively and expressive colored ink outline drawings in a contemporary popular style. He created intriguing maps and complex diagrams for his works and included a self-portrait in one of his manuscripts as well (London, British Library MS Royal 14.C.VII, folio 6). Here, he depicts himself as a small figure wearing his monastic robe and tonsure, kneeling humbly at the feet of the much larger Virgin Mary and infant Jesus. This is quite a contrast to the portrait of Eadwine.

On several occasions Matthew Paris traveled to various places in England to attend religious or royal ceremonies and he also journeyed once to Norway on monastery business. He met personally and/or corresponded with a great many noble and intellectual figures of the time and he seems to have become quite a respected figure and celebrity in his own right.

By the time of Matthew Paris, it had become quite customary for medieval monasteries to keep chronicles recording past and contemporary historical events. Usually one monk was appointed to the role of chronicler and would serve in this position as official historian throughout his life. When he passed away, he would be succeeded by another appointee. Matthew Paris took over as historian of Saint Albans from a monk named Roger Wendover, and the chronicles were continued until the fifteenth century, well after Matthew Paris's own death. Although the keeping of historical chronicles was a well-established monastic tradition in the Middle Ages, these types of manuscripts were not customarily illustrated and certainly not as extensively illustrated as Matthew Paris's work. His *Chronica Majora* (major historical work) has a "profusion of 130 illustrations . . . [that] represents an unprecedented and even revolutionary pictorial addition to the English medieval chronicle."[20]

In spite of the fact the Matthew Paris's reputation as an excellent artist was praised in the fourteenth century, there has been some scholarly disagreement in the twentieth century about his role and position as an important medieval artist. There is not such disagreement about his role as an author and historian, but some scholars have argued that Matthew Paris was not himself responsible for all of the illustrations in his books. Did Matthew Paris have assistants working for him or did he work all alone on his massive projects of book writing and illustrating?

Many medieval manuscripts, as we have seen, were collaborative ventures involving numerous scribes and artists. In the earlier medieval period, important monasteries such as Christ Church, Canterbury (where Eadwine worked) had very active scriptoria with many scribes and artists collaborating on large projects.

Although Saint Albans (where Matthew Paris worked) was an important cen-

ter of manuscript production in the twelfth century, by the time of Matthew Paris in the mid-thirteenth century, activity in the scriptorium at Saint Albans seems to have declined. In his role as monastery chronicler and historian, Matthew Paris appears to have worked independently of the few other scribes and artists at the monastery in the thirteenth century. By this period, in any event, fewer manuscripts were being produced by monastic artists. With the growth and development of universities in cities such as Paris and Oxford—and with the growing demand for books among not only university students but also educated and well-to-do lay patrons—the centers of manuscript production by the thirteenth century had shifted to the urban centers. Figures such as the monastic "prince of scribes" Eadwine were becoming out of date.

Notes

1. T. A. Heslop, "Eadwine and His Portrait," in *The Eadwine Psalter: Text, Image and Monastic Culture in Twelfth-Century Canterbury,* ed. M. Gibson, T. A. Heslop, and R. Pfaff (University Park: Pennsylvania State University Press, 1992), 178.
2. C. R. Dodwell, *The Pictorial Arts of the West: 800–1200* (New Haven, Conn.: Yale University Press, 1993), 195–196.
3. Dodwell, 42.
4. John Williams, *Early Spanish Manuscript Illumination* (New York: George Braziller, 1977), 61.
5. Williams, 16.
6. Marc Drogin, *Anathema! Medieval Scribes and the History of Book Curses* (Totowa, N.J.: Allanheld and Schram, 1983).
7. Heslop, 183.
8. Heslop, 183.
9. Dodwell, 338.
10. Dodwell, 341.
11. Dodwell, 341.
12. Excellent short introductions to the terminology, materials, and techniques of medieval manuscript creation can be found in Michelle Brown, *Understanding Illuminated Manuscripts: A Guide to Technical Terms* (Malibu, Calif.: J. Paul Getty Museum, 1994), and Christopher de Hamel, *Scribes and Illuminators* (Toronto: University of Toronto Press, 1992).
13. Brown, 98.
14. Christopher de Hamel, *A History of Illuminated Manuscripts* (Oxford: Phaidon Press, 1986).
15. Leslie Ross, *Text, Image, Message: Saints in Medieval Manuscript Illustrations* (Westport, Conn.: Greenwood Press, 1994).
16. Dodwell, 344.
17. Dodwell, 344.
18. Dodwell, 344.
19. Suzanne Lewis, *The Art of Matthew Paris in the Chronica Majora* (Berkeley: University of California Press, 1987), 2.
20. Lewis, 19.

Bibliography

Alexander, Jonathan. *Medieval Illuminators and Their Methods of Work*. New Haven, Conn.: Yale University Press, 1992.

————. *The Illuminated Manuscript*. Oxford: Phaidon Press, 1979.

Backhouse, Janet. *The Illuminated Page: Ten Centuries of Manuscript Painting*. London: British Library, 1997.

————. "The Making of the Harley Psalter." *British Library Journal* X, no. 2 (1984): 97–113.

Brown, Michelle. *Understanding Illuminated Manuscripts: A Guide to Technical Terms*. Malibu, Calif.: J. Paul Getty Museum, 1994.

Bryant, W. N. "Matthew Paris, Chronicler of St. Albans." *History Today* 19 (1969): 772–782.

Cahn, Walter. *Romanesque Bible Illumination*. Ithaca, N.Y.: Cornell University Press, 1982.

Calkins, Robert. *Illuminated Books of the Middle Ages*. Ithaca, N.Y.: Cornell University Press, 1983.

De Hamel, Christopher. *A History of Illuminated Manuscripts*. Oxford: Phaidon Press, 1986.

————. *Scribes and Illuminators*. Toronto: University of Toronto Press, 1992.

Dodwell, C. R. "The Final Copy of the Utrecht Psalter and its Relationship with the Utrecht and Eadwine Psalters." *Scriptorium* 44 (1990): 21–53.

————. *The Pictorial Arts of the West: 800–1200*. New Haven, Conn.: Yale University Press, 1993.

Drogin, Marc. *Anathema! Medieval Scribes and the History of Book Curses*. Totowa, N.J.: Allanheld and Schram, 1983.

Gibson, M., T. A. Heslop, and R. Pfaff, eds. *The Eadwine Psalter: Text, Image and Monastic Culture in Twelfth-Century Canterbury*. University Park: Pennsylvania State University Press, 1992.

Harthan, John. *An Introduction to Illuminated Manuscripts*. London: Her Majesty's Stationery Office, 1983.

Kurth, B. "Matthew Paris and Villard de Honnecourt." *Burlington Magazine,* 81 (1942): 227–228.

Lewis, Suzanne. *The Art of Matthew Paris in the Chronica Majora*. Berkeley: University of California Press, 1987.

Pächt, Otto. *Book Illumination in the Middle Ages*. London: Harvey Miller, 1986.

Petzold, Andreas. *Romanesque Art*. New York: Harry N. Abrams, 1995.

Robb, David M. *The Art of the Illuminated Manuscript*. Cranbury, N.J.: Art Alliance Press, 1973.

Ross, Leslie. *Text, Image, Message: Saints in Medieval Manuscript Illustrations*. Westport, Conn.: Greenwood Press, 1994.

Vaughan, Richard. *Chronicles of Matthew Paris: Monastic Life in the Thirteenth Century*. New York: St. Martin's Press, 1984.

Williams, John. *Early Spanish Manuscript Illumination*. New York: George Braziller, 1977.

CHAPTER 4

The Medieval Architect?: Villard de Honnecourt

Villard the Artist

One of the most famous, intriguing, and controversial documents of medieval art is the so-called Sketchbook of Villard de Honnecourt. This is a slim, bound volume of ink drawings on parchment, located today in the Bibliothèque Nationale in Paris (MS. fr. 19093). The drawings contained in this little book are of a great variety of subjects, including human figures, many charming renditions of different animals, architectural views and plans, various decorative devices, geometric schemes, and mechanisms of many different sorts. The author/artist of this little manuscript (album, portfolio) also provided captions accompanying the drawings, explaining and identifying the subjects. He identified himself by name—commonly translated as "Villard de Honnecourt." Although we know Villard's name, it is unclear quite why he did these wonderful drawings and put them together in a little book.

Although sketchbooks, model books, handbooks, and instruction manuals of diverse types do survive from the later medieval period primarily (see chapter 5), Villard's book is customarily dated to the early thirteenth century (c1230) and, as such, is a rather rare and early survival of such an illustrated work. In fact, there is really nothing else exactly like Villard's sketchbook to survive from any time during the medieval period and so this work has puzzled scholars for many years. Huge numbers of books and articles have been devoted to this intriguing medieval document, but in spite of all this scholarly attention, Villard's sketchbook seems to continue to raise more questions than it answers.

Nothing is known about Villard apart from what he tells us in his sketchbook. And this information is minimal, at least in terms of constructing a biography for this person. "The dates and details of the life of Villard are unknown,

the portfolio being the sole evidence of his existence."[1] There are no other doc-
uments to verify the existence of Villard (from Honnecourt, a small town in
northern France). There are no records of any sort concerning commissions for
artworks of any type from an artist named Villard. "Villard himself . . . says noth-
ing whatsoever of his professional career and claims authorship of no monu-
ment in any medium."[2] What securely survives of his work is only his
sketchbook which, he writes in his preface, he hopes will be "useful" to others.
The opening text reads:

> Villard de Honnecourt greets you and begs all who will use the devices found in
> this book to pray for his soul and remember him. For in this book will be found
> sound advice on the virtues of masonry and the uses of carpentry. You will also
> find strong help in drawing figures according to the lessons taught by the art of
> geometry.[3]

Although we have no biographical information about Villard, the illustrations
in his book are accompanied throughout by captions that seem to give us a sense
of his personality. We sense that he was a curious and enthusiastic sightseer,
eager to see and learn about new things. He says that he drew pictures of some
things simply because he "liked" them. He seems to have been very enthusias-
tic about a trip that he made to Hungary; next to a picture he drew of a win-
dow in the French cathedral at Reims, he wrote: "I had been invited to go to
Hungary when I drew this, which is why I liked it all the more."[4] He seems to
have been fascinated with lions and lion taming. He drew several pictures of
lions and took great care to state that he drew them from life.[5]

Many of his captions provide specific instructions for duplicating the designs
for the objects he drew. He describes the "best ways" to do things (how to build
a pillar, construct a lectern) and he advises his readers to work with care: "Take
pains with your work and you will act prudently and wisely."[6] Many of his di-
agrams are of forms and figures constructed with geometric patterns. "On these
four pages," he writes, "are figures of the art of geometry, but to understand them
one must be careful to learn the particular use of each."[7]

Altogether we may get the impression, from the captions and illustrations,
that Villard was a man of many talents and many interests who traveled eagerly,
studied seriously, and enjoyed his life. These impressions certainly contribute
to our appreciation for and interest in his sketchbook. But we still don't know
who Villard was and exactly what motivated him to create his booklet.

The many scholars who have studied Villard's sketchbook have arrived at a
number of different conclusions about Villard himself and his purpose in creat-
ing his book. It appears that he made the individual drawings over a number of
years before he decided to put them all together into a little booklet. However,
"the order of the drawings in the portfolio as it exists today is not necessarily the
original one. Many sheets have disappeared forever, and the various owners ap-
pear to have transposed the order of the [pages.]"[8] Apart from the drawings and
text by Villard's hand, there are also several additions of drawings and captions
by later artists—people who perhaps inherited and used Villard's book.

Villard the Architect

Villard's drawings, as mentioned above, are of a great variety of subjects including architectural views, plans, and diagrams. Although an actually relatively small percentage of the illustrations in the book are architectural drawings and diagrams, several scholars have chosen to concentrate on Villard's apparent interest in the Gothic architectural forms already created or being created during his lifetime in the late twelfth and early thirteenth century. Villard appears to have visited a number of locations in northern France especially and his book includes illustrations of parts of several churches and cathedrals—including the towers of Laon Cathedral which he describes as "the finest he has seen." Other architectural drawings in Villard's sketchbook include a rose window at the cathedral of Chartres, the flying buttresses at Reims Cathedral, sections of floor plans for Cambrai, Meaux, Reims, and so on. Apart from these buildings in France, Villard also appears to have traveled in Switzerland and Hungary as he includes drawings of buildings in these regions as well.

Villard's evident interest in architectural forms has thus led a number of scholars to speculate that perhaps he was a "traveling architect." This idea was first proposed by scholars in the nineteenth century, and although this notion has been questioned and disputed in more recent scholarship on Villard, a number of general sourcebooks about medieval art and architecture still describe Villard as an "important medieval architect" and "master builder." "Villard is now automatically termed an architect in literature both scholarly and popular. It is a seriously ingrained habit, difficult if not impossible to break."[9] This tradition has persisted to some extent, in spite of the fact that there is no documentary evidence otherwise to securely attribute any specific buildings (those he sketched or others which have been credited to him) or indeed any extant works of art of any sort at all (sculpture, metalwork, etc.) to Villard. Villard is yet another one of those mystery figures from the Middle Ages—whose name we know and whose sketchbook we can study and admire—but any attempts to construct a biography and career for Villard are frustrated by the lack of additional evidence. Even so, the suggestion that Villard might have been an architect has had a great deal of appeal to numerous scholars.

Medieval Architecture and Medieval Architects

What do we know about architects during the Middle Ages? Although the many great cathedrals, churches, and castles which were constructed during the medieval period remain today as some of the most impressive and enduring monuments of the era, we really do not have a great deal of information about the specific persons who were involved with this medieval building boom. One thing is clear, however; the construction of the great medieval buildings involved

The tower of Laon Cathedral, from the sketchbook of Villard de Honnecourt, c1230. Paris Bibliothèque Nationale MS fr. 19093, folio 10. (Giraudon/Art Resource)

masses of different people who were often engaged with these projects for many, many years. The construction of a big building, like a cathedral or monastery church, during the Middle Ages involved a vast range of persons of different occupations. Stonecutters and masons were required to hew and shape the blocks of stone from the quarries. Laborers were required to transport the stones (by

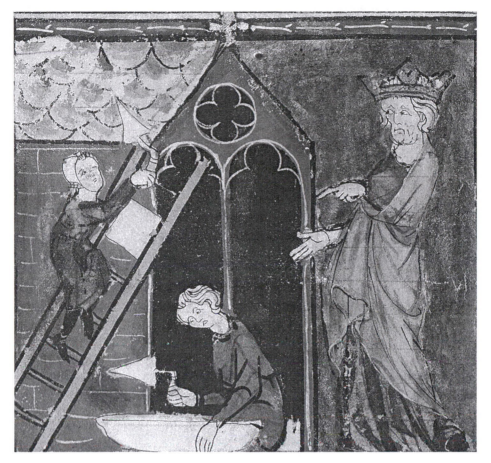

Louis V le Gros (the Fat), 1081–1137, king of France, overseeing the construction of a building. Folio 235v of a fourteenth-century French manuscript of the Great Chronicles of France. (The Art Archive/Bibliothèque Municipale Castres/Dagli Orti)

cart or barge) from the quarry to the building site. Carpenters were needed to create all the necessary woodwork involved, such as scaffolding, ladders, and the wooden centerings to hold the stonework in place until the mortar set. Sculptors (apart from the stonecutters and masons) may also have been enlisted to carve the more detailed and complex sculptures, such as the figures and narrative programs on the many doorways as well as in the interior of the building. Wall painters, glassblowers, and glass painters were also required to execute the stained glass windows typical of Gothic cathedrals. The construction of a large church or cathedral during the Middle Ages thus involved the efforts of many people—not unlike the creation of any major building today.[10]

In the present day, however, we are much more accustomed to attributing the design and overall supervision of a building's construction to an architect. We understand that architects design buildings and so we tend to think of specific buildings as being created by particular individual architects. Even though mod-

ern architects are likely to be quite uninvolved with any of the hard labor involved with the actual construction of a building, we still give overall credit to the architect in any discussion of a building's style and historical importance, for example.

During the Middle Ages, it appears that the role of architect was not yet so clearly defined and separated from many of the other roles (designer, contractor, supervisor, consultant, financial negotiator) required for the successful completion of an architectural program. In fact, the term "architect" was rather hazily and rarely applied during the medieval period, at least in the sense that we understand the term today as signifying "one who plans buildings as opposed to one who executes them . . . one who plans with a view to aesthetically as well as functionally satisfactory results, as opposed to one who concerns himself only with the technical requirements of the building."[11] In the Middle Ages, the "person responsible for the ultimate design . . . would have been the master mason, the medieval equivalent of the modern architect."[12] And, given the lengthy, collaborative, and multifaceted nature of medieval building construction—when the creation of great edifices took, in many cases, decades and decades of work on the part of many personnel—it is rare indeed, if not quite impossible, to attribute the design of any one building to any one single person.

In fact, due to the lengthy construction processes of medieval buildings, a number of different styles can often be seen even within a single building. Oftentimes, various sections of the great Gothic cathedrals in Europe do not "match" at all; the vaulting patterns, window designs, and even the front towers are sometimes in different styles from different periods.[13] Although these changes in style may strike our modern eyes as somewhat peculiar and disunified, it is obvious that these great structures were created by successions of teams or crews of builders—working under the supervision of a succession of master masons—who, while respecting and retaining the work of the previous builders, introduced different and updated ideas as the years progressed. The style and even overall plan of a building might be altered and revised a number of times before its completion. The construction progress was thus rather organic and additive, changing and evolving over time. So, we need to understand that the original design for and completion of any major building during the Middle Ages involved a series of architects or master masons, many of whose names are unrecorded.

Medieval Architectural Styles

The fact that the names of many medieval architects are unknown is not a handicap in identifying differences in medieval architectural styles however. The medieval "building boom" in church architecture, which the monk Raoul Glaber described about the year 1000 when he wrote that it seemed to him as if "the very world had shaken herself and cast off her old age, and were clothing herself everywhere in a white garment of churches,"[14] continued through the sub-

sequent centuries. Great amounts of energy and financial resources were expended all through the medieval period on the construction of churches and monasteries especially. Secular buildings such as castles and palaces for the royalty and various public buildings were constructed too. Old buildings were enlarged and renovated, brand new buildings were built, and many renovations were undertaken to both older and newer buildings.

A number of general, distinctive medieval architectural styles evolved through these centuries. Being able to recognize these different features and their regional variations can greatly assist in dating medieval buildings and the different sections of medieval buildings constructed at different time periods.

In most general terms, the Romanesque style of architecture is characterized by round arches made of stone and the Gothic style of architecture is charac-

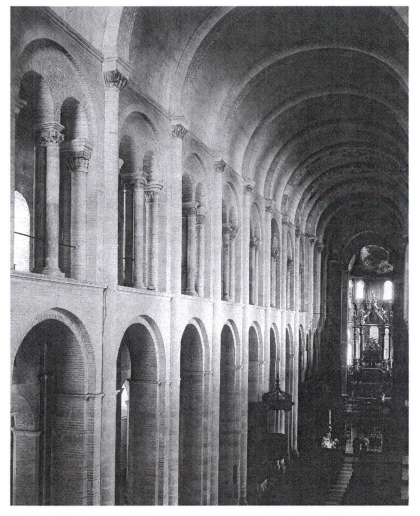

Church of Saint Sernin, Toulouse, France, c1100, interior. (The Art Archive/Dagli Orti)

terized by the use of pointed arches in stone. Buildings constructed in the Romanesque period tend to be heavier and darker than the buildings constructed in the Gothic period which have more windows. Romanesque architecture is solid and massive; Gothic architecture is lighter, taller, and brighter.

The use of round masonry arches was a form developed in classical times. Round arches and round (or barrel) vaults were especially employed by the ancient Romans in their many massive and impressive buildings and works of engineering, such as aqueducts. "The Romans had perfected arches, various forms of vaulting, intricate sequential layouts of buildings, and a repertoire of symbolic architectural forms. These provided the basis for . . . buildings throughout the Middle Ages."[15] The term "Romanesque" means "Roman-like." It signifies the phase in medieval architectural building style that made use of round arches, primarily. Buildings constructed in the round-arched Romanesque style are immediately recognizable. The buildings are solid and impressive, constructed with masses of heavy stonework.

The change that took place in medieval architecture through the use of the pointed arch form did not happen suddenly or overnight. Medieval architects experimented through the decades with a variety of different modes of construction. The typically pointed arch style of the Gothic period can be seen as an assimilation and synthesis of many previous forms and ideas.

It is not only the pointed arch form which distinguishes the Romanesque from the Gothic styles in medieval church architecture but also the resultant changes in the space-spanning formats used. The ceilings of Gothic cathedrals typically make use of what are known as "rib vaults" versus the "barrel vaults" of the earlier Romanesque style. Gothic rib vaulting is based upon pointed arches which direct the weight of the stone ceiling downwards rather than outwards as was the case with Romanesque buildings with the round arches. Thus, Gothic style buildings have more windows than Romanesque style buildings, especially when the additional innovation of "flying buttresses" was included. These arms of masonry on the outside of many Gothic churches were critical additions in supporting the structure. The overall impression of Gothic buildings is of light and height versus the darkness and heaviness of the Romanesque style.

While these general and overall style differences between the Romanesque and Gothic periods in medieval architecture are quite useful, it also needs to be recognized that far more subtle distinctions are possible. Both the Romanesque and Gothic styles in architecture went through many phases in different regions of Europe during the medieval period and distinctive variations on the general themes can be identified as well. The influences of past or contemporary architecture in the Byzantine empire and the architectural achievements of the Islamic cultures in and outside of western Europe during the medieval period also need to be seriously taken into consideration in any discussion of the sources for and evolution of architectural styles in medieval Europe.

The regional variations on the Romanesque as well as the Gothic style in the architecture of medieval Europe have been very well studied. Some researchers

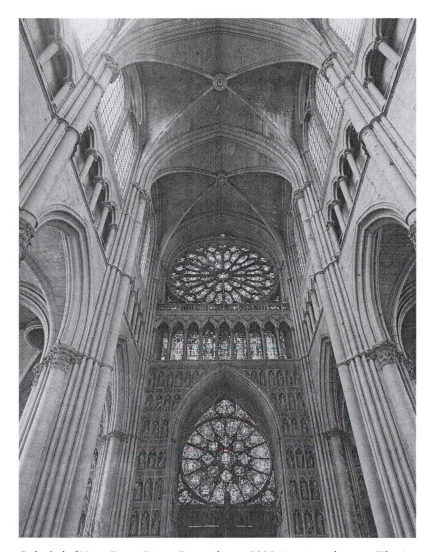

Cathedral of Notre Dame, Reims, France, begun 1210, interior to the west. (The Art Archive/Dagli Orti)

have identified a very early proto-Romanesque style in parts of Spain, France, and Italy, for example, and other scholars have taken great care to differentiate the particularly English variations on the Gothic style. Different terms are used by specialists to describe these different style phases. The terms used for describing the style phases of French Gothic architecture, such as "Rayonnant" and "Flamboyant," are different than the terms used for describing the styles of English Gothic architecture, such as "Decorated" and "Perpendicular."

It is thus possible to determine the dates of medieval buildings based on general style features and an awareness of regional variations. Nevertheless, the names of the people directly involved with these massive projects during the Middle Ages remain largely unknown.

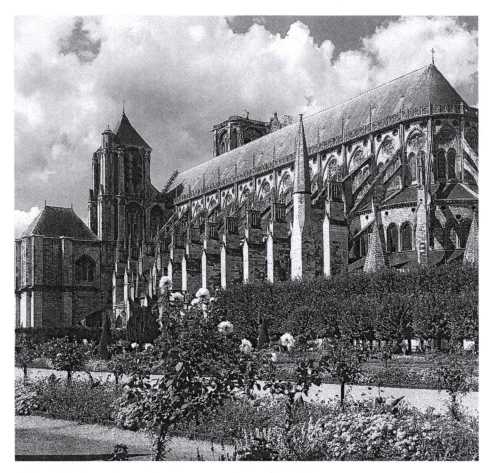

Cathedral of Saint Etienne, Bourges, France, thirteenth century, east end and south façade. (The Art Archive/Dagli Orti)

Medieval Architects: Several Names

This is not to say that we don't know the names of a number of medieval architects. From the mid-thirteenth century onwards (about the time of Villard's sketchbook), various documents and inscriptions exist which cite the names of specific persons involved with the design of particular medieval buildings. Historical chronicles from the period, building accounts, tax records, and inscriptions in the buildings themselves have provided us with the names of a number of medieval builders.

For example, we know the names of six persons presumably involved with the architecture of the cathedral of Notre Dame at Reims, France, in the thirteenth and early fourteenth century: Jean d'Orbais, Jean de Loup, Gaucher de Reims, Bernard de Soissons, Robert de Courcy, and Adam de Reims. The first four names were recorded in (now destroyed) inscriptions from around 1300 at the cathedral, and the other two names are known through other documents

and inscriptions. However, the exact contributions and specific roles of these named persons remain rather enigmatic.

An impressive tombstone of the architect "maitre" (master) Hugues Libergier (d. 1263) also exists at the cathedral of Notre Dame in Reims, which depicts him as an elegantly robed figure holding a model of the abbey church of Saint Nicaise in Reims where he worked between 1231 and 1263. The inscribed tombstone shows Hugues accompanied by the "tools of his trade," which include a measuring rod, compasses, and a right angle.

From an inscription on his tombstone at Saint-Germain-des-Prés in Paris we glean the name of Pierre de Montreuil (d. 1267), who was responsible for designing (now destroyed) sections of that building. Pierre is described not as an "architect" but as a "professor of masonry." An earlier document of 1247 also mentions Pierre as having worked as a mason at the abbey church of Saint Denis in Paris. He is also documented as "master of works" at Notre Dame Cathedral in Paris from about 1258 to 1265. He appears to have taken over from Jean de Celles (d. 1258)—praises for whose work also appear in an inscription at Notre Dame from the middle of the thirteenth century.

Inscriptions at the cathedral of Notre Dame in Amiens, France, also name Robert de Luzarches, Thomas de Cormont, and Regnault de Cormont who appear to have worked in succession at Amiens during the thirteenth century (c1220–1288). Their individual and exact contributions to the design and construction of the cathedral remain much disputed, however.

We know the name of William of Sens, a French artist who was responsible for overseeing the construction of sections of Christ Church Cathedral at Canterbury in England after a disastrous fire in the late twelfth century. His work was praised by the monk Gervase of Canterbury who wrote a dramatic description of the fire itself and the resultant rebuilding campaigns in a treatise titled *Of the Burning and Repair of the Church of Canterbury*. Gervase describes William as "a man active and ready, and as a workman most skillful both in wood and stone."[16] Gervase's descriptions of the rebuilding of Canterbury Cathedral are extremely detailed and he seems to have been acutely aware of the new Gothic style of construction which was replacing the older Romanesque work. "He realized, to an extraordinary degree, that he was witness to a historically important event and he took pains to explain the new forms in adequate new terms."[17] We also learn, from this record, that William of Sens sustained severe injuries after a fall from the scaffolding at Canterbury and that he was replaced by another architect/overseer, William the Englishman.

In the fourteenth and fifteenth centuries, many more names of medieval builders are known and their status as professionals seems to have increased. For example, the Parler family who worked in southern Germany and Bohemia was a renowned dynasty of architects and stone sculptors, recognized for their skills through three generations. The elder, Heinrich (probably from Cologne), is credited with a number of important Gothic church structures. His son Peter (c1330–1399) is especially famous for having designed most of the architecture as well as the sculpture of the cathedral of Saint Vitus in Prague. Peter even in-

cluded a small sculptural self-portrait of himself in this building (c1385). His brother Michael was an important artist as well.

Henry Yevele (d. 1400) in England served as the king's master mason in the late fourteenth century and thus assumed a very important status in this role. He ran a shop in London and was paid a high salary. He directed a number of important building projects, such as the new naves for Canterbury Cathedral and the Westminster abbey, and he consulted on numerous other architectural projects.

Although bits of information can be pieced together to construct summary biographies for a number of these individual architects, it should be noted that even a complete lack of information has not prevented various authors from simply creating quite detailed biographies describing the careers of various medieval architects!

Erwin von Steinbach and Family

Perhaps one of the most interesting examples is the case of late-thirteenth- and early-fourteenth-century Erwin von Steinbach (d. 1318), whose name has traditionally been associated with the cathedral of Notre Dame in Strasbourg, France. Scant evidence about Erwin and his actual role at the cathedral was not a stumbling block for the youthful and enthusiastic German author, Johann Wolfgang von Goethe (1749–1832) who, as a student in Strasbourg in the early 1770s, wrote an essay *Concerning German Architecture*.[18] Goethe dedicated his essay to "the spirit of Erwin von Steinbach" and praised the artistic excellence and genius of Erwin in rapturous terms. Thus began the myth of Erwin von Steinbach as a German master architect of international significance whose fame and reputation only increased as later authors repeated and added to his biography.

Although a Master Erwin and a Master Johann (who died in 1338—a son or grandson of Erwin) are recorded in tombstone inscriptions at Strasbourg, and a Master Erwin is mentioned in a document of 1284, the painted inscription which once existed inside the west facade of the cathedral attributing the work to Master Erwin von Steinbach is long vanished. Erwin may indeed have been responsible for the original design of the building's facade from 1277 to his death in 1318. Two other builders are documented as having completed the tower designs in the late fourteenth and fifteenth centuries.

In any case, after Goethe's essay, the information and legends about Erwin von Steinbach continued to be expanded in various forms.[19] By the nineteenth and early twentieth century he had been the subject of several plays, music had been composed in his honor, and portraits of Erwin and his family members had been created in painting and sculpture.

Erwin's daughter, Sabina von Steinbach, was also "discovered" in the nineteenth century. Based on a (now lost) inscription on one of the sculptures on the exterior of the Strasbourg cathedral (naming a "Savinae"), a nineteenth-cen-

tury scholar attributed several famous sculptures both on the exterior and interior of the cathedral to the previously unacknowledged but extremely skilled female sculptor, Sabina von Steinbach, the daughter of Erwin. That the sculptures in question date to a period approximately four decades before Erwin's work at the cathedral was evidently not recognized then or was seen as being not at all problematic. The name of Sabina von Steinbach continues to occur in studies of medieval female artists especially (see chapter 9).

Johann (or Jean) von Steinbach (confidently identified as Erwin's son and architectural successor) also featured prominently in the growing stories about the Steinbach family genealogy. Various statues, monuments, and plaques depicting the famous individuals and the entire artistic family happily working together as a group were created.

When Goethe composed his essay in the late eighteenth century, praising the glories of Gothic architectural style, he was writing during a period in time when appreciation for this style in architecture was just beginning to flourish again. The attribution of an impressive structure, such as the medieval cathedral of Strasbourg completely to the creative German artistic genius Erwin von Steinbach, emphasized the German contributions to, if not full responsibility for, the development of this newly re-appreciated art style. The revival of interest in Gothic architectural style—throughout Europe—in the late eighteenth and nineteenth centuries also gave rise to an actual Gothic revival in building style. During the late eighteenth and nineteenth centuries, many new buildings were constructed to look old—and specifically to emulate the so-called native medieval styles of architecture in different countries.

Contemporary political rivalries and power struggles were also reflected in the writings of the time which were concerned to attribute the origins and development of this great medieval style to, for example, French, English, or German creativity of ages past. The wonderfully romantic myth of Erwin von Steinbach and his family thus reflects, to a far deeper level, the political/nationalistic concerns of the early modern era rather than the medieval period itself.

Villard the Genius

Similarly, some of the earliest writings, by French authors, about the thirteenth-century French artist Villard de Honnecourt emphasized his significance by comparing the diversity of his interests and talents to famous Italian Renaissance artists such as Leonardo da Vinci. Leonardo (1452–1519) was a multitalented master of many fields. He was a painter, sculptor, architect, engineer, and scientist. He was interested in animal and human anatomy, aviation, botany, cartography, geology, geometry, hydraulics, mathematics, mechanics, optics, and physics. He painted portraits and religious scenes, designed a variety of architectural projects, and served as a military engineer. Leonardo was a great observer and an inventor and he kept copious notebooks with sketches and text, recording all his ideas and observations.

Villard and his sketchbook have been compared to Leonardo and his note-books largely due to the wide-ranging subjects in which both of these men appear to have been interested. Villard's sketchbook also contains a great diversity of material: there are designs for various mechanical gadgets, stone, and wood carving. Villard also sketched human figures, birds, animals, insects, sculptures, and religious scenes, apart from his architectural views and plans.

Villard has also been compared to the great Roman architect and author of architectural treatises, Vitruvius, who lived in the first century B.C.E. Vitruvius has an incredibly important position in the history of architecture largely due to his major treatise titled *The Ten Books on Architecture*. He wrote about city planning, building materials, temples, public buildings, interior design, and military engineering. His descriptions are extremely detailed. His writings were especially avidly studied in the Renaissance period when interest in all things classical was revived. Vitruvius was extremely influential on the development of architecture in the Renaissance and later periods and his works were widely published.

Realistically, neither Vitruvius's books on architecture nor the copious personal notebooks created by Leonardo da Vinci actually bear much resemblance at all to the sketchbook of Villard de Honnecourt in terms of their scope and influence. However, the comparison of Villard—about whom we know so little—to these other famous men, certainly gives Villard a stature resembling theirs. By comparisons such as these, Villard has become (depending upon author and date of writing) a "medieval Leonardo," a "Gothic Vitruvius,"[20] and so on. Quite unlike the personal notebooks of Leonardo, the published treatises of Vitruvius, and indeed the specific and practical design booklets published by later medieval architects such as the Germans Mathes Roriczer and Hanns Schuttermayer in the fifteenth century,[21] the purpose of Villard's sketchbook remains enigmatic.

Villard the Metalworker

Although many scholars have concentrated attention on Villard's architectural and geometric designs, some of the most skillful drawings in Villard's sketchbook are not of architecture but rather of draped human figures. Although these drawings are not necessarily remarkable for their anatomical accuracy, Villard appears to have been extremely interested in detailed drapery patterns. In his depictions of drapery, Villard made use of specific repeated conventions of a distinctive type commonly found in a great deal of medieval art created around the year 1200.

Characteristic of this style are softly grooved and flowing drapery folds which envelope figures in luxuriant and loose swoops of fabric. The drapery patterns reveal the forms of the figures beneath and provide the figures with a sense of volume and realism. The curving lines are characteristically done in loops and hoops. Art historians have named this style the *muldenstil* or *muldenfaltenstil* (the

"trough fold" or "softly grooved" style). It is a style that appeared in a variety of different art media through Europe including painting, sculpture, and metalwork in the late twelfth century and it continued to be popular well into the early thirteenth century.

It has been noted that "Villard was virtually obsessed with *Muldenfaltenstil*,"[22] and that his detailed drawings of figures and drapery—indeed all of his drawings for smaller-scale objects—seem to be much better conceived than many of his sketches of larger-scale subjects, such as his architectural drawings. Some of his architectural drawings, even of buildings we presume he sketched in person, are not really at all accurate. He left out critical elements and altered the appearance of many of the sections of architecture that he drew. These facts have led some scholars to believe that it is far more likely that Villard was a sculptor or a metalworker rather than an architect. He seems to have had a great deal of sensitivity to the design techniques involved with the creation of medieval metalwork objects, especially liturgical pieces, such as shown in his drawings for crucifixes and other religious figural groups. Villard's linear precision and apparent interest in drapery details characteristic of the *muldenstil* might compare well with other examples of medieval metalwork, such as those created by Nicholas of Verdun, an earlier proponent of the *muldenstil* (see chapter 2).

Villard the Mysterious

The lengthy and ongoing discussions about the identity and profession of Villard de Honnecourt and the purpose of his sketchbook are doubtless, at least in part, a result of the uniqueness of his booklet of drawings. The fact that nothing quite like Villard's sketchbook survives from the medieval period does not necessarily, however, indicate that other artists—whether architects, metalworkers, or sculptors—did not make sketches in the Middle Ages or that other artistically gifted medieval people did not make visual notes on sights they encountered during their travels. However, "no corroborative sketches or collections of sketches exist from the thirteenth century to suggest that anyone made or kept visual records merely for the sake of keeping records. Sketchbooks did not exist and parchment, even the generally poor-quality parchment employed by Villard, must have been reasonably costly."[23]

Even so, the fact that nothing really resembling Villard's book has come down to us from the medieval period may serve as a very useful reminder of the amount of material of various sorts which does not survive from centuries past—as well as the dangers and challenges of speculating from incomplete evidence. There are a great number of medieval works of art which no longer exist today. We know about some of these no-longer-extant works because descriptions were written about them before they were destroyed or altered beyond recognition. Just as happens today, in the medieval period old buildings were torn down and new buildings were built in their place. People during the Middle Ages seem to have been, of logical necessity, great recyclers of materials, so bits and pieces of

old structures were often reused in new buildings. Archaeologists and architectural historians with specialized training can often determine the differences between the relatively older and newer materials and thus reconstruct the successive phases of a building's history through such analysis.

During the medieval period, sheets of parchment were not infrequently reused as well. Texts written on that durable material could be scraped off, carefully, and new texts could be written on old parchment pages. Bits and pieces of old manuscripts are also frequently found reused as extra or filler pages (flyleaves) in medieval manuscripts. These extra pages served as a sort of buffer between the book and its binding. It appears that medieval bookbinders often felt few qualms at all about chopping up older outdated manuscripts and using their pages to serve as flyleaves for their newer manuscripts. Of course, objects made of meltable metal materials were especially susceptible to reuse in the Middle Ages—just as in earlier and later periods as well.

All of these factors—combined with natural disasters (such as buildings and libraries burning up in fires), the deliberate destruction of medieval works of art during times of political and religious unrest such as the Reformation period in sixteenth-century England or the French Revolution in the late eighteenth century, the restoration works carried out on so many medieval monuments in the nineteenth century, and the (to our modern sensibilities) much less sophisticated attitude toward the preservation of medieval works of art altogether shown by our ancestors—make us marvel indeed that any works of art at all from the Middle Ages have actually survived.

Those works of art that have survived from the medieval period have doubtless done so due to a great variety of circumstances, including sheer luck. We can presume that some works of art from the medieval period have survived because they were extremely treasured objects whose value continued to be recognized and protected by future generations in spite of political and religious upheavals.

This is surely the case with the few surviving luxury manuscripts from the very early medieval period. The parchment used for these fifth- and sixth-century manuscripts was stained purple (the imperial color) and the texts were written in silver. These were clearly productions for the royalty. Doubtless a great many more, much less lavish, manuscripts were written and illustrated during this period but these luxury productions remain of greatest interest for students of art history. Naturally, attention is often focused upon the best, brightest, and the most attractive.

On the other hand, it may well be the case that some medieval objects still exist today because they were not ever considered to be special heirlooms at all. Many of the medieval manuscripts still contained in public and private collections today were not owned by or commissioned for imperial or wealthy persons. These less expensive and less deluxe examples of medieval art may give us another "window" in our approach to the medieval period, and give us more information about the types of art and related activities which ordinary medieval people enjoyed. But we need to be cautious about this as well.

Although Villard de Honnecourt may indeed have traveled all over Europe recording his impressions in visual and written form in his sketchbook, the fact still remains that no such similar sketchbook by a medieval person exists to date. This lack of comparative examples poses a huge contrast to all of the information that is so normally and so readily available about contemporary artists, for example.

All that can really be said with any certainty about (the artist? sculptor? architect? man of many interests?) Villard de Honnecourt, however, is that his sketchbook surely remains one of the very most intriguing documents to have survived from the medieval period. "Perhaps the most accurate way to characterize him is to resurrect a now debased and distorted word, 'dilettante.' This word originally described 'one who delighted in the world around himself.' Who better fits this definition than Villard de Honnecourt?"[24]

Notes

1. Carl Barnes, "A Note on the Bibliographic Terminology in the Portfolio of Villard de Honnecourt," *Manuscripta.* 31, no. 2 (1987): 71.

2. Carl Barnes, *Villard de Honnecourt—The Artist and His Drawings: Critical Bibliography 1666–1981* (Boston, G. K. Hall, 1982), xxxv.

3. Theodore Bowie, ed., *The Sketchbook of Villard de Honnecourt* (Bloomington: Indiana University Press, 1959), 14.

4. Bowie, 102.

5. Bowie, 72.

6. Bowie, 88.

7. Bowie, 86.

8. Bowie, 5.

9. Barnes, *Critical Bibliography,* xxxv.

10. Excellent illustrations and text explaining the construction phases of Gothic cathedrals can be found in David Macaulay, *Cathedral: The Story of Its Construction* (Boston: Houghton Mifflin, 1973).

11. Nikolaus Pevsner, "The Term 'Architect' in the Middle Ages," *Speculum* 17, no. 4 (1942): 549.

12. Robert Calkins, *Medieval Architecture in Western Europe from A.D. 300 to 1500* (Oxford: Oxford University Press, 1998), 306.

13. See especially John James, *The Template-Makers of the Paris Basin* (Leura, Australia: West Grinstead Publishing, 1989).

14. Caecilia Davis-Weyer, *Early Medieval Art: 300–1150* (Toronto: University of Toronto Press, 1986), 124.

15. Calkins, 1.

16. Teresa Frisch, *Gothic Art 1140–c1450* (Toronto: University of Toronto Press, 1987), 17.

17. Frisch, 14.

18. See W. Robson-Scott, *The Literary Background of the Gothic Revival in Germany: A Chapter in the History of Taste* (Oxford: Clarendon Press, 1965), and Paul Frankl, *The*

Gothic: Literary Sources and Interpretations through Eight Centuries (Princeton, N.J.: Princeton University Press, 1960), 417–442.

19. Roland Recht, "Le Mythe Romantique d'Erwin de Steinbach," *L'Information de l'Histoire de l'Art* 15, no. 1 (1970): 38–45.

20. Frankl, 37.

21. Lon Shelby, ed., *Gothic Design Techniques: The Fifteenth-Century Design Booklets of Mathes Roriczer and Hanns Schmuttermayer* (Carbondale: Southern Illinois University Press, 1977).

22. Barnes, *Critical Bibliography,* xxxiv.

23. Barnes, *Critical Bibliography,* xxviii.

24. Barnes, *Critical Bibliography,* xxxix.

Bibliography

Barnes, Carl. "A Note on the Bibliographic Terminology in the Portfolio of Villard de Honnecourt." *Manuscripta* 31, no. 2 (1987): 71–76.

———. *Villard de Honnecourt—The Artist and His Drawings: Critical Bibliography 1666–1981.* Boston: G. K. Hall, 1982.

Bowie, Theodore, ed. *The Sketchbook of Villard de Honnecourt.* Bloomington: Indiana University Press, 1959.

Bucher, Francois. *Architector: The Lodge Books and Sketchbooks of Medieval Architects,* vol. 1. New York: Abaris Books, 1979.

Calkins, Robert. *Medieval Architecture in Western Europe from A.D. 300 to 1500.* Oxford: Oxford University Press, 1998.

Coldstream, Nicola. *Masons and Sculptors.* Toronto: University of Toronto Press, 1991.

Davis-Weyer, Caecilia. *Early Medieval Art: 300–1150.* Toronto: University of Toronto Press, 1986.

Evans, Michael. *Medieval Drawings.* London: Paul Hamlyn, 1969.

Frankl, Paul. *The Gothic: Literary Sources and Interpretations through Eight Centuries.* Princeton, N.J.: Princeton University Press, 1960.

Frisch, Teresa. *Gothic Art 1140–c1450.* Toronto: University of Toronto Press, 1987.

Gimpel, Jean. *The Cathedral Builders.* New York: Harper and Row, 1984.

Harvey, John. *The Master Builders: Architecture in the Middle Ages.* London: Thames and Hudson, 1971.

———. *The Mediaeval Architect.* London: Wayland, 1972.

James, John. *Chartres: The Masons Who Built a Legend.* London: Routledge and Kegan Paul, 1982.

———. *The Template-Makers of the Paris Basin.* Leura, Australia: West Grinstead Publishing, 1989.

Kostof, Spiro, ed. *The Architect: Chapters in the History of the Profession.* New York: Oxford University Press, 1977.

Macaulay, David. *Cathedral: The Story of Its Construction.* Boston: Houghton Mifflin, 1973.

Pevsner, Nikolaus. "The Term 'Architect' in the Middle Ages." *Speculum* 17, no. 4 (1942): 549–562.

Pierce, James. "The Sketchbook of Villard de Honnecourt." *New Lugano Review* 8/9 (1976): 28–36.

Recht, Roland. "Le Mythe Romantique d'Erwin de Steinbach." *L'Information de l'Histoire de l'Art* 15, no. 1 (1970): 38–45.

Robson-Scott, W. *The Literary Background of the Gothic Revival in Germany: A Chapter in the History of Taste.* Oxford: Clarendon Press, 1965.

Roth, Leland. *Understanding Architecture: Its Elements, History, and Meaning.* New York: HarperCollins, 1993.

Scheller, Robert. *Exemplum: Model-Book Drawings and the Practice of Artistic Transmission in the Middle Ages (ca.900–ca.1470).* Haarlem: De Erven F. Bohn N.V., 1996.

Shelby, Lon, ed. *Gothic Design Techniques: The Fifteenth-Century Design Booklets of Mathes Roriczer and Hanns Schmuttermayer.* Carbondale: Southern Illinois University Press, 1977.

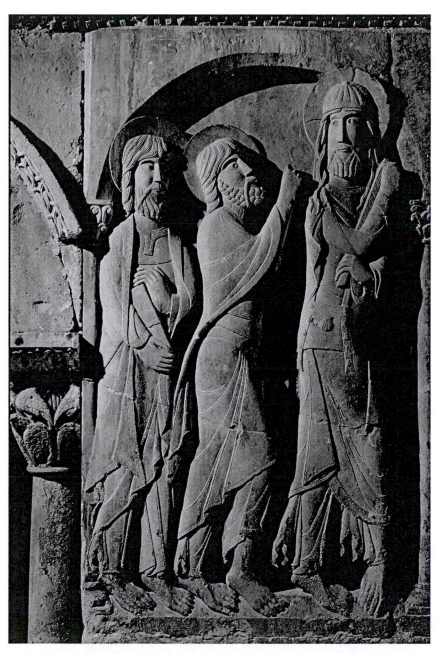

Christ and the pilgrims from Emmaus. Romanesque stone relief at the Monastery of Santo Domingo de Silos Spain, twelfth century, detail. (The Art Archive/Monastery of Santo Domingo de Silos Spain/Dagli Orti)

RIGHT: Las Platerias portal, Cathedral of Santiago de Compostela, Spain, eleventh-century Romanesque. (The Art Archive/Cathedral of Santiago de Compostela/ Dagli Orti)

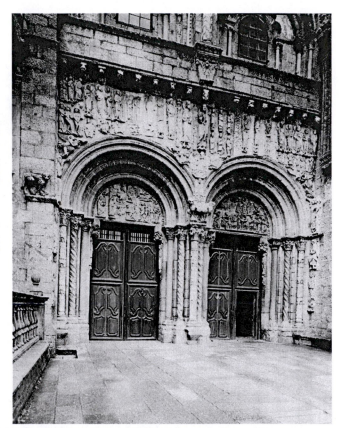

BELOW: The Stavelot Triptych, c1154. (The Pierpont Morgan Library, New York/ Art Resource, NY)

Matthew Paris and the Virgin and Child, from the Chronica Majora, c1240. London, British Library MS Royal 14. C. VII, folio 6. (The Art Archive/British Library/British Library)

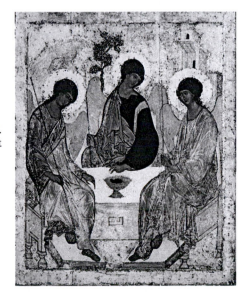

Andrei Rublev, Trinity icon, c1408–1427. Tretyakov Gallery, Moscow. (Scala/Art Resource, NY)

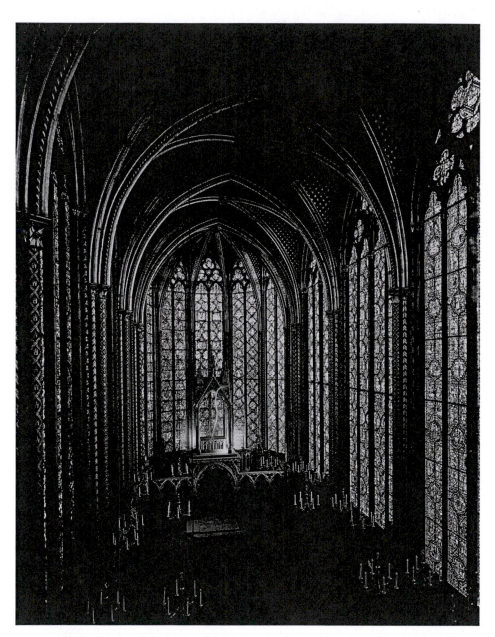

Sainte-Chapelle, Paris, c1243–1248, interior of upper chapel. (The Art Archive/Dagli Orti)

TOP: Windows and buttresses of Leon Cathedral, Spain, 1250–1350. (The Art Archive/ Album/Joseph Martin) BOTTOM: The Bayeux Tapestry, c1070–1080, battle scene. Musée de Peinture, Ancien Evêchè, Bayeux. (The Art Archive/Musée de la Tapisserie Bayeux/Dagli Orti)

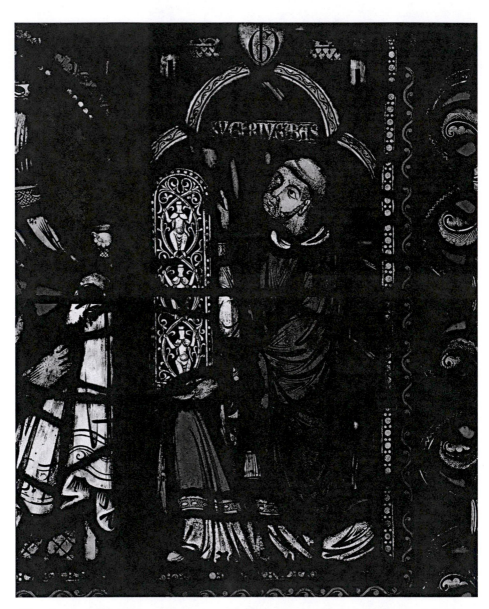

Abbot Suger, c1081–1151, detail from a stained glass window in the ambulatory of the abbey church of Saint Denis, Paris. (The Art Archive/Basilique Saint Denis, Paris/Dagli Orti)

Church of Sant'Apollinare Nuovo, Ravenna, Italy, c500, interior. (The Art Archive/San Apollinare Nuovo Ravenna/Dagli Orti)

Duccio, *Maestà* altarpiece, c1308–1311, front. Museo dell'Opera del Duomo, Siena, Italy. (Scala/Art Resource, NY)

January calendar page, from the *Très Riches Heures* of Jean de Berry, c1413–1416. Chantilly, Musée Condé MS 65, folio 2. (Rèunion des Musées Nationaux/Art Resource, NY)

CHAPTER 5

A Medieval Art Manual by Theophilus

The Book

Any person searching for information on the Internet or visiting a bookstore or library today will be certain to come across a huge variety of sources and publications offering advice and instructions on "how to do" any number of activities. There are diet books, self-help books, recipe books, manuals giving instructions on preparing legal documents, and guidebooks offering tips for understanding everything from art to computers to foreign languages. With titles ranging from *Learning to Look* to *How to Visit an Art Museum* to *Art for Dummies*, in any given area of human knowledge and interest there are numbers of sources available today which offer guidance and handy hints.

Such handbooks are not simply a modern phenomenon by any means, and during the Middle Ages also, there were experts who recorded their knowledge in "how to" books. These guidebooks are extremely interesting to study because they can provide detailed information on ideas, attitudes, processes, techniques, materials, and working methods that we might not otherwise understand so clearly.

One of the earliest and most important of these medieval treatises on how to do art is titled *The Various Arts* (*De Diversis Artibus*). The work was written sometime in the first half of the twelfth century (possibly c1130) by an author who called himself "Theophilus." Probably, this Greek name (which means "lover of God") was not the writer's real name but rather a pseudonym which he adopted as an author. In the preface to his book he describes himself as a "humble priest" and a "monk," and he urges his readers to respectfully honor God by avoiding idleness and engaging in the productive "practice of the various useful arts."

The "arts" which Theophilus describes in his treatise are wonderfully various indeed. He discusses a great many different and complicated painting and metalworking techniques especially. He also describes the creation of stained glass windows, tells how to build an organ, cast bells, and make paper. (This is one of the earliest references to paper in western Europe; throughout the Middle Ages, the typical writing material was parchment, or animal skin. See chapter 3.) He gives advice on specific materials and tools to use. He describes where to find and how to make these materials and tools. He explains how to set up appropriate workshops/studios for these various production processes and offers painstaking step-by-step guidance on complex technical procedures.

The Author

The treatise is divided into three major sections: "The Art of the Painter," "The Art of the Worker in Glass," and "The Art of the Metalworker." By far the longest section in Theophilus's book concerns metalworking. The author here describes how to work with bronze, gold, and silver, and how to do a great number of decorative techniques ranging from casting to carving to embellishing metal objects with enamel and precious stones. The relatively great emphasis on metalworking in the treatise, combined with the fact that Theophilus describes himself as a "monk," has led scholars to speculate that Theophilus may be the pseudonym for the German Benedictine monk and metalworker, Roger of Helmarshausen, who created a number of extremely skillful works of liturgical art in gold, enamel, and precious stones in the early twelfth century. Indeed, the earliest surviving copies of Theophilus's manuscript come from Germany (one of these manuscripts also names the author as "Rogerus") and during the twelfth century, the northwestern regions of Germany were particularly famous for a number of named and unnamed master metalworkers (see chapter 2). So it may be the case that Theophilus and Roger of Helmarshausen are one and the same person.

The works attributed to Roger of Helmarshausen include several portable altars such as the one made for the abbey of Abdinghof probably in the very early twelfth century. It has gilded bronze panels with a variety of figural scenes. Like other metalwork objects attributed to Roger (none of his works are signed), the high quality of the craftsmanship as well as the particular style of showing drapery folds is distinctive. Other pieces attributed to Roger include works done in silver, bronze, and gold with engraved or embossed (raised) areas and beautiful sections of enamel work. Roger used gems, pearls, and fine filigree details. All of these metalworking methods and materials are included in Theophilus's treatise. In the ninety-six sections of his book devoted to metalwork, we find descriptions of how to cast and solder silver, how to work with various types of gold, how to work in enamel, how to set gems and pearls, how to work in copper and brass, and so on. All of the techniques most often employed by medieval metalworkers—the exact techniques seen on the pieces at-

tributed to Roger of Helmarshausen—are found described in the manual of Theophilus.

However, whether or not we can confidently identify Theophilus with Roger may be of somewhat less importance here than the significance of the treatise itself. It is a comprehensive, clear, and well-organized encyclopedia of art techniques containing everything a medieval artist might want or need to know about the materials and processes involved with the creation of a great range of different art forms. The care and detail with which the author describes these techniques is particularly impressive; it sounds as if he is speaking from direct personal knowledge of all of these processes and in fact several times refers to his own experiences with a number of complicated techniques. He states that he has been personally concerned to discover and learn about the techniques he describes in his book.

Practice and Experience

Although there are some sections in the book which are fancifully drawn from folklore and alchemical traditions—such as how to soften crystal with goat's blood and how to make gold from the powder of basilisks, including how to hatch basilisks for this purpose (a basilisk is a mythical serpent-like creature mentioned in the Bible as well)—the book, by and large, is filled with practical advice. The treatise "represents the deliberate attempt by one person to give shape to his own personal knowledge and experience and present it in a rational and ordered way."[1]

The wide-ranging information in the book, of course, also raises some questions. Was Theophilus himself a skilled practitioner of all these various arts? There is some evidence indeed that the modern concept of "artistic specialization" differs somewhat from ideas about art and art-making during the medieval period.

In the present day, although it is not extraordinary to find artists who work in a whole variety of different media, generally speaking, artists select one area of concentration in which they develop their skills (be it oil painting, photography, ceramic sculpture, or video art.) In contrast, it appears that some medieval artists, such as "Master Hugo" (who worked at the English abbey of Bury Saint Edmunds in the middle of the twelfth century), for example, were talented in a wide range of different areas (see chapter 3). Documents from Bury state that Master Hugo not only worked for many years painting the illustrations for a magnificent Bible manuscript, but also created bronze doors for the monastery and carved a beautiful wooden crucifix as well. So Master Hugo presumably was a painter and a sculptor as well as a metalworker.

Numerous other examples of medieval artists who appear to have worked in a range of different media could easily be cited here: the otherwise anonymous German manuscript painter (active c1000) known as the "Registrum Master" (after one of his most famous works) may have been a skilled ivory carver as

well; and Saint Dunstan (c909–988), who became the archbishop of Canterbury in the tenth century, is credited with great skill in manuscript painting as well as metalworking.

The fact that Theophilus, in his treatise, claims and appears to have been conversant with all of the techniques he describes does not necessarily mean that he was equally skilled in all of these areas. However, from the direct and specific instructions and the practical hints and "tips" he offers, it appears likely that, in addition to his own work as an artist, Theophilus certainly watched other artists very carefully and gleaned experience from so doing.

Indeed, it is the very practical and clear nature of Theophilus's descriptions that set his manual apart from other medieval examples of such guidebooks. A number of other examples of manuals on art and various technological processes survive from the Middle Ages but in the majority of cases these collections of recipes are rather less systematic than Theophilus's treatise. The information contained in these other examples largely appears to represent bits and pieces of knowledge copied from earlier sources, which resulted often in a curious mixture of accurate data along with incorrect, outdated, and confusing directions. Theophilus certainly appears to have been aware of these previous sources and traditions but he differs greatly in his adoption of a very clear, step-by-step approach to his topics.

Some of these earlier examples of medieval art manuals date back into the very early Middle Ages (for example, the seventh century) and seem, in turn, to represent fragments of information copied from even earlier texts. In some cases it appears that the texts were simply copied over and over again and no one actually tested the information to see if it was accurate. Due to the fact that quite often "the scribes felt free to add commentaries or to make additions or corrections to the text they were working on, or simply to ignore some parts of it,"[2] some of the directions transmitted make no sense at all. This is not to say that useful information was not contained in these earlier handbooks but probably more was actually learned by direct experience than by following the instructions in these guidebooks. Theophilus's treatise poses a great contrast to these earlier examples.

The treatise of Theophilus also contrasts with examples of medieval model books or sketchbooks. A number of different sorts of these illustrated works survive from various periods during the Middle Ages. Some appear to be unique collections of notes and sketches with unclear purposes, such as the thirteenth-century sketchbook of Villard de Honnecourt (see chapter 4), while other examples are collections of ideas for designs, figures, and forms specifically intended for artists to copy.[3] These illustrated model or pattern books are very different from the treatise of Theophilus with its detailed technical directions.

The contrast between Theophilus's treatise and earlier medieval compilations on art techniques may also reflect, as some scholars have suggested, some important changes in attitudes toward the arts as well as contemporary debates about the arts in the early twelfth century.

Medieval Attitudes toward the Arts: Saint Bernard of Clairvaux

As mentioned earlier, Theophilus described himself as a monk. There is general scholarly agreement that he would have been a member of the Benedictine monastic order. This order was founded in the sixth century by Saint Benedict of Nursia (c480–c550) and, by the time of Theophilus in the twelfth century, had grown to be the largest and dominant form of monasticism in the medieval west. Benedictine monasteries throughout Europe were flourishing centers of scholarship and the arts. They were often quite wealthy establishments with richly decorated churches filled with luxurious metalwork objects of the exact type that Theophilus describes in his treatise.

However, the Benedictine emphasis on the arts and the time, energy, and financial resources devoted to church decoration struck a number of medieval theologians as quite inappropriate for the religious lifestyle. For example, Saint Bernard of Clairvaux (1090–1153) was a particularly vocal critic of the lavish decoration of Benedictine monastery churches. In the early twelfth century, Saint Bernard called for a reform of practices and a return to a more austere and simple lifestyle for monks who, he felt, were distracted from their lives of prayer and piety when surrounded by needless luxury objects in fancy churches and monastery buildings enriched with sculpture and painting.

Saint Bernard was a member of the Cistercian order, which had begun in the late eleventh century as a reform movement aiming for a much stricter form of Benedictine monasticism. As the Cistercian order grew in the early twelfth century, the contrast with the Benedictines was increasingly evident and, in terms of their attitudes toward the arts, the Cistercians advocated plain architecture, minimal decoration, and the use of simple materials. The Cistercian critique of Benedictine luxury and laxity inspired a number of counterarguments, needless to say, and the debate about the proper role of art in the religious context continued for several decades in the early twelfth century.

The most often quoted passages that Saint Bernard wrote about art occur in his c1125 work *Apologia ad Guillelum Abbatem*. He composed this treatise in the form of a letter to a friend and fellow monk, William of Saint Thierry (c1085–1148), who was the abbot of a Benedictine monastery in northern France. William had, apparently, asked for opinions, advice, and support on a variety of matters from his friend Saint Bernard. In particular, it is Bernard's description of the needless expense of luxurious art (*Apologia* 28–29) which has led some scholars to describe him as "the most eloquent among the enemies of Romanesque art."[4] In these famous passages, Bernard indeed appears to be extremely negative about religious art. He writes:

> O vanity of vanities, but no more vain than insane! The Church is radiant in its walls and destitute in its poor. It dresses its stones in gold and it abandons its children naked. It serves the eyes of the rich at the expense of the poor. The curious

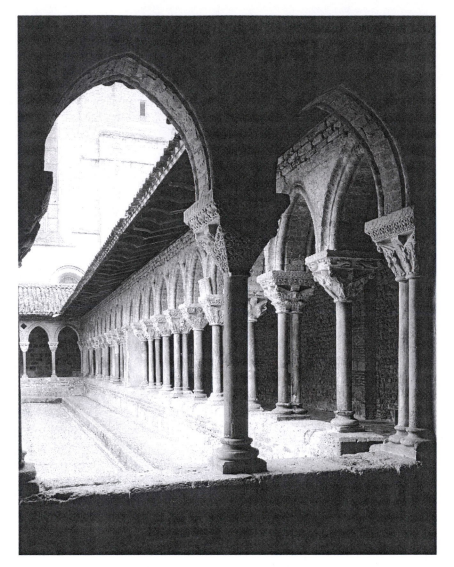

Cloister, Church of Saint Pierre, Moissac, France, c1100. (The Art Archive/St. Pierre church Moissac France/Dagli Orti)

find that which may delight them, but those in need do not find that which should sustain them.[5]

Bernard seems clearly to be suggesting that it would be far more fitting if money were spent not on fancy artwork in churches but rather in assisting those in need of basics, such as food and clothing. When people are poor, needy, and suffering, Bernard suggests, it is foolish to spend money on works of art. Artworks do not alleviate social problems, such as poverty, after all.

Further along in his text, Bernard wrote an especially "exasperated outburst"[6]

about medieval sculpture in monastery churches and cloisters. Apart from being a wonderful description of some of the fabulous and fantastic forms of Romanesque art, Bernard's text emphasizes the inappropriateness of such artistic distractions in the spiritual life.

> But apart from this, in the cloisters, before the eyes of the brothers while they read—what is that ridiculous monstrosity doing, an amazing kind of deformed beauty and yet a beautiful deformity? What are the filthy apes doing there? The fierce lions? The monstrous centaurs? The creatures, part man and part beast? The striped tigers? The fighting soldiers? The hunters blowing horns? You may see many bodies under one head, and conversely many heads on one body. On one side the tail of a serpent is seen on a quadruped, on the other side the head of a quadruped is on the body of a fish. Over there an animal has a horse for the front part and a goat for the back; here a creature which is horned in front is equine behind. In short, everywhere so plentiful and astonishing a variety of contradictory forms is seen that one would rather read in the marble than in books, and spend the whole day wondering at every single one of them than in meditating on the law of God. Good God! If one is not ashamed of the absurdity, why is one not at least troubled at the expense?[7]

It is altogether tempting to read these passages by Saint Bernard "as an almost total condemnation of monastic art,"[8] if not of art in general. That would be a simplification however. Closer, more careful reading of the whole of Bernard's text reveals more complexities and subtle distinctions. Bernard did not simply attack art in general but he focused on what he defined as the excessive and luxurious—specifically "as inappropriate to the profession of the monk."[9]

The general topics regarding the roles and relationships of art and religion attracted and inspired a number of other writers in the first part of the twelfth century. Some scholars believe that the German Benedictine monk, artist, and manual-writer, Theophilus, must have been aware of Saint Bernard's views and that he composed his treatise on the arts partially as a response and contribution to these contemporary debates. Especially in each of the prefaces to the three main sections of his book, Theophilus takes very special care to describe the usefulness of the arts in inspiring piety and he emphasizes how the process of artistic creation is an act of devotion to God. Human skill in the arts is a gift from God, Theophilus asserts, and so humans should not neglect these God-given talents but rather develop and apply these gifts in a worshipful manner. Not to do so would be sinful, he implies. "Do not bury your talent given you by God,"[10] Theophilus writes. "Do not despise useful and precious things. . . . For, foolish is the merchant who suddenly finds a treasure in a hole in the ground and fails to pick it up and keep it."[11]

He also makes reference to biblical precedents, for example, mentioning Moses, David, and Solomon and the construction of the ancient temple in Jerusalem—a house of worship whose creation and embellishment was ordained and inspired by God. He notes that God gave Moses very specific in-

structions for constructing the tabernacle—a sanctuary used by the Israelites in their wanderings before the permanent temple was constructed in Jerusalem. Theophilus mentions the "gold and silver, bronze, gems, wood and . . . art of every kind"[12] involved with these religious architectural projects. King David, he writes, had "discerned that God delighted in embellishment of this kind."[13]

Theophilus takes care to describe how rich and marvelous adornments, carried out in beautiful materials, are fully appropriate and indeed required in the creation of sacred places of worship. The implication is that it would be completely inappropriate not to use the most beautiful materials and the most skillful techniques possible in creating places and objects for the worship of God.

These lavish praises for the arts and their necessity in a religious context contrast sharply with the attitudes expressed by Saint Bernard of Clairvaux who, as a preeminent and influential theologian of the time, was certainly more than well versed in the biblical precedents Theophilus cited in his treatise. Bernard also used many examples from the Bible to support his own views, though his interpretations were different than those of Theophilus and other authors on the opposite side of the debate. According to Bernard: "Those who . . . have left all to follow Christ do not seek gold. . . . [T]he intentions of those who embellish the church for temporal gain are not pure. . . . [S]uch actions are not effectively for the honor of God, nor should they be tolerated as such."[14]

It should be emphasized again that it is far too simplistic to describe these divergent opinions as simply being pro or anti art. Bernard's concerns were primarily focused upon luxury arts in the monastic context. The complexity of the whole discussion, the use and interpretation of biblical passages, and the careful argumentation of various ideas by many authors about the relationship of art and religion in western Europe in the twelfth century is not unlike the intense controversies regarding religious imagery which took place centuries earlier in the Byzantine world (see chapter 8). During the eighth and ninth century in the Byzantine empire, great debates arose about the proper use of and proper attitudes toward images of holy figures. This "Iconoclastic Controversy," in which a number of authors composed detailed works either criticizing or validating holy images, "was motivated by a complex variety of factors, not the least of which was a struggle between ecclesiastic and imperial authority."[15] A great many artworks were destroyed during this period in the Byzantine world before the use of holy images was formally again accepted and sanctioned in the middle of the ninth century.

Although Saint Bernard's views have been described as a type of "puritanical iconoclasm,"[16] it is wise always to keep larger contexts in mind. "Bernard's Apologia is not, and never was intended to be, a programmatic statement on art. . . . But . . . a thoughtful and tempered expression of his thoughts on the narrower question of monastic art."[17] However, the general issues raised in the medieval discussion about the relationship of art and religion are themes that have continued to recur with some frequency in the post-medieval and modern period as well.

Medieval Attitudes toward the Arts:
Abbot Suger of Saint Denis

One further medieval author should be mentioned here whose writings about art follow and expand upon many of the themes of Theophilus. Toward the middle of the twelfth century, Suger (1081–1151), the abbot of the Benedictine monastery of Saint Denis near Paris, wrote several accounts of the reconstruction and renovation of the monastery church that were carried out under his direction. Suger is surely one of the most intriguing characters of the medieval period whose influence on and involvement with art, politics, and religion was enormous. "He was a man of massive accomplishments—and a correspondingly massive sense of self."[18]

A massive amount has been written about Suger: his ideas, motivations, and contributions to the development of the Gothic style. His church at Saint Denis (c1140–1144) is customarily described as the first fully Gothic building. Suger's writings contain detailed descriptions of this construction process.

Of most interest here are Suger's many philosophical comments about religious art which are altogether in contrast to the opinions expressed by his friend and correspondent, Saint Bernard. Suger wrote with great enthusiasm and pleasure about luxurious art. "There is an ecstatic quality in his experiences of beauty in the church."[19] He loved bright and glittering objects, fancy materials, and fine craftsmanship, such as his beautiful chalice which still survives today. He wrote:

> Often we contemplate, out of sheer affection for the church our mother, these different ornaments both new and old. . . . Thus, when—out of my delight in the beauty of the house of God—the loveliness of the many-colored gems has called me away from external cares, and worthy meditation has induced me to reflect, transferring that which is material to that which is immaterial, on the diversity of the sacred virtues; then it seems to me that I see myself dwelling, as it were, in some strange region of the universe which neither exists entirely in the slime of the earth not entirely in the purity of Heaven; and that, by the grace of God, I can be transported from this inferior to that higher world.[20]

Suger seems to have regarded beautiful art as a means to inspire devotion. He was a great advocate of praising God via fine craftsmanship and with luxurious materials. Stained glass windows and glowing objects of metalwork adorned with precious gems radiate earthly light, according to Suger, the contemplation of which could lead the viewer to the heavenly light of God. The material world is only a reflection of the spiritual realms, but material objects of brightness and splendor may serve to brighten people's minds to greater spiritual understanding and piety.

Suger also records that on the magnificent doors of the church of Saint Denis the following verse was inscribed:

> Whoever thou art, if thou seekest to extol the glory of these doors,
> Marvel not at the gold and at the expense but at the craftsmanship of the work.

Bright is the noble work; but, being nobly bright, the work
Should brighten the minds, so that they may travel, through the true lights,
To the True Light where Christ is the true door.
In what manner it be inherent in this world the golden door defines:
The dull mind rises in truth through that which is material
And, in seeing this light, is resurrected from its former submersion.[21]

That the abbey church of Saint Denis was also the traditional burial place of the French kings and that Abbot Suger was a trusted friend and advisor to several kings during his lifetime might also be noted here. Possibly these facts provided an additional political motivation for Suger's work in embellishing this great structure to serve as a fitting monument for royal patrons as well. It should also be noted that "Suger placed his mark on his church. Four of his images and seven inscriptions containing his name appeared in his church. . . . It is hard to find a clearer identification between building and patron in ecclesiastical architecture."[22]

Suger's impressive sense of himself and of his personal accomplishments makes him one of the most fascinating of medieval personalities, especially "as much of Suger's activity and even more of his motivation remain obscure."[23] His writings on art and his glowingly enthusiastic descriptions of the architecture and ornamentation of the church of Saint Denis are extremely significant documents of medieval aesthetic theories.

Texts and Contexts

Returning now to Theophilus and his treatise. Although a fundamentally practical manual, Theophilus's treatise provides much more than a uniquely clear "how to" guidebook for medieval art techniques. In addition to a wealth of advice on specific materials and processes, the manual also gives us a great deal of insight into contemporary attitudes about the arts and the role of the artist in medieval society.

We can appreciate and use such a text as Theophilus's treatise in a variety of different ways, just as the medieval authors discussed above shaped a variety of different arguments from some of the very same sources. On the one hand, the manual can be used as a straightforward collection of recipes. Persons interested in medieval art materials and techniques can follow his directions and duplicate his results to a large extent. The text functions very well indeed on this purely practical level.

On the other hand, the text can be analyzed and brought into play in larger philosophical discussions. It can be used as an example of the "Benedictine" attitude toward art in the medieval period, especially if contrasted with carefully selected quotes from the "Cistercian" point of view as exemplified by Saint Bernard of Clairvaux.

The text can also serve in discussions about medieval artists and how medieval artists understood their role and position in medieval society. Theophilus's

emphasis on humility and his self-effacing attitude, even in his adoption of his pseudonym, may contribute to presenting a picture of the anonymous medieval artisan laboring solely for the glory of God.

All of these different ways of approaching the text need to be tempered and balanced with an awareness of what we do (and do not) also know about the context in which the book was created. We can only imagine that caution and a desire to avoid misreading his directions and ideas would have appealed to Theophilus as well!

Notes

1. C. R. Dodwell, ed. and trans., *Theophilus: The Various Arts/De Diversis Artibus* (Oxford: Clarendon Press, 1986), xiii-xiv.

2. Salvador Viñas, "Original Written Sources for the History of Mediaeval Painting Techniques and Materials: A List of Published Texts," *Studies in Conservation* 43 (1998): 115.

3. See Robert Scheller, *Exemplum: Model-Book Drawings and the Practice of Artistic Transmission in the Middle Ages (ca. 900–ca. 1470)* (Haarlem: De Erven F. Bohn N.V., 1996).

4. Caecilia Davis-Weyer, *Early Medieval Art: 300–1150* (Toronto: University of Toronto Press, 1986), 168.

5. See Conrad Rudolph, *The "Things of Greater Importance": Bernard of Clairvaux's Apologia and the Medieval Attitude Toward Art* (Philadelphia: University of Pennsylvania Press, 1990), 11.

6. Veronica Sekules, *Medieval Art* (Oxford: Oxford University Press, 2001), 78.

7. See Rudolph, 11–12.

8. See Rudolph, 6.

9. See Rudolph, 8.

10. Dodwell, 63.

11. Dodwell, 3.

12. Dodwell, 62.

13. Dodwell, 62.

14. Rudolph, 42.

15. Leslie Ross, *Medieval Art: A Topical Dictionary* (Westport, Conn.: Greenwood Press, 1996), 126.

16. James Snyder, *Medieval Art: Painting, Sculpture, Architecture, Fourth through Fourteenth Century* (New York: Harry N. Abrams, 1989), 290.

17. See Rudolph, 8–9.

18. John Benton, "Introduction: Suger's Life and Personality," in *Abbot Suger and Saint-Denis: A Symposium*, ed. Paula Gerson (New York: Metropolitan Museum of Art, 1986), 7.

19. Umberto Eco, *Art and Beauty in the Middle Ages* (New Haven, Conn.: Yale University Press, 1986), 14.

20. See Teresa Frisch, *Gothic Art: 1140–c1450* (Toronto: University of Toronto Press, 1987), 9.

21. Frisch, 7.

22. Benton, 7.

23. Benton, 7.

Bibliography

Crosby, S., J. Hayward, C. Little, and W. Wixom. *The Royal Abbey of Saint-Denis in the Time of Suger (1122–1151)*. New York: Metropolitan Museum of Art, 1981.

Davis-Weyer, Caecilia. *Early Medieval Art: 300–1150*. Toronto: University of Toronto Press, 1986.

Dodwell, C. R., ed. and trans. *Theophilus: The Various Arts/De Diversis Artibus*. Oxford: Clarendon Press, 1986.

Eco, Umberto. *Art and Beauty in the Middle Ages*. New Haven, Conn.: Yale University Press, 1986.

Frisch, Teresa. *Gothic Art: 1140–c1450*. Toronto: University of Toronto Press, 1987.

Gerson, Paula, ed. *Abbot Suger and Saint-Denis: A Symposium*. New York: Metropolitan Museum of Art, 1986.

Hawthone, J., and C. Smith, ed. and trans. *Theophilus: On Divers Arts*. Chicago: University of Chicago Press, 1963; reprint New York: Dover, 1979.

Lasko, Peter. *Ars Sacra 800–1200*. New Haven, Conn.: Yale University Press, 1972, 1994.

Panofsky, Erwin. *Abbot Suger on the Abbey Church of Saint-Denis and Its Art Treasures*. Princeton, N.J.: Princeton University Press, 1946, 1979.

Rudolph, Conrad. *The "Things of Greater Importance": Bernard of Clairvaux's Apologia and the Medieval Attitude Toward Art*. Philadelphia: University of Pennsylvania Press, 1990.

Scheller, Robert. *Exemplum: Model-Book Drawings and the Practice of Artistic Transmission in the Middle Ages (ca. 900–ca. 1470)*. Haarlem: De Erven R. Bohn N.V., 1996.

Sekules, Veronica. *Medieval Art*. Oxford: Oxford University Press, 2001.

Snyder, James. *Medieval Art: Painting, Sculpture, Architecture, Fourth through Fourteenth Century*. New York: Harry N. Abrams, 1989.

Van Engen, John. "Theophilus Presbyter and Rupert of Deutz: The Manual Arts and Benedictine Theology in the Early Twelfth Century." *Viator* 11 (1980): 147–163.

Viñas, Salvador. "Original Written Sources for the History of Mediaeval Painting Techniques and Materials: A List of Published Texts." *Studies in Conservation* 43 (1998): 114–124.

White, Lynn. "Theophilus Redivivus." *Technology and Culture* V, no. 2 (1964): 224–233.

CHAPTER 6

Walls of Color and Light: Mural Painting, Mosaics, and Stained Glass

Immobile Art

Often when we think of works of art, we may first of all think of objects such as paintings or pieces of sculpture which are hung on walls or displayed in museums or homes. This definition of art—as more-or-less portable or moveable objects—has become a fairly traditional way of thinking in the modern world. People visit art galleries to look at and sometimes to purchase paintings, prints, or sculptures for their own collections and to display in their homes. We visit art shows in museums and galleries to look at works of art from other peoples' collections. The great museums of the world have their own permanent collections as well as changing exhibitions of works of art. Certainly many modern artists create large installations in museums or galleries that involve nontraditional media beyond the forms of painting and sculpture. Some modern art is impermanent, designed to be seen just for a short period of time and perhaps recorded in photographs or on video. And, although many huge sculptures in public places are not portable at all but are designed to stay in one place, generally speaking, we tend to think of works of art as objects which, once they are created by an artist, can travel—be moved around, bought, sold, and exhibited in different spaces. The forms of art to be discussed in this chapter are very different from moveable art. In this chapter we will be considering works of art which are created for specific interior spaces and once created, do not move.

Ancient and Medieval Wall Painting

The art of decorating wall surfaces with permanent paintings has a very ancient history. Through the centuries, a variety of different techniques have been

employed. The most common form of wall painting is known as fresco. Fresco is an Italian word which means "fresh" and refers to painting on freshly plastered wall surfaces. There are two main types of fresco painting: wet and dry. True fresco or *buon fresco* is the wet style. The true fresco technique essentially involves painting rapidly and directly onto sections of moist plaster as the plaster is applied to a wall surface. The painting, when dry, is thus "in" the wall rather than "on" the surface of the wall. True fresco is extremely durable and fixed permanently into the wall to which it is applied. Dry fresco or *fresco secco* is a very similar technique except that the painting is done on the wall after the plaster surface has dried. *Fresco secco* is less durable than true fresco. Sometimes the two techniques are combined and details *al secco* will be added to a wall otherwise painted in true fresco. Fresco painting can also be done on plaster which has been wetted but is not freshly applied. Although the term fresco is often used for all of these various techniques, strictly speaking, only wet fresco is really true fresco. So, the more general terms "wall painting" or "mural painting" are altogether more convenient and accurate to describe this form of art.

The ancient Egyptians, Etruscans, Greeks, and Romans were all great masters of mural painting. The Egyptians and Etruscans decorated the interiors of their tombs with vast areas of painted wall surfaces. Ancient Greek palaces were enriched with painted interiors, and the Romans were extremely fond of wall painting as well. Many private homes and public places throughout the Roman world were enriched with painted walls. Various decorative patterns, landscape scenes, architectural forms, and mythological scenes were especially popular during different periods of Roman history and one can follow the history of Roman wall painting through a distinct series of style phases.

When Christianity developed in the late Roman empire, early Christian artists naturally adopted the Roman wall painting techniques for their own purposes—at first to adorn Christian burial places in the catacombs, following the Roman tradition—and later in the enrichment of early churches and worship spaces. Obviously, the painted subjects and symbols used for Christian religious purposes ultimately developed and expanded beyond the typical themes popular in Roman wall painting, but the techniques used remained the same.

By the time we reach the medieval era, the fashion of painting the walls of various types of structures had a long history already and many artists throughout the medieval period continued to be engaged with this form of art. A great many examples of medieval wall painting survive today—although only a tiny fraction of the original amount. In fact, it may be the case that "of all the medieval arts, mural painting has suffered the greatest losses."[1] Changes in taste and the level of appreciation for medieval wall painting in later centuries have resulted in many losses and cover-ups and repaintings of these wall surfaces. When buildings were remodeled (as they often were, even during the medieval period itself) wall paintings were often destroyed. Many medieval wall paintings have faded as well, so they appear today far less brilliant than they were originally. "Natural deterioration, accidental or deliberate demolition, redecoration, and finally unsuitable methods of restoration, have all contributed to the loss of

about 98 or 99 per cent of the original material."[2] In spite of all these losses and problems with deterioration, there still exist a significant number of fragments as well as impressively preserved cycles of medieval wall painting. In the Middle Ages, wall paintings "were an essential part of the furbishing of any new or newly rebuilt church, and a feature of any overall scheme of internal decoration."[3] Wall paintings were of course extremely popular in medieval secular buildings as well—especially fine homes, palaces, and public buildings, although much less secular wall painting has survived in comparison to wall paintings created for medieval religious buildings.

Undertaking a study of medieval wall painting, however, involves some of the very same challenges as are encountered in other areas of medieval art. In spite of the fact that during the Middle Ages, "virtually all the churches of the West were decorated with wall paintings . . . that thousands of wall painters were active . . . only about a score are known by name."[4] So, we cannot approach the study of medieval wall painting in terms of the achievements and styles of individual artists, as we might do with the study of wall painting during the Renaissance period. For the medieval era, the named artists—and the works which can be securely attributed to them—are really greatly outweighed by the copious anonymous productions. This is typical of medieval art in general. And, even when the names of wall painters are known, there is often very little additional evidence about their careers and biographies. It appears that many medieval wall painters were itinerant artists; they moved from place to place and commission to commission either as individuals or as teams. Some wall painters were monks, although the majority certainly were not. Most wall painters were men, but there are also scattered literary and documentary references that may indicate female wall painters.

Given the scanty evidence on specific individuals, it is more customary and useful to approach the study of medieval wall painting in terms of historical periods, countries, and regions. There are elements of style which are shared by many regions at the same time, as well as characteristic features and styles which can be seen in particular regions at specific time periods. There are also style features which seem to travel (with traveling artists?) as well as details unique to specific areas. Also, there are subjects that became especially popular at different periods and in different places.

In spite of the many losses, there are still so many medieval wall paintings which survive in thousands of churches throughout Europe and Scandinavia, it is impossible to identify a typical example even for each region and time period. In general, many Spanish medieval wall paintings are notably brightly colored and have a strong sense of dark outlines. There are several distinctive styles in French wall painting of the twelfth century and, as throughout most of the rest of Europe, some of these styles appear to have been extremely influenced by slightly earlier and contemporary Byzantine art. The art of wall painting was extremely popular in the Byzantine world also through the Middle Ages, and Byzantine artists traveled to and worked in Europe at various times. Wall painting styles in Italy were very influenced by Byzantine art.

Particular symbols and subjects can be traceable to Byzantine influence as well. In other cases, regions exhibit their own local preferences in terms of subjects and symbols. In later medieval England, for example, paintings of the Last Judgment and end of time (or "Doom" paintings) became especially popular in churches as well as large pictures of Saint Christopher, the patron saint of safe journeys. Some saints are only depicted in some regions, others are commonly found all throughout Europe.

Some medieval wall paintings are so fragmentary and faded it is difficult to see what they represent at all. Other cycles of paintings are far more impressive and much better preserved.

Cycles of Significance

One of the most impressive displays of medieval mural paintings can be seen in the church of Saint-Savin-sur-Gartempe in central France. Produced around 1100, this cycle has been described as "the pinnacle of French wall painting"[5] for the Romanesque period, and "artistically and iconographically the most important Romanesque mural paintings in France."[6]

Upon entering the substantial structure, one understands immediately why this church is so famous for its mural paintings. There are paintings everywhere in the building. There are paintings in the entrance area (western porch, or narthex) and in the crypt (basement). The entire length and width of the round-arched (barrel-vaulted) ceiling of the nave of the church is covered with painting as well. Originally there were even more paintings in the church; some sections have been damaged and lost. Even so, one receives an overwhelming impression of pictures after pictures of holy people, significant religious events and concepts, drama, and mystery. Apart from being impressed with the sheer extent of the painting, one is also inspired to want to read and understand these paintings—they are not mysterious in the sense of being unclear, illegible, or unrecognizable at all. Even a most basic familiarity with the Hebrew and Christian scriptures allows one to immediately recognize particular scenes. One can pick out, on the ceiling: Adam and Eve, Noah's Ark, the Tower of Babel, Moses and the Israelites crossing the Red Sea, and so on. Indeed, these scenes were intended to be read visually and we can assume that viewers of these paintings in the medieval era as well would have been quickly able to decipher the major portions of the visual narratives. These paintings are not decorative by any means at all; they are excellent examples of the instructional and inspirational functions of religious art in the Middle Ages.

The paintings on the nave vault at Saint-Savin-sur-Gartempe are arranged in four horizontal registers running the length of the ceiling. Altogether there are thirty-six biblical scenes depicted—from God's creation of the universe to the episode of Moses receiving the Ten Commandments. The frieze-like composition—in narrative "strips"—has been compared to slightly earlier wall hangings, such as the Bayeux Tapestry (see chapter 9). The figures are lively, legible,

and clear. "They have small heads, prominent, almond-shaped bellies, and spindle legs. All alike seem possessed with a curious agitation, gesticulating and swinging around rapidly, their legs crossed and the extremities of their garments billowing around them as they turn."[7] Minimal landscape and architectural elements are included in several of the scenes, but no excess details detract from the narrative clarity. Like Michelangelo's much more famous painted ceiling of the Sistine Chapel in Rome, four hundred years later, these scenes were meant to be viewed from floor level (without modern binoculars—which do help, in both cases!) and certainly were carefully studied by medieval churchgoers as well as by modern viewers.

The church of Saint-Savin with its barrel-vaulted ceiling and long nave is similar, in general terms, to many other Romanesque churches. The architecture

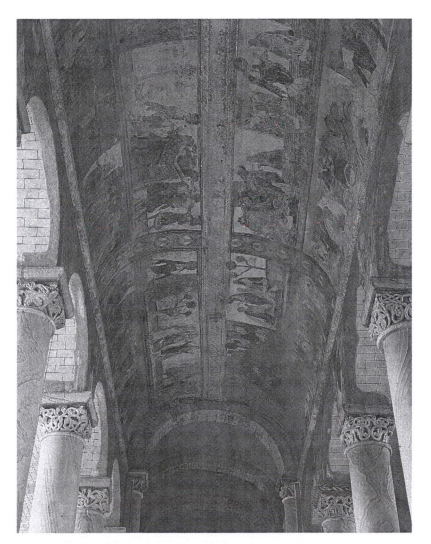

The abbey church of Saint-Savin-sur-Gartempe, France, c1100, nave ceiling. (The Art Archive/Dagli Orti)

here, however, also exhibits a distinctive regional variation on the Romanesque style. Saint-Savin is termed a "hall church" due to the fact that, unlike Romanesque buildings elsewhere where the nave walls may have a series of different levels, the interior of Saint-Savin exhibits an impressive set of massive columns which run from the floor to the vaulting of the ceiling. Although a basilica style structure—with a typically long horizontal emphasis toward the high altar at the east end of the church—the "hall" type structure of Saint-Savin with the huge columns running from floor to ceiling also effectively forces the eye upwards—to the extensively painted ceiling.

Like many other Romanesque churches, Saint-Savin also has a narthex, or entrance area. Visitors to the church first pass through this entrance area before reaching the main body of the church. The narthex at Saint-Savin is also enriched with wall paintings. The scenes shown here are from the Apocalypse or the Book of Revelation, the last book of the Christian Bible. Depictions of scenes from the Apocalypse were extremely popular in the medieval era. This biblical book contains descriptions of the end of time and the Last Judgment and, although some of the subjects from this complex text may be mysterious and less familiar to modern viewers, the religious concepts as well as the pictorial traditions of apocalyptic illustration were doubtless quite familiar to medieval viewers. The entrance portals of many Romanesque churches were also often enriched with sculptures depicting scenes from the Apocalypse (see chapter 1).

Typical of most medieval churches as well, Saint-Savin was dedicated to a specific holy figure whose relics (physical remains of a variety of sorts) were preserved somewhere in the building. In this case, the church was dedicated to two brothers, Savin and Cyprianus. According to the traditions, these brothers were fifth-century Christian martyrs (saints killed for their refusal to give up their Christian beliefs) who underwent a whole series of horrifying tortures before being decapitated. The gruesome episodes of the lives and deaths of Saints Savin and Cyprianus are depicted in a series of mural paintings found in the crypt of the church. This basement room is small and low and the painted scenes here are also on the barrel-vaulted ceiling.

Scholars have often remarked that the painting style and the colors used for the crypt murals in Saint-Savin seem to be different from the painting elsewhere in the church. These scenes are more detailed and busy than the nave ceiling murals and use many more dark shades of blue and green versus the dominant earth tones (reds, browns) used in the nave ceiling. The ceiling murals have faded in any case. Scholars have suggested that perhaps different painters worked on the murals in various areas of the church, perhaps at different time periods.

It has also been suggested by scholars that all sections of the wall painting in this church were inspired by illustrations in slightly earlier manuscripts. Perhaps the team (or teams?) of artists working here had access to an illustrated manuscript of the Bible, or an illustrated manuscript of a saint's life, to assist them in creating their extensive program of pictures. It was extremely common in the medieval era for artists to follow and copy from other works. This was

not due to a lack of personal creativity on the part of medieval artists generally, but a desire to "get it right" by following the traditions. Copying from previous examples was one way to do this. Unfortunately, however, no manuscripts survive which have the exact same set of illustrations for any major portion of the murals at the church of Saint-Savin-sur-Gartempe, nor do we know the names of any artists who worked there. The paintings are unsigned, the artists are unknown, and their sources are unclear.

What we can say with some certainty, however, is that the style of the paintings at Saint-Savin indicates very little influence of Byzantine painting style which, at this point elsewhere in Europe, was being reflected in a great number of other examples. The many figures depicted in the scenes in the murals at Saint-Savin and the overall composition of the scenes are quite different from the contemporary paintings elsewhere in Europe which reflect Byzantine style in drapery patterns, composition, and subject matter. Although perhaps not as up to date with the newest style trends, and more regional and conservative in character, the paintings at Saint-Savin-sur-Gartempe were extremely influential in their own right (other wall paintings in France reflect the influence of the Saint-Savin style) and were certainly highly successful in their role and function of conveying clear biblical narratives to the medieval audience.

Illuminating Mosaics

Like medieval wall painting, the art of creating mosaics has a very ancient history. Mosaics are made from bits and pieces of various materials: stones, pebbles, ceramic, marble, and glass. These mosaic bits, regardless of material, are generically called tesserae. Mosaics can be created of tesserae on floors, walls, or other surfaces. Just about any surface can hold a mosaic as the tesserae are firmly placed and embedded in a variety of plaster or cement-like substances to hold them in place. In broadest definition, "a mosaic is a coherent pattern or image in which each component element is built up from small regular or irregular pieces of substances such as stone, glass or ceramic, held in place by plaster, entirely or predominantly covering a plane or curved surface, even a three-dimensional shape, and normally integrated with its architectural context."[8]

Just as with wall painting, the art of mosaic was adopted and adapted in the medieval era for new purposes. Mosaic floor pavements were very popular with the ancient Greeks and Romans in particular. During the classical period, floor mosaics were naturally made of materials that one could walk upon—durable materials such as stones, pebbles, and ceramic. The Romans especially excelled in the art of mosaic—creating vast floors in private homes and public buildings with carefully placed tesserae. Depending upon the size of the cubes or bits—and depending upon the taste of the time period—Roman mosaics are more or less detailed. Purely decorative patterns are found in black and white cubes of marble; more detailed scenes were created in smaller pieces of various colors.

Some later Roman mosaics almost resemble paintings in their details, achieved from using tiny tesserae and a wide range of different colors.

Although there are examples of wall mosaics as well as mosaic pavements from the classical period also, it appears that the art of mosaic was more or less reinvented in the early Christian period when mosaics began to be more frequently moved up onto wall (versus pavement) surfaces and used as decorations for the interiors of churches. Clearly, less durable materials were then required as these mosaic walls were not designed to be walked upon. It was perhaps due to the religious context and the sacred nature of the subjects and symbols required in church interiors which signaled the shift. In other words, it was deemed inappropriate to have people walking on top of holy images. Indeed, a Byzantine imperial edict of 527 "forbade the use of sacred symbols in pavements in the Eastern Empire."[9] And certainly by this period in western Europe as well, "the rise of the large mosaic from floor to ceiling was complete."[10]

The medieval era has been called "the Golden Age of mosaic."[11] Like the wall paintings in medieval churches, medieval church mosaics were not portable art forms. These works of art were also designed for specific spaces and places, and show much the same development in subject matter and different styles as do medieval religious wall paintings.

Some of the most impressive examples of early medieval mosaics date from the fifth and sixth century and are found in several religious buildings in the city of Ravenna in northern Italy, for example, in the churches of San Vitale, Sant'Apollinare in Classe, and Sant'Apollinare Nuovo. A number of the anonymous artists working in Ravenna in this period probably came from Byzantium. They might have learned their art in the city of Constantinople. Indeed, throughout the medieval period, the art of mosaic was especially popular in the Byzantine world and the high quality Byzantine mosaics were widely imitated and highly influential on the development of Islamic art as well.

Again, these Christian wall mosaics differ from their classical ancestors in being constructed of different materials. Not meant to be walked upon, these mosaics are made of glass tesserae, many coated with real gold. A much wider range of colors was now possible as well with the use of colored glass tesserae and, because these surfaces were not to be walked upon, they did not need to be smooth and flat. Thus it became customary to tilt the tesserae at slightly different angles, so that each individual piece "catches and reflects light in a way calculated by the mosaicist, making the faceted surface glisten and glimmer like the starry sky."[12] These golden and glowing mosaics are absolutely breathtaking and the depictions of holy figures and religious scenes appear to be shimmering in heavenly realms.

The beauty and inspirational effectiveness of mosaic art for the interior walls of religious structures continued to be recognized and developed through the medieval period in both western Europe and Byzantium. The procedures and methods of medieval mosaic art were, in fact, quite similar to the processes involved with mural painting—especially of the true fresco technique. In both cases, artists worked on their wall compositions from top to bottom—either

placing the mosaic cubes into the sections of moist fresh plaster or painting into the plaster in sections before it dried.[13]

Although these two forms of wall decoration are related in some senses, it is obvious also that mosaic is a more complex technique and involves costlier materials than mural painting. Mural painting was less expensive altogether and so a far greater number of medieval churches were painted than were ever enriched with mosaic decoration. Many impressive programs of medieval mosaics do survive, especially in Byzantine-influenced Italy and Sicily through the late Gothic period, but wall paintings are far more common.

In many ways, however, mosaics far better suited "the taste of the Middle Ages for the translucent and the coloristic"[14] and were "associated in the West with ideas of power and splendour."[15] The nature of the materials and the glorious effects were ideally suited for conveying awesome and inspirational religious and political messages. The medieval taste for elaborate and glowing art is also reflected in the many magnificent objects of metalwork created for church interiors (see chapter 2) as well as, perhaps most effectively of all, in the art of stained glass.

Painting with Light

Apart from medieval wall paintings and mosaics—more or less permanently affixed to their architectural structures—another form of wall decoration became exceedingly popular especially during the Gothic period. This, of course, is stained glass. Many people think of stained glass as one of the most characteristic and impressive forms of medieval art—and the impact of visiting a Gothic cathedral enriched with glowing, colored windows is certainly a uniquely moving experience, as it was designed to be!

Like wall painting and mosaic, the art of glassmaking also has a very ancient history. Glass objects, such as vessels and beads, were produced in ancient Egypt and were popular in the ancient Roman world as well. The creation of large-scale windows of glass does not really begin, however, until later in the medieval era when the technical advances in stone architectural construction brought about by the use of pointed arches, rib vaults, and flying buttresses allowed for the opening up of the previously thick and supportive wall surfaces into window zones (see chapter 4). This change from the Romanesque to the Gothic architectural style happened gradually, but beginning in the twelfth century it became increasingly customary to include stained glass windows in any major church or cathedral.

Although the shimmering mosaics of glass and gold tesserae described above rely to a great extent upon lighting conditions for their gorgeous effects, stained glass is an art form which completely depends upon natural light to be fully appreciated. In that sense, the art of stained glass could truly be described as "painting with light."

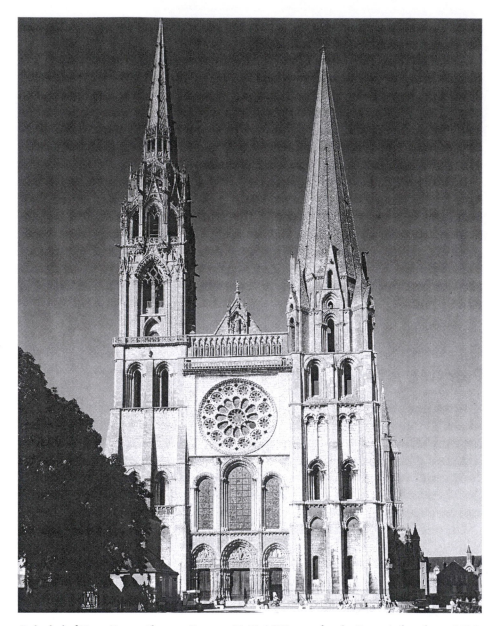

Cathedral of Notre Dame, Chartres, France, c1145–1170, west façade. Rose window dates c1216. (The Art Archive/Dagli Orti)

Stained glass windows are constructed from pieces of colored glass which are carefully held together by I-shaped strips of lead, known as *cames*. Stained glass windows are thus not unlike mosaics, in that they are made of a variety of separate pieces placed together to form a design. The idea of putting pieces of glass together in a metal framework is also not unlike the techniques of enamel work practiced in the Middle Ages as well (see chapter 2). But stained glass is ulti-

mately extremely different from either mosaic or enamel work and "is technically perhaps the greatest of all the contributions made by the Middle Ages to the pictorial arts."[16] Stained glass windows are also held in place by stone frameworks which help to support the sections of leaded glass panels. Details, such as faces and drapery patterns, were also painted with special enamel paints onto the glass pieces during the assembly process. Thus, stained glass is an art form which really combines piecing (like mosaics) and painting (like murals).

Very few examples of stained glass survive from the early Middle Ages, but the art form was certainly known and practiced—doubtless on a limited scale—before the twelfth century. The monastic author Theophilus, in his early-twelfth-century how-to-do-art manual (see chapter 5), devotes a great many chapters to a description of glassworking, including the creation of stained glass windows. The process was complex and costly, which may also explain why stained glass was not more widely produced before the twelfth century, a "time of affluence . . . in limited centres of wealth."[17] Theophilus's treatise is typically detailed in describing the materials and methods involved with creating stained glass. The basic processes involved in the medieval period are actually much the same as they still are today when, beginning in the nineteenth century, the art of stained glass has undergone a modern revival.

Stained glass windows in medieval churches appear in a variety of different forms and locations depending upon the date of the structure. Typically, the use of the pointed arch in Gothic construction resulted in windows with pointed arch shapes. These are known as lancet windows. Lancets may appear singly, or in pairs, or in other groupings. An amazing variety of combinations developed during the medieval period.[18] For example, a pair of lancets may be topped off by a circular window. Circle-shaped windows are extremely often found in medieval cathedrals and a development in formats can be traced from small examples in the twelfth century to the magnificent "rose windows" of the thirteenth and fourteenth centuries.[19]

As the Gothic style evolved, the shape, size, and scale of stained glass windows became increasingly elaborate and complex. The amount of wall space given over to stained glass windows increased. Some buildings, such as the Sainte-Chapelle in Paris, created in the mid-thirteenth-century French rayonnant (radiant/radiating) style, appear to be made almost completely out of glass. Standing inside such a building gives one the impression of being within a glittering, ethereal realm—a miraculous and heavenly space. It has been said that "what most Gothic cathedral planners were aiming for [was] a new vision of space."[20] Stained glass windows were a most effective means of achieving this goal, as many authors from the medieval to the modern period have remarked.

One of the finest places to study medieval stained glass is the French Gothic cathedral of Notre Dame at Chartres. Like many medieval cathedrals, the construction of Chartres took place over several centuries.[21] The very first church on the site was actually built in the fourth century. This was followed by a series of larger structures in the tenth and eleventh centuries; the foundations of the eleventh-century church were incorporated into later structures. A series of

fires, notably in the early and later twelfth century, required successive rebuilding of sections of the church. Parts of the church, notably portions of the west front, date to the middle of the twelfth century, while most of the building was destroyed in an especially dramatic fire in 1194. Work on the rebuilding of Chartres Cathedral progressed well into the first several decades of the thirteenth century during a notably flourishing period for the evolution of Gothic architectural forms, known as the High Gothic.

The vast number of stained glass windows which survive at Chartres is truly remarkable. Originally there were 186 windows in Chartres Cathedral with stained glass; 152 magnificent windows can still be seen there today.[22] These windows, as well as the impressive sculptures on the west front and two side (transept) entrances to the church, are of dates ranging from the middle of the twelfth to the middle of the thirteenth century. Chartres, "the one cathedral where the stained glass has survived nearly in its entirety,"[23] has been described as a "celestial city,"[24] and has captured the imagination of visitors for centuries.[25] Art historians write in very glowing terms about the windows and their effect at Chartres: "The deep colors—perhaps the most intense colors ever achieved in art—constantly change our perceptions of space and the visibility of the parts. The nave becomes a diaphanous, shimmering, structural web wrapped in veils of color that seem to float in layers."[26] Another contemporary art historian writes, "Resplendent blue and red glass fills most of the expanse of the walls and diffuses the light, producing in the relatively dark interior a warm purplish glow in which puddles of colored light further dematerialize supports and walls."[27] Writing in 1904, the author Henry Adams was so moved by the glorious windows of Chartres Cathedral he said that it was possible to become "a little incoherent in talking about it."[28]

The windows on the lower section of the west facade of Chartres are the earliest, probably dating to about 1150, though it should be noted that these windows were damaged in the fire of 1194 and significant sections of the glass have been replaced and restored. Even so, these three western lancet windows are an excellent introduction to the styles and subjects shown in medieval stained glass windows. Filled with scenes related to the lives of Christ and Mary—like the subjects found in medieval mosaics and wall paintings—these windows were designed to teach as well as to inspire. Progressing further into the church, viewers gaze upwards at a vast series of tall lancet windows filled with standing figures of saints. The lower side areas of the cathedral show windows filled with further biblical scenes and episodes from the lives of saints. Apart from these subjects, many of the windows include references to the people or civic groups who paid for the individual windows, such as the furriers (dealers in fur) shown at the base of the window depicting events in the life of the Carolingian emperor Charlemagne.[29] Other civic groups, or guilds, represented in the windows at Chartres include the bakers, weavers, goldsmiths, and carpenters.

The two great rose windows on the north and south transepts, for which "wealthy royalty provided the funds,"[30] are magnificent and complex jewel-like forms that appear to float in the heavens. These windows date to the 1220s and

1230s and show "a much higher proportion of glass to stone"[31] than the rose window on the west front of the building which dates to c1216. The geometric complexity of these later windows is especially impressive. The north rose window—often called the "Rose de France"—is composed of a multitude of sections showing individual biblical figures arranged in concentric rings surrounding the image of the Virgin and Child. "The sixteen primary and thirty-two secondary divisions of the rose are further divided by the ironwork to give nearly 700 panels made up of an estimated 50,000 pieces of glass. . . . [T]he underlying geometry is as spectacular as the window itself."[32] The south transept rose illustrates scenes from the Last Judgment, a subject frequently found in medieval religious art.

The complexity and size of these later windows at Chartres is indicative of the trend which continued to be pursued in stained glass through the subsequent centuries of the medieval period. The desire to build ever taller and lighter buildings filled with huge expanses of windows did, however, reach some dramatic limits. For example, the late-thirteenth-century French cathedral of Beauvais, "which would have been the ultimate Rayonnant cathedral . . . finally exceeded the structural requirements of the Gothic building."[33] The vaults collapsed in 1284 and although repairs were made, the building as it stands today represents a highly truncated version of what was originally visualized for this cathedral.

The Artists

All of the many different artists who worked on the great medieval cathedrals—including those involved with the creation of stained glass windows—remain largely anonymous. A great deal of teamwork was involved, and "there is much evidence throughout medieval artistic production to suggest that artists were accustomed to collaborate and that artistic skills were interdependent."[34] This would surely be the case with the large-scale and expansive programs of church decoration such as were involved with the creation of murals, mosaics, and stained glass windows. Although Suger (1081–1151), the famous abbot of the monastery of Saint Denis in the middle of the twelfth century, wrote extremely detailed accounts of the building programs undertaken there under his direction, and was especially enthusiastic about his stained glass windows, he does not mention a single artist by name. He writes only that he enlisted "the best painters" he could find and "many masters from different regions."[35] He does not give any more specific information about these artists as individuals. Although there are, in fact, quite a number of references to wall painters and stained glass artists scattered through various medieval documents,[36] the information is hardly adequate to construct biographies of any of these people. This situation, of course, changes with artists working in the late medieval/early Renaissance period, especially with those Italian artists who the Renaissance author Vasari chose to include in his biographical chapters on Italian art, such

as the great fresco painter Giotto (1267–1337). More information also exists about later medieval artists who were employed at the courts of wealthy royal patrons.

The wall paintings, mosaics, and stained glass produced in the earlier medieval period are more customarily discussed by art historians in terms of workshops. "The Chartres glass workshops were especially renowned," we learn.[37] Detailed studies of the stained glass at particular locations may reveal the individual style traits of specific artists. The contributions and collaborations of several distinct artists who worked on the stained glass windows at Saint Denis during the time of Abbot Suger have been identified.[38] Documentary and stylistic evidence certainly also supports the notion that teams of artists as well as individuals traveled from job to job in the medieval period, as witness Suger's statement about hiring "many" artists from "different regions." The work of specific individuals as well as those working in changing teams of collaborators can, in some cases, be traced from place to place. That we know so little about these often highly sought-after medieval mural painters, mosaic artists, and stained glass creators provides, in some ways, a wonderfully ironic contrast to the immobile masterworks and "glorious visions"[39] they have left behind.

Notes

1. Otto Demus, *Romanesque Mural Painting* (New York: Harry N. Abrams, 1970), 7.

2. Demus, 65.

3. C. R. Dodwell, *The Pictorial Arts of the West: 800–1200* (New Haven, Conn.: Yale Univerity Press, 1993), 36.

4. Dodwell, 36.

5. Dodwell, 233.

6. Demus, 420.

7. André Grabar and Carl Nordenfalk, *Romanesque Painting from the Eleventh to the Thirteenth Century* (Lausanne: Skira, 1958), 92.

8. Peter Fischer, *Mosaic: History and Technique* (New York: McGraw-Hill, 1971), 7–8.

9. Fischer, 69.

10. Fischer, 70.

11. Fischer, 69.

12. Fischer, 71.

13. Paul Binski, *Painters* (Toronto: University of Toronto Press, 1991), 62.

14. Dodwell, 159.

15. Dodwell, 159.

16. Dodwell, 375.

17. Dodwell, 375.

18. See the very useful line drawings in Yves Christie, Tania Velmans, Hanna Losowska, and Roland Recht, *Art of the Christian World A.D. 200–1500: A Handbook of Styles and Forms* (New York: Rizzoli, 1982).

19. Painton Cowan, *Rose Windows* (London: Thames and Hudson, 1979).

20. Michael Camille, *Gothic Art: Glorious Visions* (New York: Harry N. Abrams, 1996), 27.

21. John James, *Chartres: The Masons Who Built a Legend* (London: Routledge and Kegan Paul, 1982).

22. James Snyder, *Medieval Art: Painting, Sculpture, Architecture, Fourth through Fourteenth Century* (New York: Harry N. Abrams, 1989), 372.

23. Snyder, 371.

24. Camille, 41.

25. See the texts included in Robert Branner, ed., *Chartres Cathedral* (New York: Norton, 1969).

26. Snyder, 371.

27. Robert Calkins, *Medieval Architecture in Western Europe from A.D. 300 to 1500* (New York: Oxford University Press, 1998), 204.

28. Branner, 235.

29. Leslie Ross, "Reading Medieval Art," in *The Thread of Ariadne,* ed. P. Umphrey, (Fort Bragg, Calif.: Q.E.D. Press, 1988), 105–125.

30. Snyder, 373.

31. Cowan, 35.

32. Cowan, 135.

33. Calkins, 241.

34. Veronica Sekules, *Medieval Art* (Oxford: Oxford University Press, 2001), 49.

35. Dodwell, 39.

36. See Dodwell, 37–40.

37. Snyder, 371.

38. Michael Cothran, "Suger's Stained Glass Masters and Their Workshop at Saint-Denis," in *Paris: Center of Artistic Enlightenment,* eds. George Mauner, Jeanne Porter, Elizabeth Smith, and Susan Munshower (University Park: Pennsylvania State University Press, 1988), 46–75.

39. Camille, *Gothic Art: Glorious Visions.*

Bibliography

Armitage, E. Liddall. *Stained Glass: History, Technology and Practice.* Newton, Mass.: Charles T. Branford, 1959.

Binski, Paul. *Painters.* Toronto: University of Toronto Press, 1991.

Branner, Robert, ed. *Chartres Cathedral.* New York: Norton, 1969.

Calkins, Robert. *Medieval Architecture in Western Europe from A.D. 300 to 1500.* New York: Oxford University Press, 1998.

Camille, Michael. *Gothic Art: Glorious Visions.* New York: Harry N. Abrams, 1996.

Christie, Yves, Tania Velmans, Hanna Losowska, and Roland Recht. *Art of the Christian World A.D. 200–1500: A Handbook of Styles and Forms.* New York: Rizzoli, 1982.

Cothran, Michael. "Suger's Stained Glass Masters and Their Workshop at Saint-Denis." In *Paris: Center of Artistic Enlightenment,* edited by George Mauner, Jeanne Porter, Elizabeth Smith, and Susan Munshower. University Park: Pennsylvania State University Press, 1988.

Cowan, Painton. *Rose Windows.* London: Thames and Hudson, 1979.

Demus, Otto. *Romanesque Mural Painting.* New York: Harry N. Abrams, 1970.

Dodwell, C. R. *The Pictorial Arts of the West: 800–1200.* New Haven, Conn.: Yale University Press, 1993.

Fischer, Peter. *Mosaic: History and Technique.* New York: McGraw-Hill, 1971.

Grabar, André, and Carl Nordenfalk. *Romanesque Painting from the Eleventh to the Thirteenth Century.* Lausanne: Skira, 1958.

Grodecki, L., and C. Brisac. *Gothic Stained Glass: 1200–1300.* Ithaca, N.Y.: Cornell University Press, 1985.

James, John. *Chartres: The Masons Who Built a Legend.* London: Routledge and Kegan Paul, 1982.

Ross, Leslie. "Reading Medieval Art." In *The Thread of Ariadne,* edited by P. Umphrey. Fort Bragg, Calif.: Q.E.D. Press, 1988.

Sekules, Veronica. *Medieval Art.* Oxford: Oxford University Press, 2001.

Snyder, James. *Medieval Art: Painting, Sculpture, Architecture, Fourth through Fourteenth Century.* New York: Harry N. Abrams, 1989.

CHAPTER 7

The Panel Painters: Duccio and Company

The Celebration

At noontime on June 9, 1311, the people of the city of Siena in Italy turned out for an important and festive event. The huge new altarpiece for the cathedral of Siena, which had been created by the painter Duccio di Buoninsegna (c1255–1319), was carried through the streets of the city in a grand procession from the artist's studio and placed on the high altar of the cathedral. Documents record that the bishop, all the clergy, monks, nuns, city officials, and important citizens of the town participated in this parade. Bells were rung; shops were closed all day; alms were given to the poor; many speeches were made; and many prayers were offered. Clearly, the completion and installation of this altarpiece in the cathedral of Siena was a very big event for the city. The sense of joy and devotion that is described in the documents is truly impressive!

This great altarpiece, which originally measured slightly over sixteen feet high and fifteen feet wide, is known as the *Maestà*. This is an Italian term for "majesty" and refers to images of Mary and the infant Jesus enthroned and surrounded by saints and angels. Versions of this subject matter had been created by earlier artists, but Duccio's is especially notable in terms of its large size and complexity. It is painted on both sides and, when positioned on the high altar of the cathedral, the front side, depicting the seated Virgin and Child accompanied by saints and angels, would have been viewed by the congregation attending religious ceremonies. The back side, which shows a series of scenes from the Bible, would have been seen largely by members of the clergy seated in the choir area behind the high altar. Duccio's altarpiece was created to replace an earlier, smaller, but extremely revered painting of the Virgin Mary. His new altarpiece was designed specifically for this position in the cathedral and Duccio received this commission directly from the cathedral authorities (the Opera dell' Duomo) in 1308.

Duccio, *Maestà* altarpiece, c1308–1311, back. Museo dell'Opera del Duomo, Siena, Italy. (Scala / Art Resource, NY)

Duccio and the Documents

The original contract for this commission, which Duccio signed on October 9, 1308, specified that the artist would be paid a salary for each day that he worked on the project "with his own hands," that all the materials would be provided for him, and that he should agree "not to accept or receive any other work" until the altarpiece was finished.[1] This was an extremely important commission and we can surmise that Duccio received this job because he was regarded as the leading painter in Siena in the early fourteenth century. Indeed, this commission is considered to be Duccio's masterpiece, "the climax of [his] career."[2] It was produced late in his artistic life, less than ten years before his death which was probably in 1319.

Apart from the documents recording the commission for the *Maestà,* the Sienese archives contain several other records concerning the painter Duccio—not quite enough information to piece together a complete biography of the artist but relatively more information than is the case with a number of other earlier medieval artists. The carefully preserved Sienese civic chronicles and detailed financial archives contain a wealth of information which historians can study and analyze in order to understand and reconstruct medieval life in this flourishing Italian city. Siena enjoyed an especially "long period of peace and prosperity from 1287 to 1344 . . . which found expression in the creation of a beautiful city adorned with the finest art."[3] Duccio's career as an artist thus falls roughly into this extremely prosperous period for his home city. His exact birth date is unknown, but scholars generally agree that he was born around 1255 or 1260. An artist named Duccio is recorded as having received payment for completing some paintings on important book covers and wooden storage chests for the Sienese government in 1278 and 1279. These commissions were given to all the notable Sienese painters and Duccio received these jobs periodically up through 1295.

More interesting, perhaps, are records of several fines (financial penalties of varying amounts) assessed against Duccio for various infractions and offenses in the 1280s and 1290s. He was fined in 1289 for failing to attend an important civic meeting and refusing to swear allegiance to a government official; in 1294 he was fined again for failing to pay off the earlier fines. He also was fined for failing to participate in the civic militia. His refusal "to obey certain ordinances of the city of Siena"[4] throughout his career (there are records of further fines in the first decade of the fourteenth century) may lead one to believe that the painter Duccio was an obstreperous character, "less than a diligent, patient and law-abiding citizen. But one must guard against reading too much into these records. . . . The judicial records are often the best source of information on many artists' lives. But just because their names appear in these ledgers, one cannot automatically assume that they were habitual criminals in the present-day sense of the term."[5]

These records are extremely useful, however, for potentially tracing the moves and travels of a Sienese citizen such as Duccio. There is no record mentioning

him in Siena between 1295 (when he was fined again, and also is mentioned as having served on a committee to select a site for a new public fountain) and 1302, and so scholars have speculated that Duccio might have been away from the city during these years. Perhaps he traveled to Rome and Paris? The Parisian tax records of 1296 and 1297 list an artist who could be "Duccio of Siena" ("Duch de Siene," "Duche le lombart").[6] There are no documents recording that Duccio was ever in Rome but some scholars have based their speculations about this Roman journey on style comparisons and analysis of artistic influences on Duccio—works of art which he might have seen and which influenced his own style and subject matter. One of Duccio's earliest surviving works, the *Rucellai Madonna* (1285) was commissioned by a church in the city of Florence, so it is not at all unlikely that Duccio worked and traveled outside of Siena during his career. Some scholars have also speculated that Duccio may have traveled to France as early in his career as the late 1270s. This speculation is again based on analysis and comparison of some aspects of Duccio's style to contemporary and earlier French Gothic art.

Duccio apparently returned to Siena in 1302. He is mentioned in a document of 1304 in connection with some acreage (a vineyard) which he owned outside the city. This land ownership does not indicate that he was exceptionally wealthy by any means, but he was obviously financially comfortable at this later point in his career. He lived in Siena during the last decade of his life in a house (which also contained his workshop) near the cathedral. This is the period of time during which he received the important commission for the cathedral *Maestà* altarpiece.

Workshops, Guilds, and Artistic Practice

A highly respected master painter such as Duccio, working in Siena in the late thirteenth and early fourteenth century, would not have functioned as a solo artist but would have been in charge of a workshop of other artists. The majority of artists during the Middle Ages functioned and were organized in this way. There were no art schools (in the modern sense) during the medieval era and artists learned their crafts and gained their skills through firsthand experience, by serving as pupils (apprentices) under established masters. It is wise to remember also that during the Middle Ages (and indeed well into the Renaissance period) "the word 'artist' as a generic term was almost never used: a painter was called a painter, a sculptor a sculptor, and so on. They were seen as members of a particular occupation, not, as in our day, as people with a vision and a calling. They had no special title which implied that, either by vocation or inspiration, they were different from any other group of craftsmen."[7] Medieval artist's studios or workshops were often located in specific areas of a city, just as craftspeople in various other fields often congregated in certain city districts.

Shops or studios were overseen by a master who negotiated the contracts and secured the commissions on behalf of the group of other artists (pupils, ap-

prentices, assistants) working under his supervision. "The production of art was, first and foremost, a cooperative venture."[8] In terms of medieval panel painting workshops, there is little evidence to suggest that women were ever engaged in this occupation, although women artists worked in many other media during the Middle Ages (see chapter 9). The workshop master "had the final say on everything that went on in the shop,"[9] and doubtless selected his assistants carefully. Apprentices would usually join a workshop when they were in their early teens or up until their early twenties and they would serve as assistants generally from three to six to eight years. The arrangements were carefully negotiated and it was understood that the ultimate goals of the training an apprentice would receive in a workshop would enable him to eventually become a master himself, set up his own workshop, and take on pupils in turn. This tradition of workshop training was thus extremely beneficial for all concerned. The master artists had the benefit of personally trained assistants to help with the shop's production and the assistants were often given room and board and sometimes even a small salary while they were learning their trade. The various tasks allocated to the beginning and progressively more advanced students would vary, naturally. In the case of panel painting, which involved a whole series of different stages from preparing the wooden panels, grinding the pigments, applying gold leaf, and so on, we assume that workshop pupils would need to acquire and master all the skills required in succession, moving on to increasingly more difficult lessons and tasks.

In many cases, just as with other crafts and trades in the Middle Ages, panel painters came from the same family and relatives naturally carried on the family business. Fathers and sons and/or brothers often formed the core members of a painting workshop. Sometimes master artists worked together, shared workshops, or rented space together. Collaboration was extremely common and the production stages typically involved with the completion of a medieval panel painting involved many hands. Indeed, in the medieval workshop, "the hands of the various assistants were conceived of as extensions of the master's own hand."[10]

The hierarchical and collaborative arrangements of the medieval painting workshop were also reflected and regulated by medieval painters' guilds, just the same as most other professions in the Middle Ages. Guilds were "associations regulating production, sales, demarcation, ethics, etc."[11] Guild membership was required of craftspeople in various professions and "it appears as though membership in the guild was a prerequisite to the execution of any important commission."[12] Guilds supported and protected craftspeople by regulating prices for materials, by setting standards and controls for production quality, and by serving as civic organizations with a voice in local government. "To these protective measures were sometimes added charitable ones: enjoining the visitation of the sick and indigent members by those more fortunate, and also ensuring that members' funerals should be well attended."[13]

Independent guilds for painters developed particularly in the fourteenth and fifteenth centuries. Before this period, painters were often grouped in the guilds of other types of craftspeople and merchants, such as leatherworkers or doctors

and pharmacists. Also, it should be noted that an "important distinction does seem to have emerged at least by about 1300: painters were usually not illuminators."[14] In other words, in the late Gothic period, artists who painted panels (and other three-dimensional objects) and painters who illustrated manuscripts were considered to be engaged in different types of image-making. The various categories of craftspeople and guilds also had different patron saints. The patron saint of panel painters was Saint Luke. The tradition that Saint Luke had painted (or drawn) the very first image—from life—of Mary and the baby Jesus was highly influential on the development of and attitudes toward holy images (icons) in the Byzantine world as well (see chapter 8).

Materials and Methods

We know a great deal about the processes involved with creating medieval panel painting not only through modern scientific analysis of the works of art themselves but also via medieval handbooks which provide directions for artists. Several how-to manuals survive from the medieval era (see chapter 5), and an especially excellent source for Italian medieval and early Renaissance painting in particular is a work that was written by the Florentine painter Cennino Cennini (c1370–1440), *Il Libro dell' Arte* (*The Craftsman's Handbook*).[15] Cennini composed his treatise probably around 1390 and his work includes extremely detailed directions and recipes for all types of painting including fresco painting, panel painting, and painting on statues and other three-dimensional objects. Cennini was a painter himself, although no works of art have been securely attributed to him, and so his guidebook is based on his own practical experience. The short descriptive sections in his book offer advice on everything a medieval painter would want and need to know (in Cennini's opinion) from "how to practice drawing with a pen" to "how to paint various kinds of beards and hair," "how to make batter or flour paste," and "how to gild on panel."

From Cennini's handbook we learn that the materials, methods, and production stages involved with European panel painting in the medieval and early Renaissance periods were, not surprisingly, extremely similar to the processes and procedures involved with the creation of painted panels in the Byzantine east during these centuries and earlier (see chapter 8). Byzantine icons (holy images) were also painted in egg tempera on carefully prepared wooden panels. The creation process involved a painstaking series of stages from selecting the wood for the panels, preparing the panels, making outlines for the design of the painting, and carefully applying the paint in different colors and layers. Although Cennini does write about oil painting in his book, the preferred and traditional painting media for medieval European and Byzantine panel paintings was egg tempera. This is the painting method that Duccio used in creating his *Maestà* altarpiece.

The technique "demands a very organised and systematic approach to painting,"[16] but results in magnificent and extremely durable "enamel-like surfaces

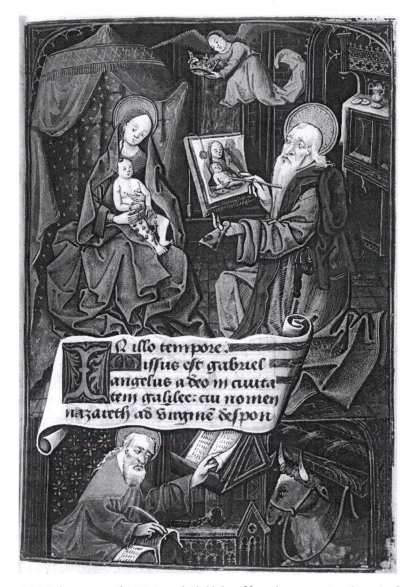

Saint Luke painting the Virgin and Child, late fifteenth-century French Book of Hours. London, British Library MS Add. 20694, folio 14. (By permission of the British Library)

of beautiful texture"[17] which do not fade, change, or darken with age in the same way that oil paintings do. The colors or pigments for egg tempera painting were derived from a variety of different mineral and vegetable substances and late medieval artists probably obtained most of the materials for grinding their colors from apothecaries/pharmacists. Colors were made from, for example, red lead, various earth pigments, ultramarine blue (extracted from semiprecious lapis lazuli), azurite ore (which also creates a blue color), green from various copper ores, and so on. The application of gold leaf onto panel surfaces also involved

painstaking processes. Often panels (especially gilded ones) were decorated by "patterns of incised lines, tooling and ornamental punching,"[18] which created rich and lively surface effects.

The art of panel painting reached especially great heights in fourteenth-century Siena. During this time "Sienese painters were in demand all over central Italy,"[19] especially for their beautiful altarpieces. Altarpieces were produced in copious numbers in the thirteenth and fourteenth century in Italy, although actually only a small percentage survive today from the originally vast output.

Altars and Altarpieces

Duccio's early-fourteenth-century *Maestà* altarpiece for the cathedral of Siena represents not only a generally traditional form of painted panel designed for a religious context but is also reflective of new interests and changing liturgical practices during the medieval era. The *Maestà* was originally placed on top of the high altar in the cathedral. Specifically designed for this position, the altarpiece provided a visual "backdrop," as it were, for the celebration of the Mass. In the early Middle Ages, priests celebrated Mass standing behind the altar of the church and facing the congregation. This practice changed in the thirteenth century and priests were directed to stand in front of the altar with their backs to the congregation through portions of the ritual. Also, "a change in liturgical practice in 1215 required the priest officiating at Mass to hold up the Host high above the altar table to show to the worshipers."[20] In the earlier medieval period, altars were often decorated with painted panels on their lower front sides; these paintings could be seen by the congregation when the priest was positioned behind the altar. When the rituals and practices changed in the thirteenth century and priests began to stand in front of the altar and performed the elevation of the Eucharist, the paintings formerly on the lower level of the altar were essentially "moved up" higher to "serve as a physical framework for the ritual."[21] Hence, altarpieces placed on top of altars become customary in the thirteenth century and increasingly popular in the fourteenth century.

Altarpieces were created in a variety of formats depending upon the space, needs, and financial resources of the commissioners. There are single panels, diptychs, triptychs, and polyptychs (with two, three, or multiple panels). The largest and most magnificent altarpieces, such as Duccio's *Maestà,* often had a lower level of painted panels known as a *predella*, and sometimes additional panels and triangular-shaped gables or pinnacles on the upper level as well.

Duccio's *Maestà*—Then and Now

The huge *Maestà* altarpiece, which the Sienese painter Duccio worked on between 1308 and 1311, originally looked and was positioned very differently than it is today. Now displayed in the cathedral museum in Siena, the altarpiece,

which was carried through the city streets in a great festive procession and placed on the high altar of the cathedral in 1311, has its own later history and trials and tribulations. The "precise original appearance of the altarpiece remains a subject of debate,"[22] to put it mildly.

The problems really began in 1506 when some major renovations were made to the interior of the cathedral. A new high altar was created and the Maestà was moved to a less prominent location in the building. The Maestà had sat atop the high altar of the cathedral for close to 200 years by that time. Tastes do change—is it possible that the style of the old altarpiece was considered to be old-fashioned by that period? In any event, the Maestà appears to have remained in the cathedral for another 250 years or so after that, but in the eighteenth century "fate struck"[23] and the outdated altarpiece was sawn up into several pieces. The back and front sections were separated and the predella and pinnacles were removed. The bits and pieces were then moved around to different locations and eventually the main front and back panels of the altarpiece were placed in two different chapels in the cathedral. Suffice it to say that some of the smaller panels from the front and back predellas and pinnacles got lost in the shuffle in the later eighteenth century. The number of panels that became missing increased in the next several decades. By the late nineteenth century, bits and pieces of Duccio's Maestà were in the hands of several private collectors and these separated panels were eventually purchased or given to various museums in Europe and the United States. Hence today, separate panels from this altarpiece can be found, for example, in London, New York, Washington, D.C., Madrid, and Fort Worth, Texas. Some panels remain completely missing.

In spite of this dismemberment, the majority of sections of the Maestà are still in Siena and, although perhaps not arranged and placed as they were originally when the painting was fresh from Duccio's studio, still give a grand impression of this remarkable creation. The central subject of the front of this altarpiece—"the physical and spiritual center"[24]—is the Virgin Mary. The cathedral and city of Siena were dedicated to Mary in the medieval period and so it was appropriate that she feature so prominently as the focal point for religious devotion. Indeed, throughout Europe at this time "the increasing, and by the early fourteenth century omnipresent cult of the Virgin was . . . one of the central aspects of religious life."[25] Mary is the largest figure depicted on the front of the altarpiece. She is dressed in a magnificent blue robe trimmed with gold edges. Seated on an elaborate throne, as the queen of heaven, she is surrounded by over two dozen beautifully painted saints and angels. Mary supports the baby Jesus tenderly in her lap while they are adored and worshiped by the heavenly crowd surrounding them. As typical with other medieval depictions of saints, many of the figures are identifiable because of what they are wearing or carrying. For example, Saint Agnes carries a lamb and Saint John the Baptist wears a camel-skin robe. The four patron saints of the city of Siena are depicted kneeling in the immediate foreground of the scene.

The closer one gets to the painting the more magnificent and detailed it becomes. The glowing colors and fine details are breathtaking. "The sinuous line

and singing colour harmonies of Duccio's art still speak directly to the eye without the need of words."[26] Apart from the striking blue robe of the Virgin, orange, pink, and red tones dominate alongside carefully placed areas of grey, blue, and green. The punchwork patterns and designs incised in the haloes and gold background shimmer elaborately. In its original position this altarpiece was meant to overwhelm and inspire worshipers. "It was to be seen in a gradual approach: at first only the gigantic figure of the Virgin would be distinct, then more and more wonderful details would, with ever-increasing rapidity, reveal themselves as one approached ever closer to the altar."[27]

Scholars have often remarked on the combination of elegant detail and sense of monumentality conveyed in this work. As mentioned earlier, features of Duccio's painting style have been attributed to his (possible) travels to Paris and Rome. It has been suggested that Duccio derived inspiration from various other earlier and contemporary works of art (sculptures, frescoes, panels, and mosaics) which he might have seen during his travels. Hints of French Gothic elegance, gracefulness, richness, and delicacy coexist here with the solidity and clarity characteristic of the styles of other slightly earlier and contemporary painters and mosaic artists in Italy. Unfortunately, it is impossible to know exactly what Duccio might have seen or exactly which works of art might have inspired him. Many scholars also believe that Duccio was inspired by Byzantine art, that perhaps he had seen examples of earlier and contemporary Byzantine illustrated manuscripts. This suggestion has been made particularly in reference to the extensive series of biblical scenes painted on the back side of the *Maestà*.

Including the pinnacles and *predella* panels, the back side of the *Maestà* consists of a whole series of smaller panels depicting a total of about forty scenes from the life of Jesus. This is an extremely extensive narrative cycle, "without precedent in Italian panel painting."[28] Most of the individual scenes on the back side of the altarpiece measure roughly twenty by twenty-one inches or so. Altogether, this presents a really dazzling display of numerous small figures acting out various biblical episodes which are placed in landscape settings, interiors, and various architectural settings. Duccio's interest in creating convincing architectural spaces is especially notable; the figures "comfortably exist with the architectural structures surrounding them."[29] Some of the buildings look like the medieval structures of the city of Siena itself, buildings which Duccio would have seen every day.

The scene of the crucifixion of Christ occupies the upper-central position on the back of the altar and is larger than most of the other scenes. This panel is full of details and figures. Duccio's ability to convey dramatic emotions is especially notable here, particularly in the depiction of the grief-stricken Virgin Mary who is fainting at the sight of her crucified son. The numerous other scenes on the back of the altarpiece include the Temptation of Christ, the Entry into Jerusalem, the Last Supper, the Agony in the Garden, the Betrayal of Christ by Judas, the Trials of Christ before Herod and Pilate, the Crowning with Thorns, the Mocking, Flagellation, Entombment, and Resurrection of Christ.

Returning to the front side, we should also note that Duccio signed the altarpiece. There is a prominent inscription on the footstool of the Virgin's throne,

right in the center of the lower section of the main panel. Translated from the Latin, the inscription reads: "Holy Mother of God be thou cause of peace for Siena, and, because he painted thee thus, of life for Duccio."[30] An alternate translation is: "Holy Mother of God bestow peace on Siena and salvation on Duccio who painted thee."[31] This inscription is intriguing in a number of ways, as has been pointed out:

> Peace, internal and external peace, the cherished and for the most part endlessly unrealized hope of every Italian city, is the first request. For the artist it is life eternal and, implicitly, eternal fame and recognition that is asked. The very fact of the inscription reflects the beginning of a change in the hopes and aspirations of artists. Increasing self-awareness was accompanied by a growing realization of the artistic values of their creations.[32]

Was Duccio thus solely responsible for all the painting on this huge and magnificent work?

Masters and Pupils—Duccio's School and Followers

The contract that Duccio signed in 1308 for the *Maestà* altarpiece specifically mentions work completed by "his own hand." Most scholars agree that it is highly unlikely that Duccio himself painted all the panels of the *Maestà*—and that the original contract actually specified for him to do so. The contract states that Duccio "is to be paid, and he is only to be paid, for every day on which he works on the panel with his own hand."[33] Because he was an established master of a workshop in Siena in the early fourteenth century—and given the traditions of workshop practice during this period—we can assume that Duccio understood his commission to involve his overall design and supervision of the painting of the altarpiece. Any parts of the altarpiece that he did not paint himself but were painted by his trained assistants were understood to be extensions of his own work. Contracts such as Duccio's "in no way excluded the normal use of workshop assistants."[34] Obviously, "faced, in such a situation, with a work of the scale and complexity of the *Maestà,* and knowing that it was completed in a mere two years and eight months from the signing of the initial contract, and therefore actually painted in a little over two years at the most, it is only reasonable to ask who Duccio's helpers were and to try to find the traces of their activity."[35] Unfortunately, in spite of the many surviving documents in the Sienese archives concerning Duccio, we do not have anything resembling an actual list of Duccio's students at any period during his career. So, scholars remain somewhat uncertain and divided about exactly who—among the several later-named master artists in Siena—were actually students of Duccio.

Among the next generation of Sienese painters who can be considered the followers and heirs of Duccio (and perhaps his actual pupils and collaborators) are Simone Martini (c1280–1344), the Lorenzetti brothers (Ambrogio [fl.

1319–1347] and Pietro [fl. 1320–1344]), Ugolino di Nerio (or Ugolino da Siena [fl. 1295–1339]), and Segna di Bonaventura ([fl. 1298–1331] who seems to have been Duccio's nephew or cousin). Simone Martini and the Lorenzetti brothers in particular achieved great fame. The more or less well-documented careers of this next generation of artists take us into another chapter of Sienese painting and further along into the first half of the fourteenth century before the onslaught of the Black Death (Bubonic Plague) which severely decimated the population of Europe beginning with the first and most severe waves of the epidemic in 1348. The careers of many later Sienese artists (although it appears not those mentioned above) were cut short by this disaster which had extreme social and economic consequences for the later medieval period.

The individual styles of the post-Duccio artists in Siena—their stylistic relationship to, similarities to, and differences from the earlier master Duccio—have been carefully studied and analyzed by many scholarly specialists. Apart from those mentioned above, there are other artists as well who are described as "Ducciesque" painters—indicating the continued influence and inspiration of the early Sienese master. Scholars use terms such as "follower of," "school of," and "workshop of" to describe these often very unclear relationships.

Many of these later artists also created magnificent altarpieces to meet the continued demand for these works through the fourteenth century. However, Duccio's magnificent *Maestà* altarpiece for the cathedral of Siena was never "widely imitated."[36] Was this because it was "quite simply too expensive for most churches"[37] whose financial resources were less than the Opera dell' Duomo of Siena was able to afford in the early fourteenth century to commission the master artist Duccio to undertake this extremely ambitious project? The *Maestà* has been called "the richest and most complex altarpiece to have been created in Italy."[38] The creation of this altarpiece may reflect a very special moment in Sienese medieval history—a period of stability, economic prosperity, and great civic pride—a time "not merely of religious fervour but of quite remarkable civic, social and political ideas."[39]

The importance of this commission, the materials and financial resources involved, the time expended, and the spectacular final results may give us a better understanding now of the festive celebrations and public holiday held in the city of Siena on June 9, 1311, when Duccio's *Maestà* was carried through the streets and placed in its prominent position in the cathedral.

Notes

1. For this contract and other surviving documents concerning Duccio, see James Stubblebine, *Duccio di Buoninsegna and His School* (Princeton: Princeton University Press, 1979), 191–208.

2. John White, *Duccio: Tuscan Art and the Medieval Workshop* (London: Thames and Hudson, 1979), 80.

3. Henk Van Os, *Sienese Altarpieces: 1215–1460,* vol. 1 (Groningen: Bouma's Boekhuis, 1984), 70.

4. Bruce Cole, *Sienese Painting From Its Origins to the Fifteenth Century* (New York: Harper and Row, 1980), 26.

5. Cole, *Sienese Painting,* 26.

6. Stubblebine, 4.

7. Bruce Cole, *The Renaissance Artist at Work* (New York: Harper and Row, 1983), 13.

8. Cole, *Renaissance Artist,* 13.

9. Cole, *Renaissance Artist,* 15.

10. Paul Binski, *Painters* (Toronto: University of Toronto Press, 1991), 19.

11. David Bomford, Jill Dunkerton, Dillian Gordon, and Ashok Roy, *Art in the Making: Italian Painting before 1400* (London: National Gallery, 1989), 6.

12. Cole, *Renaissance Artist,* 20.

13. Andrew Martindale, *The Rise of the Artist in the Middle Ages and Early Renaissance* (New York: McGraw-Hill, 1972), 12.

14. Binski, 15.

15. Cennino Cennini, *The Craftsman's Handbook: "Il Libro dell'Arte,"* trans. D. V. Thompson (New York: Dover, 1960).

16. Bomford et al., 28–29.

17. Daniel V. Thompson, *The Materials of Medieval Painting* (New York: Dover, 1956), 63.

18. Bomford et al., 24.

19. Bomford et al., 2.

20. Bomford et al., 4.

21. Van Os, 13.

22. Bomford et al., 73.

23. Van Os, 43.

24. Cole, *Sienese Painting,* 43.

25. White, 95.

26. White, 119.

27. Stubblebine, 39.

28. Stubblebine, 48.

29. Cole, *Sienese Painting,* 49.

30. Van Os, 54.

31. Cole, *Sienese Painting,* 42.

32. See White, 100.

33. White, 103.

34. White, 103.

35. White, 103.

36. Van Os, 56.

37. Van Os, 56.

38. White, 80.

39. White, 80.

Bibliography

Bellosi, Luciano. *Duccio: The Maestà.* London: Thames and Hudson, 1999.

Binski, Paul. *Painters.* Toronto: University of Toronto Press, 1991.

Bomford, David, Jill Dunkerton, Dillian Gordon, and Ashok Roy. *Art in the Making: Italian Painting before 1400.* London: National Gallery, 1989.

Carli, Enzo. *Sienese Painting.* New York: Scala, 1983.

Cennini, Cennino. *The Craftsman's Handbook: "Il Libro dell'Arte."* Trans. D. V. Thompson. New York: Dover, 1960.

Cole, Bruce. *The Renaissance Artist at Work.* New York: Harper and Row, 1983.

———. *Sienese Painting From Its Origins to the Fifteenth Century.* New York: Harper and Row, 1980.

Martindale, Andrew. *The Rise of the Artist in the Middle Ages and Early Renaissance.* New York: McGraw-Hill, 1972.

Stubblebine, James. *Duccio di Buoninsegna and His School.* Princeton, N.J.: Princeton University Press, 1979.

Thompson, Daniel V. *The Materials of Medieval Painting.* New York: Dover, 1956.

Van Os, Henk. *Sienese Altarpieces: 1215–1460.* Vol. 1. Groningen: Bouma's Boekhuis, 1984. Vol. 2. Groningen: Egbert Forsten, 1990.

White, John. *The Birth and Rebirth of Pictorial Space.* Cambridge, Mass: Harvard University Press, 1987.

———. *Duccio: Tuscan Art and the Medieval Workshop.* London: Thames and Hudson, 1979.

The Icon Painter: Andrei Rublev

Icons: History and Background

Most of the chapters in this book focus on western European art and architecture during the Middle Ages. When concentrating on the art of one particular area (even a large one) and one particular time period (even a lengthy one), it is always important to keep in mind that art and architecture were also being produced elsewhere in the world. Quite often, these different art forms were very influential on each other, and awareness of these cross-cultural influences and interchanges adds a great richness to our understanding of art history. Although the very important monuments and contributions to the history of art made by artists and civilizations in Asia and the Americas during the western Middle Ages are not covered in this book, this chapter will focus on a particular type of art characteristic of the Byzantine east which had, in fact, a great deal of influence on the development of western medieval and Renaissance art.

The art form in question here is the icon. Icon is a Greek word (*eikon*) that simply means "image." More specifically, however, the term "icon" is used to describe "holy images," for example, pictures of saints, angels, and important persons from the Christian scriptures like Jesus and Mary. Icons (pictures of holy persons) can exist in a variety of different forms and media ranging from mosaic to wall painting and even ivory. Generally speaking, however, when we think of an "icon" we imagine a representation of a holy figure created in paint on a flat wooden panel.

The creation of icons has a very long history indeed—going all the way back to the early Christian period when some of the first images of Christian figures were created. The art form evolved through the centuries, and the traditions of icon painting were especially carried on in the Byzantine east during and well after the period of the western Middle Ages.

The word "Byzantine" may be used as a geographic term as well as a term referring to an art style. In a geographic/political sense, "Byzantine" refers to the eastern half of the Roman empire centered on the city of Constantinople (present-day Istanbul in Turkey), which became the capital of the eastern Roman empire in the early fourth century under the emperor Constantine. Constantine was the first Christian ruler of the Roman empire, and he is extremely significant also for his decree in 313 (the Edict of Milan) recognizing and tolerating the Christian religion in the Roman world. His newly named capital city of Constantinople was formerly called Byzantium—hence the term "Byzantine"—which refers to the eastern region of the Roman empire and the art produced therein. During the fifth- and sixth-century "migration period" (sometimes called the "Dark Ages"), which saw the decline and eventual fall of the western half of the Roman empire, centered on the city of Rome in Italy, the Byzantine east remained relatively more stable and in significant ways preserved many of the old classical and early Christian art traditions through the subsequent centuries. While the former western Roman empire underwent a series of changes in the early medieval period, witnessing the establishment and growth of smaller empires or territories ruled over by dynasties such as the Carolingians, Ottonians, Capetians, Normans, and so on, the Byzantine empire as well underwent a series of dynastic changes and territorial conflicts. The final rulers of the much diminished Byzantine territory in the fifteenth century were members of the Greek Palaeologue dynasty, who were finally conquered by the Islamic Ottoman Turks in the middle of the fifteenth century (1453).

So, while it is surely too simplistic indeed to use the term "Byzantine" to refer to one art style or one type of art, there is no doubt that the production of icons was a characteristic feature of art in the Byzantine east for many centuries and continues to be an art form particularly associated with orthodox church denominations (Russian, Greek, etc.). Why is this? And when were the first icons produced?

Answering these questions takes us into some extremely intriguing topics, traditions, and legends which purport to go all the way back to the early Christian period and the time of Jesus himself. According to one of these stories, when Jesus was carrying his cross to his eventual crucifixion site in Jerusalem, a woman named Veronica stepped from the crowd and offered him her handkerchief so that he could wipe the sweat from his face. Miraculously, when Jesus wiped his face with her handkerchief, an image of his face remained on the cloth. (Please note that the name Veronica may be broken down to the words *vera* and *icon*—meaning "true image.") This miraculous image of Jesus (made without human hands) may be supplemented by other medieval traditions that include the story that Saint Luke (one of the four authors of the gospels) painted (or drew), from life, the very first picture of Mary with the baby Jesus.

Stories such as these—which served to legitimize the creation of holy images—were especially useful during the eighth and ninth century in the Byzantine world when, for various complex political as well as religious reasons, the making of images of holy figures (in reference to the biblical commandment for-

bidding the creation of graven images) was seriously questioned. During this period of iconoclasm (anti-imagery) which swept through the Byzantine empire (726–843), many works of art were destroyed and the production of icons virtually ceased.

> The Iconoclast Controversy was specifically concerned with the appropriateness of images in the context of worship, and documentary records from this period show how religious art became the focus for intense, often violent dispute. . . . The implications of this controversy for the development of Western art have been profound; indeed, no other culture or society is known to have engaged in such a prolonged and serious debate over the role of the visual.[1]

A great many writers of the time crafted detailed texts arguing for and against the production and use of religious imagery.[2] The advocates in favor of the creation and use of holy images for appropriate devotional purposes eventually triumphed and the production of icons continued and continues to the present day.

The first surviving examples of Byzantine icons date to the sixth and seventh centuries. These earliest examples include images of Jesus, Mary, and Saint Peter which were painted, in Egypt, in the encaustic (hot wax) technique on wooden panels. These earliest icons survive today at the monastery of Saint Catherine on the Sinai Peninsula. The Coptic (Egyptian Christian) and pre-Christian art traditions in Egypt include many other examples of funerary portraits done in the encaustic technique that were used as facial mummy covers, harking back to very ancient Egyptian traditions of burial practice. The origin of the Byzantine icon may thus reside in very ancient and non-Christian art traditions, as some scholars have most interestingly speculated. Regardless, once the tradition of holy portraiture was established, the forms and types of these images continued to grow and expand.

Icons: Function and Types

One needs to be aware of several extremely important philosophical concepts and aesthetic issues when studying and appreciating Byzantine icons of any period—medieval or modern. Although the styles and subjects of icons have varied somewhat through the centuries, by and large, the tradition of icon painting exhibits an enormously impressive continuity. This is doubtless due to the fact that icons are critically important religious objects. They are not "just" portraits or pictures of people; they are not designed to amuse, delight, or entertain viewers. Instead, icons have an extremely serious religious function. They represent holy figures who are worshiped in church and to whom believers may pray. An icon is understood to be "a copy of a divine prototype, which established a connection between the sacred personage and the person praying before the image."[3] The icons themselves are not meant to be worshiped as physical objects in and of themselves; rather they direct attention to the holy people and stories they represent. However, as focus points for religious devotion, icons are created,

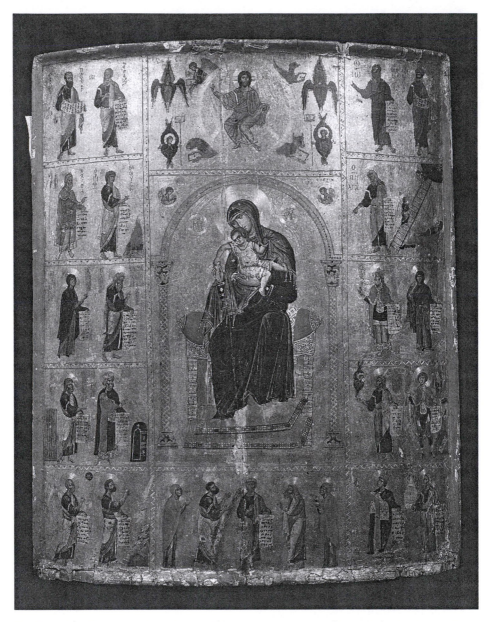

The Icon of the *Theotokos,* eleventh to twelfth century. Monastery of Saint Catherine, Mount Sinai. (The Art Archive/Monastery of Saint Catherine, Sinai, Egypt/Dagli Orti)

handled, and displayed with extreme care and reverence. Miracles have in fact been attributed to certain icons due to the holiness and power of the figures and images represented.

Mary, Jesus, saints, and scenes from their lives are the most common subjects of Byzantine icons, regardless of date. The image of Mary with the baby Jesus is one of the most frequent. She is often shown as a half-length figure holding the

baby Jesus on one arm or supporting him on her lap. Generally speaking, the figures look serious and sad (not lively or playful) and they often look out at the viewer with extremely solemn expressions. Sometimes Mary will be shown gesturing toward the infant Jesus as if she is presenting him or showing him to the viewer of the icon. Oftentimes Jesus looks more like a young adult (or a "little old man") rather than a small baby; he will be shown holding a scroll and raising one hand in a gesture of blessing. These unchildlike gestures and the mature appearance of Jesus emphasize his spiritual significance. Other icons of Mary and the baby Jesus may show more tender emotions and interaction between the figures; Jesus may be shown pressing his face to Mary's face or embracing her shoulder. She regards him somberly or looks out at the viewer with a solemn gaze as if she is aware in advance of the sacrifice and death of her son. All of these different types of Mary-and-Jesus icons have specific names and the basic formats represent standard patterns which developed gradually and vary relatively little through the centuries.[4] Again, this reflects the spiritual significance and seriousness of these works of art.

Other figures shown in Byzantine icons generally also look very serious. "People do not gesticulate; their movements are not disorderly, not haphazard."[5] When saints are depicted, they often appear to be very pious or scholarly; they may be shown holding books or scrolls, for example, or they are shown with other symbols so the viewer can identify who they are, such as the warrior saint George who may be depicted on horseback with a sword, lance, or shield. Many of these traditional symbols and attributes developed in the early Christian and early medieval period with some of the very first depictions of saintly figures. The repeated forms and attributes have long traditions, although "with each succeeding century the number and variety of pictorial representations increases."[6]

Generally speaking, the figures as well as the architectural or landscape backgrounds in Byzantine icons quite often seem unrealistic. The saintly figures are sometimes depicted as being extremely tall or elongated or otherwise strangely proportioned. The architectural settings and landscapes (if they are included at all) often seem out of proportion to the figures. Trees and buildings may seem too small in relationship to the people, and mountains look like strange rocky formations. Often there is no setting at all for the figures—simply a flat solid area of gold leaf serves as the background and the figures appear to be floating in an undetermined space. We need to understand the reasons for this lest we critique Byzantine icons unfairly. "Icons did not have as their primary function the artificial representations of 'reality,' and so cannot be viewed, as much European art has traditionally been, in terms of progress towards more and more effective illusion."[7] Icons are not meant to be realistic depictions of people or places, limited to one moment in time. They are meant to represent and symbolize the sacred: religious beliefs, heavenly events, and spiritual concepts. Byzantine icons thus use a symbolic shorthand just as most western medieval art does.

Serious and important events from the lives of Mary, Jesus, and the saints are often shown on icons: for example, the Annunciation to Mary (when the angel

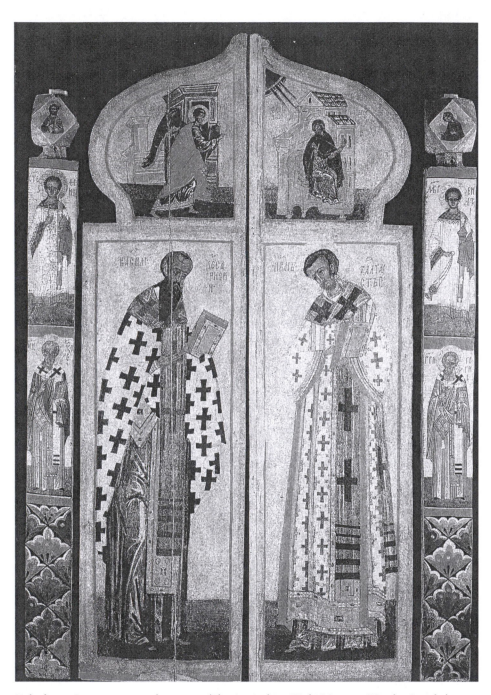

Holy doors, Russian, sixteenth century. (The Art Archive/Kizhi Museum/Nicolas Sapieha)

Gabriel appeared to her and announced that she was to give birth to Jesus), the Baptism of Jesus (by John the Baptist; the start of Jesus's public life), the Crucifixion of Jesus, and the death (Dormition) of Mary. These events, commemorated and celebrated on a yearly basis in the church calendar, often form elements in a larger pictorial program of icons found in orthodox churches, known as the icon screen or iconostasis. This screen separates the nave (main area of the church where the congregation gathers) from the sanctuary (or altar area, where priests perform the church rituals and ceremonies). Large icon screens may have dozens of painted panels, all arranged according to specific rules of placement.

The iconostasis form ultimately developed from the screens or low balustrades which were used to separate the clergy from the congregation in early Christian churches. The icon screen symbolizes the separation between the worldly and the heavenly realms while also symbolically uniting the two realms. In fully developed form (say by the fifteenth century) an iconostasis will typically have several levels of painted panels arranged according to specific traditions. The largest icons on the lowest level will show images of Mary, Jesus, the most important angels (like the archangel Michael), and sometimes the Four Evangelists (Matthew, Mark, Luke, and John—the authors of the gospels). An icon of the biblical event or saint to whom the specific church is dedicated will also customarily be placed on the lower level of the icon screen. The upper tiers of the icon screen will include smaller icons of prophets, saints, and images representing the events commemorated on the major holy days in the church calendar.

Icons: Materials and Techniques

The layout of the icon screen, the rules for where to place specific individual icons in churches, the choice of subjects for icons, the poses of the figures, and even the colors used in icons are all guided by traditions which developed through the medieval period. One can purchase modern books which describe the step-by-step process of icon painting.[8] Icons are still created today in great numbers and the materials and techniques have changed very little since the Middle Ages.

Most icons are painted on carefully prepared wooden panels using egg tempera paint—a mixture of egg yolk with mineral pigments. The wooden panel is carefully selected and prepared with several coats of glue/chalk or "gesso" to provide a uniformly smooth and white painting surface. Each coating must be fully dry before the next layer can be applied. Even the process of preparing a panel for painting is lengthy and time consuming and requires much patience and concentration. When the panel is ready for painting, the artist will trace or transfer the design onto the surface and any areas which are to be covered with gold leaf (such as backgrounds and haloes) need to be completed before the actual painting can begin. The gilding (laying on of gold leaf) is also an extremely

exacting process as the very thin sheets of gold need to be handled with supreme care. After gilding, the painting process can begin with carefully prepared paints made from a mixture of egg yolk, water, and ground pigments. Different minerals and natural/organic materials create the various colors or pigments. Again, the painting process follows a painstaking series of steps. Flat areas of color are laid on in a consecutive series of layers, building up from darker to lighter tones. The series of paint applications in careful washes or thin layers gives a sense of glowing richness to the figures and scenes. Finally, highlights, additional lines of gold, and details such as inscriptions (usually abbreviated letters identifying the figure or scene) are added. The icon is left to dry for a period of time and then is coated with a preservative, a protective layer of oil or varnish.

Obviously, the creation of an icon—from start to finish—represents a significant commitment of time on the part of the artist. The painstaking care and patience required reflects the seriousness of the task as well. The creation of an icon is also an act of religious devotion, a spiritual experience in itself, and icon-creation requires an appropriate attitude as well as the careful following of a conventional set of procedures.

Most icons, certainly before the fourteenth century, were not signed by the artists who painted them. And, while artists' signatures on icons became more common in the later Byzantine period, these signatures were generally accompanied by a phrase such as "through the hand of" (artist's name). The artist thus indicates "that he feels that a Divine element enters into the execution of his icon, that Divine grace illumines his mind and guides his hand."[9] The icon painter is engaged in a devotional act, not in an act of independent creativity with a desire for personal fame or renown.

Given these serious attitudes and the careful and canonical procedures involved with icon painting, it might seem that Byzantine icons are simply repetitive copies of one another and that medieval and modern iconographers (icon painters) were/are extremely uncreative artists, simply copying old examples over and over again. This is far from the case. It is quite possible to recognize icons from different places and different time periods and also to identify the styles of individual artists. The expressiveness of the figures, the handling of drapery folds, the attention to fine details and patterns all vary according to time period and location. In other words, it is quite incorrect to describe Byzantine art as static or unchanging and to think of icons as purely repetitive copies of older examples. There is an evolution and development in Byzantine art style in much the same way as can be seen in western medieval art during the same centuries. It is important to recognize that "in the copying of earlier icons—an essential feature of medieval art—artists would adopt what was best from the earlier painting traditions, while modifying the image according to the artistic practice of their time."[10]

We also always need to keep in mind that our modern concepts of "creativity" and the "creative artist" are ideas which really do not apply so well at all to older periods of art. Nowadays, we may think that the artists who are the most creative are those artists who do something totally new and completely differ-

ent than other or earlier artists. We tend to describe new ideas, new styles, and new techniques as innovative, daring, bold, and record-breaking. Some modern artists strive to be revolutionary by being shocking or sensational. These modern ideas and constant interest in the "new and different" may make us less sensitive than we should be to periods of history or to cultures where traditions were (or are) of much greater significance than innovations—and the innovations that do indeed take place are of a more subtle nature.

An Icon Painter: Andrei Rublev

Our focus artist for this chapter is Andrei Rublev, a Russian painter who lived during the fourteenth and fifteenth centuries (c1360/70–c1427/30). Rublev has been described as the most famous and esteemed artist of medieval Russia and indeed is considered a saint by the Russian Orthodox Church. He was a monk and he lived and worked primarily at the Holy Trinity monastery at Zagorsk near Moscow. As we have seen with so many other artists discussed in this book, few biographical details are known about his life. And, as we have also seen with other artists discussed in this book, not all of the works of art attributed to Rublev are agreed upon by scholars as being by his hand.

He is mentioned in several chronicles and documentary sources as working on the (later destroyed) frescoes and icons of the Cathedral of the Annunciation in Moscow in 1405 along with other artists including Theophanes the Greek (fl. 1378–1405). In 1408–1409, Rublev worked with his friend and fellow monk Daniil Chernyi (or Daniel Chorny) on the frescoes for the Cathedral of the Dormition in Vladimir. He collaborated with Chernyi on other occasions as well during the 1420s, notably on frescoes and icons for the Trinity Cathedral in Zagorsk. Some scholars have speculated that he may have traveled into Byzantine territory and that he might have visited Constantinople and other art centers.

Rublev painted icons, frescoes, and illustrated manuscripts, but it is in the field of icon painting that Rublev's fame resides. In particular, one icon he painted sometime between 1408 and 1427 is considered to be his masterpiece, indeed, the most praised and admired of all Russian icons. This is his icon of the *Trinity* in the Tretyakov Gallery in Moscow. The work is painted in egg tempera on a wooden panel measuring about forty-four by fifty-five inches and, at first glance, appears rather simple and straightforward in terms of subject matter and composition. Perhaps it is the apparent simplicity of the work which gives it such great power and inspires many to continue to study it and want to learn more about it.

The work depicts three winged angels seated around a table. They are very nicely balanced; the two angels seated at the sides of the table mirror each other and serve almost like parentheses enclosing the third, central angel, who is sitting behind the table. The angels are dressed in beautiful flowing robes of various soft colors; all of their heads are tilted slightly; they have healthy-looking,

curly, and flowing hair styles, and the details of their faces, hair, and drapery patterns are treated in a delicate and detailed fashion. There is a stemmed cup placed on the center of the table. Background details are minimal, but one can see (reading from left to right) a few architectural details, a leafy green tree, and a craggy mountain rising behind the halo of the right-hand angel.

This beautiful composition has a great deal of symbolic significance. As we would already imagine from the traditions of icon painting described above, this composition and subject matter is not a new invention on the part of the artist, Rublev. Indeed, the subject is derived from the Bible (Genesis 18) and represents the three men (actually angels/heavenly visitors) who, mysteriously and unexpectedly, came to see Abraham and his wife Sarah. Abraham and Sarah served them a meal and hosted them as generously as they could do. Before the three angels departed they praised their hosts for their generous spirit and prophesied that, in spite of their advanced age and her previous sadly childless state, Sarah would bear a son to Abraham. This came true in due course and Sarah gave birth to Isaac.

This story, from the Old Testament, was interpreted by later Christian writers in Christian religious terms. In other words, the three heavenly visitors who came to Abraham and Sarah were understood, by Christian writers, to symbolize the three persons of the Trinity: Father, Son, and Holy Spirit. This type of reinterpretation or updating of stories from the Hebrew Old Testament to correlate with Christian beliefs is very typical of much theological writing of the early Christian and medieval period, and also explains why so many subjects from the Old Testament appear in Christian art in both western Europe and Byzantium.

By the time Rublev painted his icon in the fifteenth century, the subject of the "three heavenly visitors" was a traditional subject for icons and was long understood to symbolize Christian beliefs in the Trinity: the three-in-one nature of God. The doctrine of the Trinity is a complex concept all told, continuing to be discussed even in present times, challenging to understand and certainly difficult to visualize. Artists in both the western and Byzantine worlds in the medieval period came up with different ways to represent the concept. In western art of the medieval and Renaissance periods, God the Father may be represented as an old man with a long white beard, Jesus may be shown as a younger man or as the crucified Christ, and the Holy Spirit is often represented as a white bird, or dove. Many variations on the theme appear in early Christian and western medieval art, but in eastern or Byzantine art, the subject of the three angels who visited Abraham and Sarah eventually became the preferred way to represent the symbolic union of the one "nature" and three "persons" of God. Rather than differentiating between the three "persons" (by showing God as an old man, Jesus as a separate individual, and the Holy Spirit as a bird), the three equivalent angels who visited Abraham and Sarah seemed a more appropriate way to represent the unity of the three "persons" of God. Byzantine icons representing the Trinity thus were customarily included in programs of icons as one of the images to signify and celebrate the yearly church commemoration of the Pentecost. This event, as described in the Christian scriptures (Acts 2), also involved

a manifestation of God's presence. After the death of Jesus, the apostles (his immediate followers) were gathered together as a group and a great vision of wind and fire from heaven descended upon them; they were filled with the Holy Spirit and were inspired to spread the Christian message to all peoples.

Rublev's early-fifteenth-century *Trinity* icon thus represents a traditional, tried-and-true, accepted, and agreed-upon formula for depicting the powerful and complex subject. The three angels in his composition all look much the same; they seem to be all of the same age and same physical size and type. They all have the same hairstyles. There are no great differences between them at all apart from the colors of their robes; they are quite unified in appearance and pose. The whole composition in fact concentrates the viewer's attention on the three angelic figures who take up most of the space in the picture and who create a unified circular compositional movement by their positions, wings, and tilted heads. The landscape details are minimal; there are no distractions in the scene nor are there other figures or stories included. Abraham and Sarah, the generous and pious hosts of these three heavenly visitors, are nowhere to be seen.

The exclusion of Abraham and Sarah in this icon in fact marks an important departure from tradition on the part of the artist Rublev. Customarily, previous icons depicting this subject also included the figures of Abraham and Sarah—as well as some other narrative details—giving a more story-like atmosphere and sense of place and setting to the subject. Rublev chose to delete those narrative details in order to focus the viewer's attention and concentration on the three figures and the symbolic meaning of the subject.

His success in so doing is more than evidenced by the many later copies of his icon which were created. His new interpretation of the subject—firmly based on traditions but with subtle variations—was praised and accepted and served to set a new standard. Praises of his creative genius are not so much due to his novel or brand-new handling of a subject in art—nor to his invention of a new subject never seen before or a technique never before known—but rather to his ability to take a traditional subject and render it even more powerful by his subtle variations on the theme.

The traditional symbolism of the "Old Testament Trinity" is actually amplified by Rublev's interpretation which still contains the customary elements and references. The tree in the center of the composition is not only the oak tree specifically mentioned in the biblical text but is also understood to symbolize the Tree of Life from the Garden of Eden. This life-giving tree is also a symbol for the sacrifice of Jesus and this tree is placed behind the central angel in Rublev's icon. This central figure is generally understood to represent the "Son" or the second person of the Trinity. The building/architectural structure of the left side of the composition represents Abraham's house, but may also be interpreted as a reference to God as the "builder" of the church. The mountain on the right side of the composition is not just a landscape element, but can be seen to represent or symbolize the heights of spirituality. The cup in the center of the table contains the head of a calf. According to the story in Genesis, Abraham had his servant slaughter a calf to prepare a meal for his three guests. Sometimes this detail—of the servant slaughtering the calf—was included in earlier

icons of the subject. Rublev also chose to omit this, possibly distracting, narrative detail. In his version, the calf's head in the chalice also very effectively functions as a powerful symbol of the sacrifice of Jesus—who is often described as the sacrificial "lamb of God" in Christian religious texts. The overall grace and calmness of Rublev's angels and their creation of a flowing circular composition may also be seen as suggestive of wholeness and unity. The geometric figure of the circle is often used as a symbol for heaven and divine perfection.

It is interesting to speculate about Rublev's inspiration and what led him to adjust and reinterpret the previous pictorial traditions in his creation of the *Trinity* icon in the early fifteenth century. Unfortunately, very little information is known about Rublev's personality and what his artistic or theological influences may have been. However, as a monk of a prominent monastery near the major cultural center of Moscow, Rublev certainly would have been aware of the contemporary theological and mystical discussions taking place at the time. Many scholars have described the intensity and expressiveness of Rublev's art as being reflective of a particular mystical movement in Greek and Russian spirituality emphasizing silent and constant inner prayer and visions of divine light. The great fourteenth-century mystic, Saint Sergei of Radonezh, had founded the monastery where Rublev lived. Saint Sergei was a highly influential figure in politics as well; he was a great preacher and advocate for peace. Some scholars have said that the peacefulness, calm, and harmony of Rublev's icon may reflect the teachings and goals of Saint Sergei and the unsettled politics and struggles of the period.

Conclusion: The Artist in Byzantium and Medieval Russia

Fourteenth- and fifteenth-century Russian icon painters, such as Andrei Rublev and his colleague Daniil Chernyi, continued and expanded the traditions of sacred art previously developed in the Byzantine empire. Christian missionaries from the Byzantine world had been earlier very active in spreading the Christian religion outside the geographic borders of Byzantine territory. The Christian religion reached Russia and was accepted there by around the year 1000. Along with Byzantine Christianity came Byzantine religious art. The traditions of Christian art, which developed in medieval Russia, thus depended at first very much on the forms, types, and styles of later Byzantine art. Also, as the once vast territory of the Byzantine empire diminished through the centuries up to the Ottoman conquest of 1453, many Greek/Byzantine artists traveled outside the empire seeking work. Hence, the influence of Byzantine art was even further spread by these migrating artists.

The Greek artist Theophanes, with whom Rublev is recorded as working in the early fifteenth century, is a case in point. He came to Russia and worked in Novgorod and Moscow after a previous career in church decoration and icon painting in various Byzantine centers including Constantinople. Working di-

rectly with this Greek artist would have further introduced Rublev to the art styles current in the final phase of art associated with the Byzantine empire (the Palaeologue period).

The capture of the Byzantine capital city of Constantinople by the Ottoman Turks in 1453 brought an end to the Byzantine empire but not to Byzantine art, by any means. It is in regions such as Russia that the Byzantine traditions were carried on and where Byzantine art and style continued to flourish for centuries after the collapse of the Byzantine empire itself. To describe this art of Russia or other areas, such as Crete, as still "Byzantine" is rather problematic, however. "We can see, for example, that the art of Russia or of Venetian Crete are unimaginable without the activities of Byzantine artists. But at what point did such art and the artists who produced it become 'Russian,' 'Cretan' or 'Venetian' rather than 'Byzantine'? These are questions worth pondering, but best left open."[11]

> As mediators between heaven and earth, icons have provided for many centuries direct access to the Divine. Personal belief in the icon . . . existed in the Byzantine Empire from the sixth century, and by the twelfth century had spread to neighbouring lands, such as the Serbian and Bulgarian Kingdoms, and to more distant Russia. It was the high regard accorded to these icons and their active presence in private and public life that visibly identified these cultures as Orthodox and differentiated them from the Catholic West. In short, icons become significant carriers of a tradition which, in some parts of Eastern Europe, continued uninterrupted into the twentieth century.[12]

Andrei Rublev, working in Russia in the fifteenth century, is not considered a "Byzantine artist" but rather a Russian icon painter following in the spirit and traditions of Byzantine art. His influence on later religious art in Russia was enormous. Many later artists imitated his style and copied his compositions. His *Trinity* icon in particular set a precedent and established a pictorial type repeated by many other icon painters. Although we have no documentary evidence to prove this, it is highly doubtful indeed that Rublev set about to become the most famous and beloved artist of medieval Russia. Rublev, in many ways, may be considered as an ideal type of icon painter—"the humble silent monk, filled with a spirit of piety and inner harmony."[13]

The sacred nature of the holy image—the traditions of iconography—were "no obstacles to true artistic talent"; indeed, these traditions "did not prevent a gifted painter from expressing his own artistic individuality."[14] The genius of Andrei Rublev rests in his profound awareness of and deeply reverential approach to the spiritual meanings, traditions, and goals involved with the creation of sacred art.

Notes

1. John Lowden, *Early Christian and Byzantine Art* (London: Phaidon, 1997), 147.

2. Lowden, 147–184. Cyril Mango, *The Art of the Byzantine Empire: 312–1453* (Englewood Cliffs, N.J.: Prentice Hall, 1972), 149–177.

3. E. Smirnova, "Moscow Icon Painting from the Fourteenth to the Sixteenth Century," in *The Art of Holy Russia: Icons from Moscow, 1400–1600* (London: Royal Academy of Arts, 1998), 54.

4. For example, the *Hodegetria* ("guiding") type of icon shows Mary holding the baby Jesus on her left arm and gesturing toward him with her right hand. This particular type is said to be derived from the original image of Mary painted by Saint Luke. The *Eleousa* ("compassionate/merciful/lovingkindness") image portrays affection between the two figures by gestures and expressions. There are a number of other types and variations. See Leonid Ouspensky and Vladimir Lossky, *The Meaning of Icons* (Crestwood, N.Y.: St. Vladimir's Seminary Press, 1983), and Leslie Ross, *Medieval Art: A Topical Dictionary* (Westport, Conn.: Greenwood Press, 1996).

5. Leonid Ouspensky, "The Meaning and Language of Icons," in *The Meaning of Icons,* 40.

6. Constantine Cavarnos, *Orthodox Iconography* (Belmont, Mass.: Institute for Byzantine and Modern Greek Studies, 1977), 14.

7. Robin Cormack, *Writing in Gold: Byzantine Society and Its Icons* (New York: Oxford University Press, 1985), 256.

8. Such as Guillem Ramos-Poquí, *The Technique of Icon Painting* (Tunbridge Wells, U.K.: Burns and Oates/Search Press, 1990).

9. Cavarnos, 65.

10. Smirnova, 51.

11. Lowden, 420.

12. Thalia Gouma-Peterson, "The Icon and Cultural Identity After 1453," in *Holy Image, Holy Space: Icons and Frescoes from Greece,* ed. Myrtali Acheimastou-Potamianou (Athens: Greek Ministry of Culture, 1988), 64.

13. Yuri Malkov, "The Icon Painter in Medieval Russia," in *The Art of Holy Russia: Icons from Moscow, 1400–1600* (London: Royal Academy of Arts, 1998), 82.

14. Malkov, 81.

Bibliography

Acheimastou-Potamianou, Myrtali, ed. *Holy Image, Holy Space: Icons and Frescoes from Greece.* Athens: Greek Ministry of Culture, 1988.

The Art of Holy Russia: Icons from Moscow, 1400–1600. London: Royal Academy of Arts, 1998.

Cavarnos, Constantine. *Orthodox Iconography.* Belmont, Mass.: Institute for Byzantine and Modern Greek Studies, 1977.

Cormack, Robin. *Byzantine Art.* Oxford: Oxford University Press, 2000.

———. *Writing in Gold: Byzantine Society and Its Icons.* New York: Oxford University Press, 1985.

Evans, H. C., and William Wixom, eds. *The Glory of Byzantium: Art and Culture of the Middle Byzantine Era A.D. 843–1261.* New York: Metropolitan Museum of Art, 1997.

Lasareff, Victor. "La Trinité d'André Roublev." *Gazette des Beaux-Arts* 6, no. 54 (1959): 289–300.

Lowden, John. *Early Christian and Byzantine Art.* London: Phaidon, 1997.

Mango, Cyril. *The Art of the Byzantine Empire: 312–1453.* Englewood Cliffs, N.J.: Prentice Hall, 1972.

Ouspensky, Leonid, and Vladimir Lossky. *The Meaning of Icons.* Crestwood, N.Y.: St. Vladimir's Seminary Press, 1983.

Ramos-Poquí, Guillem. *The Technique of Icon Painting.* Tunbridge Wells, U.K.: Burns and Oates/Search Press, 1990.

Ross, Leslie. *Medieval Art: A Topical Dictionary.* Westport, Conn.: Greenwood Press, 1996.

Weitzmann, Kurt. *The Icon: Holy Images—Sixth to Fourteenth Century.* New York: George Braziller, 1978.

CHAPTER 9

Women Artists of the Medieval Era

Medieval Women Artists: General Considerations

The wide-ranging influences of the women's movement of the later twentieth century resulted in some significant changes in attitude in the field of art history studies—changes which are still being explored today. Many art historians, especially in the second half of the twentieth century, have devoted a great deal of time and careful research to rediscovering previously unrecognized female artists from ages past. These scholars rightly pointed out that a number of women artists, including even those who were famous and well respected during their own lifetimes, have been excluded from standard surveys of art history. The reasons for this exclusion are highly complex, but the result of all this research and study in the modern period is that a much greater number of women artists, from various time periods, are now more studied and recognized.

In other chapters of this book, we have already encountered some of the challenges involved with trying to recreate the lives and careers of artists from the medieval period. Even in the cases of the artists whose names we actually know from the Middle Ages, we have seen that, more often than not, detailed biographical information about these artists is lacking. We may have a signature of an artist or a document mentioning an artist, and we may be able to piece together, sometimes on the basis of their individual style, a number of works of art created by a specific artist. However, we often simply do not have enough information to go on and many medieval artists remain somewhat shadowy figures whose works we admire, but about whose lives we really know very little.

This problematic situation also very much applies to female artists from the medieval period. While there is no doubt at all that there were many women who

worked as artists during the Middle Ages—and that many medieval women were important patrons of the arts as well—reconstructing the careers, roles, artistic interests, and contributions of medieval women is a complicated and sometimes frustrating undertaking. It is possible that there may be even less surviving evidence for medieval women artists than for their male contemporaries. Nevertheless, studies devoted to medieval women artists have given us the names of several and more detailed information on a selected few. Some of these studies have also resulted in interesting cases of the more or less scholarly creation of female artists from the medieval period, based on rather scanty evidence.

Signatures and Self-Portraits

A number of female artists from the medieval period signed their works, just as male artists sometimes did. Among these female artists who signed their works we may list the manuscript painters: Ende, Guda (or Guta), and Claricia. Ende's name appears at the end of a large and magnificently painted manuscript produced in Spain in the late tenth century, c975. The manuscript is known as the "Gerona Beatus," referring to its location in the Gerona cathedral library in Spain, and the subject, which is a commentary on the Apocalypse compiled by the Spanish abbot of Liébana, named Beatus, in the late eighth century. The Gerona Beatus is one of a series of manuscripts of this popular work; many copies were produced in medieval Spain especially. Typical of Spanish Beatus manuscripts, the work is enriched with many pages of pictures rendered in vibrant colors, illustrating the subjects described in the text.[1] The Gerona Beatus is especially acclaimed for its rich colors and detailed paintings. Ende's signature appears at the very end of the book and she describes herself as a "painter" and "servant" or "helper of God." Presumably she was a nun, and worked on the creation of this magnificent manuscript, along with a male artist or scribe named Emeritus, whose name appears after hers. The manuscript was probably produced at the monastery at Tábara. Analysis of the painting styles in the manuscript, as well as the fact that Ende is listed first in the signature inscription, has led some scholars to the conclusion that Ende may have been responsible for painting the major portion of the illustrations in the book, but we know nothing more about her. "Ende is the earliest securely documented female artist in Spain. . . . [Her] significance stems not only from her status as one of the first known female artists in Europe, but also from her achievements as one of the most expressive and innovative painters of her era."[2]

Two women artists from the twelfth century also signed their names and included their self-portraits in illustrated manuscripts. In the early twelfth century, Guda, a German nun, "signed herself with a self-portrait, possibly the first self-portrait of a woman surviving in the West."[3] Her self-portrait is contained within an enlarged initial letter in an illustrated manuscript. She depicts herself holding a foliage scroll on which is inscribed, in Latin: "Guda, woman and sinner, wrote and painted this book." We know nothing more about her.

Another German artist, Claricia, included an especially lively portrait of her-self in an illustrated manuscript of the Psalms from the late twelfth century. She shows herself swinging from and forming the base of an enlarged initial "Q." Her name is inscribed next to her head. She is dressed in a long robe with flow-ing sleeves and her long hair swings freely. She "does not wear the habits of a nun; she must have been a well-to-do young woman who was sent to the nuns for schooling, and learned to participate in bookmaking. It becomes clearer and clearer as the Middle Ages move on that miniature painting was regarded as an appropriate occupation and a becoming accomplishment for a lady."[4] There were several artists involved with the creation of the manuscript in which Claricia placed her self-portrait, and other illustrations by her hand have been identi-fied in the book. She does not appear to have been responsible for any of the major illustrations in the book, so scholars have concluded that she must have been a student or an assistant.[5]

There are a number of other examples of medieval women whose signatures occur in manuscripts or who are otherwise documented as having written and illustrated books. For example, the German nun Diemud of Wessobrunn (1057–1130), is documented as having "produced some 45 manuscripts in the years between 1075 and her death around 1130."[6] Unfortunately, scholars have not yet been able to convincingly identify her work in any surviving manuscripts, and the situation is complicated by the fact that further research has uncovered several female scribes named Diemud working in Germany through the thirteenth century. There are also quite a number of illustrations of women scribes in me-dieval manuscripts.[7] It is clear that women were engaged in writing and copying books throughout the medieval period, as well as illustrating books.

In the middle of the fourteenth century, a female manuscript painter named Bourgot is documented as sharing several important commissions for lavishly illustrated books with her father, the renowned painter Jean le Noir (fl. 1331–1375). Bourgot was "the most famous of the professional female illumi-nators of the fourteenth century,"[8] and the father-daughter team was "so famous that they were sought after by aristocracy and by royalty—who did not hesi-tate to raise great inducements to entice them away from the service of others."[9] As with so many of the sumptuously illuminated manuscripts created for courtly patrons during this very late or "International Gothic" period of art, the collab-orative nature of manuscript production quite often makes it difficult if not im-possible to separate one artist's work from another (see also chapter 10).

Ende, Guda, Claricia, and Bourgot were all involved with the production of illustrated manuscripts, but signatures of female artists have been noted on other types of medieval artworks as well. However, as we have seen with the signa-tures of artists generally in the Middle Ages, it is sometimes difficult to interpret the evidence. The inscription naming the artist (?) Gislebertus on the sculpture of the Romanesque church at Autun is an excellent case in point (see chapter 1). Scholars are now somewhat divided as to whether or not Gislebertus was the artist or the patron of the building. A similar situation arises with the early-fourteenth-century mural paintings from the church of Santa Clara in Toro

(Zamora), Spain. This cycle of frescoes "is now regarded as one of the most extensive and significant monuments of Gothic painting to survive in Spain."[10] An inscription on one of the scenes in this impressive cycle reads: *Teresa Diec Me Fecit* ("Teresa Díaz made me"). This is very similar to the formula used in the Gislebertus inscription at Autun, thus the same questions can be raised. Perhaps Teresa was the patron or the donor who paid for the paintings and not the artist who painted them. If she was the artist, she would be "the earliest female artist in Europe who is known to have worked in a monumental medium, as opposed to the smaller-scale media more commonly associated with medieval women artists."[11]

Herrad and Hildegard

There are also several women who are traditionally featured in studies of medieval female artists whose own personal contributions as artists were somewhat more indirect. Both Herrad of Hohenbourg (c1130–c1196) and Hildegard of Bingen (1098–1179) are extremely important and much-studied medieval female figures, responsible for some of the most intriguing and imaginative examples of medieval book illustration.

They were both abbesses (leaders) of convents (monasteries for women). Convents flourished during the medieval period as centers of learning and art alongside the monasteries for men. Convents "permitted women to pursue lives dedicated to spiritual contemplation, which was highly respected in the society of the Middle Ages. . . . The most learned women of the Middle Ages, those who made significant contributions to their cultures, were nuns."[12] Abbesses were frequently extremely powerful figures with a great deal of influence on contemporary culture and politics.

Much less is known about Herrad's life than about Hildegard's. Hildegard is acclaimed for her extensive writings including poems, hymns, plays, scriptural commentaries, and treatises on medicine and natural history. She invented a secret language and alphabet, composed music, and maintained an active written correspondence with popes, emperors, kings, archbishops, and other important figures such as Saint Bernard of Clairvaux. In terms of the visual arts, Hildegard is most known for her two books of visions, notably the *Liber Scivias,* which contains descriptions and illustrations of the mystical visions she experienced throughout her life beginning from the age of five. It was not until she was in her early forties that she was encouraged to record her visions, and when the "unfinished text was shown to Pope Eugenius III and Saint Bernard of Clairvaux . . . in 1147–8 . . . they endorsed her continuation of it."[13] Hildegard's book contains over thirty remarkable illustrations: images of light and darkness, stars, the sun and moon, demons and dragons, and fascinating symbolic diagrams of complex theological concepts. The pictures are exceptional for their vibrancy and visual impact. A great deal of scholarship has been devoted to analysis of these illustrations and to Hildegard's role in their creation.

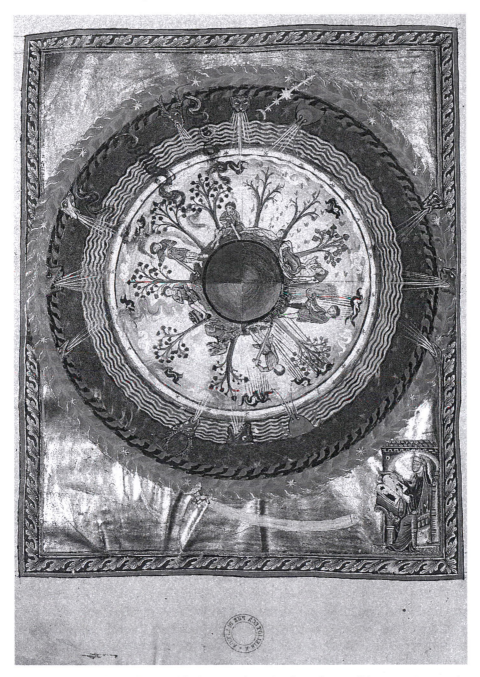

The universe and the earth created for humans, from the eleventh to twelfth century Latin codex Visions of Saint Hildegard of Bingen, *Book of the Works of God*. (The Art Archive/Biblioteca Civica Lucca/Dagli Orti)

One particularly interesting illustration shows Hildegard herself, receiving her visions in the form of streaming rays of light descending from the heavens into her eyes. She is accompanied in this picture by her scribe Volmar, to whom she dictated her visions. Hildegard is shown holding wax tablets on which she could be drawing or writing. Smaller illustrations showing Hildegard holding these same tablets appear elsewhere in the manuscript, and several scholars interpret these to be indications of her role as author/writer of the text.[14] In reference to the illustration of Hildegard with Volmar, however, others have argued that "the clearest explanation for the duplication of records is that he writes as she repeats what voices say to her, and she draws the pictorial compositions."[15] Unfortunately, Hildegard's role as an artist is far from clear, and this fact is compounded by the loss of the manuscripts produced during her lifetime. Although known through later copies and reproductions, Hildegard's hand in the actual, original designs of these fantastic illustrations remains a matter of scholarly debate. Some believe that the illustrations were created by several different artists working under her close supervision. Others would prefer to believe that Hildegard played a more prominent role in not only designing but also in executing the pictures. Some have argued that "once her artistic role is accepted, she becomes the only 'great master' of the Middle Ages, comparable to such Renaissance figures as Leonardo da Vinci in the breadth of her achievements and the originality of her images."[16] In contrast, other scholars have described these illustrations as "mere curiosities."[17]

The assessment of Herrad of Hohenbourg's contributions to the visual arts in the Middle Ages is similarly frustrated by lost material. Like Hildegard, she was responsible for the creation of an extremely important illustrated text. Known as the *Hortus deliciarum* (Garden of Delights), the book covers religious history from the creation of the universe to the end of time. It is a compendium of texts arranged by Herrad for the instruction and "delight" of the women in her convent. It is a large book, fully illustrated, "exceptional for the breadth of subject matter, the coherence of its grand programme, and the sheer brilliance of its art."[18] Unfortunately, what some scholars believe to have been the original manuscript created under Herrad's direction in the late twelfth century (or finished in the early thirteenth century after her death in c1196) was destroyed in the shelling of Strasbourg in 1870. Although copies of a good many of the illustrations had previously been made, the original manuscript had a greater number of pictures than are now available for study. Scholarly interest in this book has been extensive, and many have remarked on the fine quality, range of pictorial sources, and distinctive style features of the illustrations. The influence of Byzantine art on the subjects shown in the book and the illustration styles used have often been noted, and the hands of at least three different artists who worked on the illustrations have been discerned.

In her preface to the book, Herrad says only that she created the text, thus, most writers seem to agree that she was not actually directly involved with creating any of the pictures. The text and illustrations work so closely together, however, that "it is hard to believe that she was not also involved in what is such

a vital part"[19] of the manuscript. If Herrad did not create the illustrations herself, nevertheless, "hers was the mind that generated this rich compendium of visual *schemata*. As such, Herrad is certainly a towering figure in medieval art."[20]

The Arts of the Convents

The religious settings in which both Herrad and Hildegard produced their remarkable creations in the twelfth century are characteristic of the contexts in which much art was created by women in the Middle Ages. There has been a great deal of recent scholarly interest in medieval nuns as artists, and in the types of art produced and used in medieval convents. Herrad's great compendium was designed for the education of the sisters in her convent, and it appears that illustrated books for the education and spiritual edification of nuns were frequently produced during the medieval period. Some of these books have escaped scholarly attention or have, in fact, been ignored or dismissed due to the quality of the pictures. In comparison with the very fine illustrations in Herrad's *Hortus deliciarum*, for example, the pictures in some of these late medieval *Nonnenbücher* (Nuns' books) might appear rather humble if not even crude. Such assessments of quality may fail to take several important factors into consideration, and "to write them off . . . implicitly asks them to meet criteria to which they did not and could not aspire."[21] Many of the devotional pictures contained in manuscripts made by and for nuns in the late medieval period are among the most powerful and compelling examples of religious images to be produced in the Middle Ages. Rather than dismissing these examples as productions of unprofessional folk art, current scholarship more often recognizes that these images can provide great insights in the visual culture of medieval religious women.

We have already noted that medieval convents as well as monasteries were great centers of manuscript creation through the medieval period, producing books of a variety of formats and decorative scopes. Some of these books were for use in house, but there is evidence as well of books being commissioned or ordered from convents for use elsewhere. Similarly, "women's work in the convent often meant making textiles, either for personal or communal use, or for sale to other institutions."[22]

The Textile Arts

The various forms of textile arts, such as weaving, sewing, tapestry, and embroidery, played an extremely significant role in medieval society. It is certainly somewhat difficult for modern-day people to comprehend or visualize the importance of these art forms in the Middle Ages.

In today's consumer-orientated society textiles tend to be very much taken for granted; produced on a massive scale they are then fairly rapidly discarded. Me-

dieval people, however, prized their clothes and furnishings much more highly. Rich cloths, silks, tapestries and embroideries were vital symbols of wealth and status, second only to precious metals and jewels.[23]

The creation and decoration of fine textiles, especially the arts of weaving and embroidery, were activities frequently undertaken by medieval women, both secular and religious. Embroidery involves working with needle and thread to create surface designs on cloth, and it is an art form which can have results ranging from the simple to the extremely complex and luxurious. A variety of different stitches can be used and combined for increasingly complicated patterns, and depending upon the colors, size, and materials used for the threads, embroidery work can be stunningly lavish. Threads spun of gold and silver were used in the most sumptuous medieval embroideries, and pearls and other ornaments were included in these fine and deluxe productions.

There are a great number of documentary references to the achievements of medieval women in these fields. For example, Edith, a tenth-century nun in Anglo-Saxon England, was said to be very skilled in embroidery; Christina, the prioress of Markyate in England embroidered three *mitres* (two-pointed hats worn by bishops and archbishops) of "wonderful workmanship which were sent as gifts to the English pope, Adrian IV, in 1155."[24] Liturgical vestments of all sorts worn by priests, such as albs (tunics), copes (cloaks), and bands of material worn over the shoulders (stoles) or arms (maniples) were all frequently elaborated with needlework in the Middle Ages. The early-eleventh-century Kunigunde was famous for her fine work in creating jeweled and gold vestments. The interiors of medieval churches were frequently decorated with hangings, embroidered altar frontals, and other rich examples of the textile arts, mirroring the medieval taste for fine craftsmanship in metalwork objects (see chapter 2).

One of the most often cited references to a famous medieval woman embroiderer occurs with Mabel of Bury Saint Edmunds. In the thirteenth century, her name appears "at least twenty-four times in the household accounts of Henry III (1216–1272) in the years 1239 to 1245, during which period she was engaged upon several embroidery projects for the King."[25] The records refer to payments for her work and for the materials she used, including gold, pearls, and silk.

Members of the medieval aristocracy were extremely fond of richly embellished garments, and the wall hangings, bed hangings, and tapestries that were displayed in palaces were highly cherished possessions of the wealthy. There are many descriptions of royal robes adorned with gold embroidery, set with pearls and gems. Many of these were surely created by noble women, a number of whom are praised in documentary sources as well. Very few of these secular and ceremonial garments survive from the medieval period, whereas a far greater number of liturgical vestments and related works are preserved. The losses are many, even so, and the examples that survive are certainly among the most precious.

It is an irony of history that so much fine ecclesiastical embroidery survives with little supporting documentary evidence showing how it was designed and pro-

duced, whilst a wealth of documentary evidence for the production of lavishly or-
namented royal clothing . . . is still available but is itself supported by virtually no
surviving examples.[26]

It would be quite incorrect to imagine that only women were involved with
the textile arts in the Middle Ages, or that these women were necessarily either
aristocratic ladies or nuns living in convents. There appear to have also been a
number of middle-class professional women embroiderers at work in medieval
cities certainly by the thirteenth and fourteenth centuries. A good example is
Rose of Burford, who was the wife of a merchant in London. She was clearly
highly skilled and well regarded, as she was patronized by royalty. Queen Is-
abella of Spain is documented as having commissioned Rose to decorate a litur-
gical vestment that the queen intended to give as a gift to the pope. The work
of English embroiderers, such as Rose of Burford, was especially famous and
sought after, and the term *opus Anglicanum* (English work) was used in the thir-
teenth century to refer especially to the high quality ecclesiastical embroidery
produced in England.

Men were also involved with the crafts of cloth weaving, tapestry, and em-
broidery. This is well indicated in a number of documentary references includ-
ing records from the English royal workshops of the early fourteenth century and
the guild regulations drawn up by the Parisian embroiderers in the late thirteenth
century. Both men and women are mentioned. On the evidence of the documents
from Paris, it appears that embroiderers, like the practitioners of many other arts
and crafts during the Middle Ages, decided to organize formally and regulate
prices, quality, and competition. (See also chapter 7 for medieval painters' guilds.)
The Parisian guild regulations of 1292 give information on workshop practices,
lengths of apprenticeships, and professional standards. The document also in-
cludes a list of about two hundred names of embroiderers in Paris, including
many men. During the Middle Ages, skills in particular arts and crafts were often
passed along from generation to generation. Family businesses in the textile arts
thus might involve husband-and-wife teams assisted by children and other rela-
tions—both male and female. Although we tend to think of embroidery espe-
cially as a "traditional feminine accomplishment,"[27] it is clear that by the thirteenth
century at least, increasing numbers of men were involved. Some scholars have
noted a decline in the quality of embroidery being generally produced by the
fourteenth century and have questioned whether this was due to the increased
number of men involved or to changes in production methods.[28]

Anastaise and Christine

The increasing shift of art production to urban centers in the later Middle
Ages and the demand of secular patrons for luxurious works of art is certainly
well reflected in the career of Christine de Pisan (c1363/64–1429/34), one of
the most fascinating and well-studied female figures of the late medieval/early

Renaissance period. Christine was the first professional female author in France. She supported herself and her family by her many writings which include: poetry; religious, historical, and political works; moral treatises for men and for women; and a notable work cataloguing the achievements of important women in history. Christine was not an artist herself, but her manuscripts were frequently illustrated by some of the top artists of the day. She appears to have been an extremely astute businesswoman, very adept at self-promotion. She was patronized by royalty and nobility, and she achieved great celebrity during her lifetime. As her career as author and book-producer flourished, it appears that Christine was able to afford to employ an increasingly skilled group of scribes and artists, including women. In 1404, Christine wrote:

> With regard to painting at the present time . . . I know a woman called Anastaise, who is so skillful and experienced in painting borders and miniatures of manuscripts that no one can cite an artist in the city of Paris, the center of the best illuminators on earth, who in these endeavors surpasses her in any way. . . . And this I know from my own experience, for she has produced some things for me which are held to be outstanding among the vignettes of the great masters.[29]

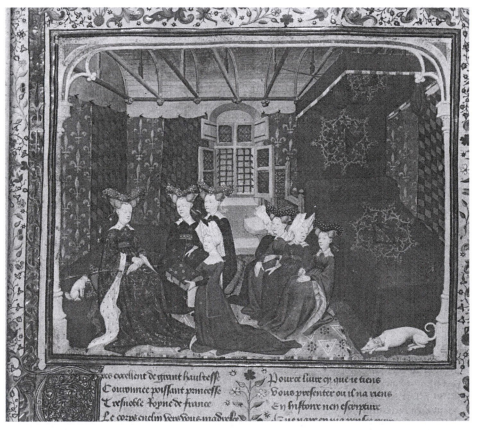

Christine de Pisan presenting her works to Queen Isabella of Bavaria, c1410. London, British Library MS Harley 4431, folio 3. (By permission of the British Library)

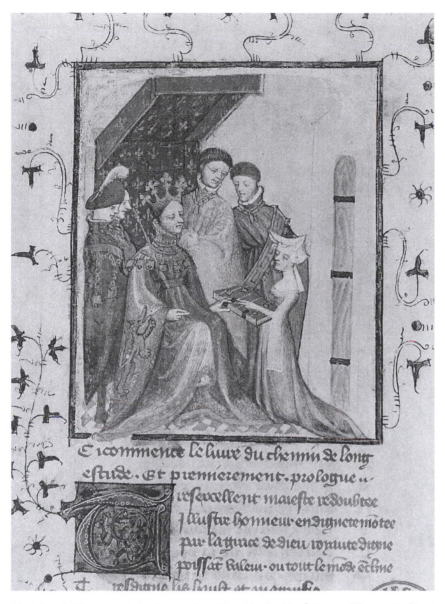

Christine de Pisan presenting her work to King Charles VI of France. (The Art Archive/
Bibliothèque Nationale Paris/The Art Archive)

Although some scholars have disagreed about the precise translation and in-
terpretation of this passage as regards what it indicates about Anastaise's artistic
specialization (borders, backgrounds, full-page paintings?), it is clear that pro-
fessional female artists were working in major urban centers in the late medieval
period on projects often designed for secular patrons. Bourgot, the daughter of
the painter Jean le Noir, is an even earlier example than Anastaise.

Within this sphere of late medieval manuscript illumination we also find some

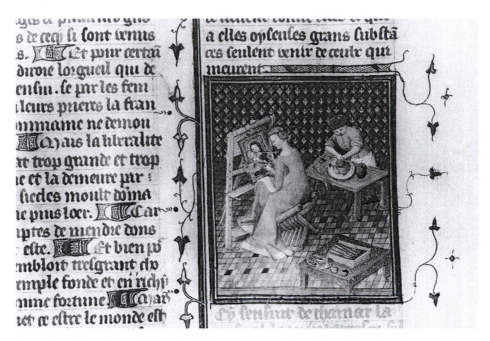

The artist, Thamyris, painting the Virgin and Child. Boccaccio, *Concerning Famous Women,* c1402–1404. Paris, Bibliothèque Nationale MS Fr. 12420, folio 86. (Courtesy of the Conway Library, Courtauld Institute of Art, London)

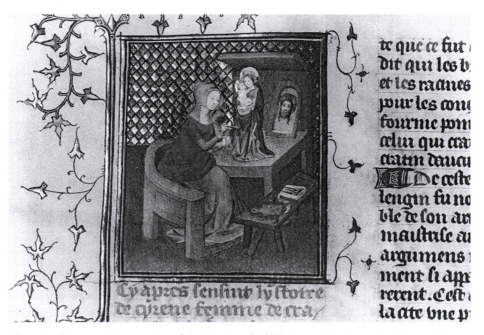

The artist, Irene, painting a statue of the Virgin and Child. Boccaccio, *Concerning Famous Women,* c1402–1404. Paris, Bibliothèque Nationale MS Fr. 12420, folio 92v. (Courtesy of the Conway Library, Courtauld Institute of Art, London)

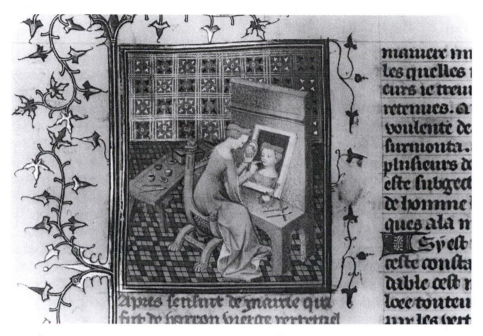

The artist, Marcia, painting a self-portrait. Boccaccio, *Concerning Famous Women,* c1402–1404. Paris, Bibliothèque Nationale MS Fr. 12420, folio 101v. (Courtesy of the Conway Library, Courtauld Institute of Art, London)

excellent examples of illustrations of female artists at work. The writings of the fourteenth-century Italian author Boccaccio, notably his discussion of famous (and infamous) women in history, inspired some of Christine de Pisan's own writing, including the text in which she praised the work of Anastaise. Copies of Boccaccio's works on famous women that were illustrated in the early fifteenth century include images of several female artists that "have been reproduced over and over again, gracing the covers of a wide variety of both scholarly and popular publications . . . because they are among the first full-fledged images of painters."[30] The pictures are meant to be of the female artists from the ancient classical period which Boccaccio described in his text, but clearly they have been updated to depict medieval-style costume, art materials, and interiors. It is tempting to use these illustrations as pictorial documents of medieval female artists, but it is wise to remember their function as illustrations of great female artists described in ancient literature.

The stories about the classical female artists that Boccaccio included in his book also need to be understood within the literary traditions which his text continued and which it represents. Biographical sketches of famous people have been composed by a great many authors through the centuries, and these often serve more as a "reflecting mirror"[31] of their own periods than of past times.

Mathilda and Sabina

This is certainly the case with the biographical information about two further female artists of the medieval era: Mathilda (eleventh century) and Sabina (early fourteenth century). The names of these two female artists have entered, exited, and reentered discussions of medieval art for several centuries. Interpretations of their contributions, and even their very existence as artists, have varied widely.

The extremely famous and impressive work of medieval secular embroidery known as the Bayeux Tapestry, which visually narrates—at great length—the Norman Conquest of England in 1066, has accrued the intriguing tradition that it was embroidered by Queen Mathilda, the wife of William the Conqueror. "Queen Mathilda's name has always been connected with the Bayeux Tapestry, the tradition being that she and her court ladies worked on the enormous piece, over 200 feet of embroidered linen, while her husband, William, was off conquering England."[32] This view was especially prevalent in writing of the nineteenth and early twentieth century. Most scholars now feel it highly unlikely that Mathilda, although known to be a patron of the arts, was herself directly involved with this massive work of embroidery. Indeed, the design, execution, patron, and purpose of the long-studied work remain subjects of much continued discussion. However, the view of the patient wife staying at home and producing a time-consuming work of art to honor the achievements of her famous husband certainly lacks the appeal to modern scholars that such a concept had to earlier authors.

In contrast, the figure of the great female sculptor of medieval Germany, Sabina von Steinbach, does seem to retain a great deal of contemporary appeal, and her name can be found in several modern sourcebooks on medieval art. It does seem, however, that her existence is shadowy, at best. The name "Savinae" was first noticed in the seventeenth century in a (now lost) inscription on one of the sculptures on the exterior of Strasbourg Cathedral. This inspired a later German scholar to credit the sculptural work to the female artist Sabina—the daughter of the architect Erwin von Steinbach, about whom also very little is known. The creation and recognition of the German master architect Erwin von Steinbach and his family, including sculptor-daughter Sabina, seems to have largely been the result of political/nationalistic sentiments in nineteenth-century Germany, and an interest then in emphasizing the German contributions to the Gothic style of sculpture and architecture (see chapter 4).

Apart from the fact that the inscription naming Savinae/Sabina no longer exists at Strasbourg, we have on many occasions already seen the challenges involved with interpreting such inscriptions as medieval artists' signatures or as indications of patronage. Someone named Sabina might well have been the patron who paid for the sculptures, not necessarily the artist. There is some evidence that medieval women were sometimes engaged in the monumental arts, such as sculpture and the creation of stained glass. Documents, such as late medieval guild records, do show that women were involved in both fields, presumably assisting male family members. Nevertheless, there is no doubt that the

arts most practiced by women during the Middle Ages were painting and embroidery.

The story of the female sculptor Sabina featured prominently in nineteenth-century German plays, poems, musical offerings, and monuments created to perpetuate tales of the artistic genius of the German Steinbach family. There are German paintings from the middle of the nineteenth century which, for example, depict Sabina carving the exterior sculpture of Strasbourg Cathedral, watched by her admiring father, Erwin.[33] Similarly, a British painter of the late nineteenth century depicted Queen Mathilda and her court ladies, seated in a dark castle interior, diligently at work with their embroidery of the Bayeux Tapestry.[34] These depictions of famous female artists from the medieval era provide fascinating modern documents, whose inclusion or exclusion in the history of art depends very much on the context in which we choose to place or use them.

Notes

1. John Williams, *Early Spanish Manuscript Illumination* (New York: George Braziller, 1977).

2. Pamela Patton, "Ende," in *Dictionary of Women Artists,* ed. D. Gaze (London: Fitzroy Dearborn, 1997), 498.

3. Annemarie Weyl Carr, "Women Artists in the Middle Ages," *Feminist Art Journal* V, no. 1 (1976): 5.

4. Carr, "Women Artists," 6.

5. Dorothy Miner, *Anastaise and Her Sisters* (Baltimore, Md.: Walters Art Gallery, 1974), 11–12.

6. Annemarie Weyl Carr, "Women as Artists in the Middle Ages," in *Dictionary of Women Artists,* ed. D. Gaze, 8.

7. Lesley Smith, "Scriba, Femina: Medieval Depictions of Women Writing," in *Women and the Book: Assessing the Visual Evidence,* ed. Lesley Smith and Jane Taylor (London: British Library, 1996), 21–44.

8. Whitney Chadwick, *Women, Art, and Society* (London: Thames and Hudson, 1990), 57.

9. Miner, 18.

10. Pamela Patton, "Diaz, Teresa," in *Dictionary of Women Artists,* ed. D. Gaze, 456.

11. Patton, "Diaz," 457.

12. Wendy Slatkin, *Women Artists in History from Antiquity to the Twentieth Century* (Englewood Cliffs, N.J.: Prentice Hall, 1990), 27.

13. Madeline Caviness, "Hildegard of Bingen," in *Dictionary of Women Artists,* ed. D. Gaze, 685.

14. Smith, 24.

15. Madeline Caviness, "Anchoress, Abbess, and Queen: Donors and Patrons or Intercessors and Matrons?" in *Women's Literary and Artistic Patronage in the Middle Ages,* ed. June Hall McCash (Athens: University of Georgia Press, 1996), 115.

16. Caviness, "Hildegard," 686.

17. Otto Pächt, *Book Illumination in the Middle Ages* (London: Harvey Miller, 1986), 160.

18. C. R. Dodwell, *The Pictorial Arts of the West: 800–1200* (New Haven, Conn.: Yale University Press, 1993), 297.

19. Michael Evans, "Herrad," in *Dictionary of Women Artists,* ed. D. Gaze, 676.

20. Carr, "Women Artists in the Middle Ages," 8.

21. Jeffrey Hamburger, *Nuns as Artists: The Visual Culture of a Medieval Convent* (Berkeley: University of California Press, 1997), 3.

22. Ann Roberts, "Convents," in *Dictionary of Women Artists,* ed. D. Gaze, 23.

23. Kay Staniland, *Embroiderers* (Toronto: University of Toronto Press, 1991), 5.

24. Dodwell, 29.

25. Staniland, 10.

26. Staniland, 27.

27. Roberts, 23.

28. Slatkin, 36.

29. Miner, 7–8.

30. Brigitte Buettner, *Boccaccio's 'Des cleres et nobles femmes': Systems of Signification in an Illuminated Manuscript* (New York: College Art Association, 1996), 46.

31. Buettner, 20.

32. Slatkin, 16, 18.

33. See Roland Recht, "Le Mythe Romantique d'Erwin de Steinbach," *L'Information de l'Histoire de l'Art* 15, no. 1 (1970), Figure 15.

34. Rozsika Parker, *The Subversive Stitch: Embroidery and the Making of the Feminine* (London: Women's Press, 1984), Figure 12.

Bibliography

Apostolos-Cappadona, Diane. *Encyclopedia of Women in Religious Art.* New York: Continuum, 1996.

Buettner, Brigitte. *Boccaccio's 'Des cleres et nobles femmes': Systems of Signification in an Illuminated Manuscript.* New York: College Art Association, 1996.

Carr, Annemarie Weyl. "Women Artists in the Middle Ages." *Feminist Art Journal* V, no. 1 (1976): 5–9, 26.

Caviness, Madeline. "Anchoress, Abbess, and Queen: Donors and Patrons or Intercessors and Matrons?" In *Women's Literary and Artistic Patronage in the Middle Ages,* ed. June Hall McCash. Athens: University of Georgia Press, 1996.

Chadwick, Whitney. *Women, Art, and Society.* London: Thames and Hudson, 1990.

Dodwell, C. R. *The Pictorial Arts of the West: 800–1200.* New Haven, Conn.: Yale University Press, 1993.

Gaze, D., ed. *Dictionary of Women Artists.* London: Fitzroy Dearborn, 1997.

Hamburger, Jeffrey. *Nuns as Artists: The Visual Culture of a Medieval Convent.* Berkeley: University of California Press, 1997.

———. *The Visual and the Visionary: Art and Female Spirituality in Late Medieval Germany.* New York: Zone Books, 1998.

McCash, June Hall, ed. *Women's Literary and Artistic Patronage in the Middle Ages.* Athens: University of Georgia Press, 1996.

Miner, Dorothy. *Anastaise and Her Sisters.* Baltimore, Md.: Walters Art Gallery, 1974.

Pächt, Otto. *Book Illumination in the Middle Ages.* London: Harvey Miller, 1986.

Parker, Rozsika. *The Subversive Stitch: Embroidery and the Making of the Feminine*. London: Women's Press, 1984.

Peterson, Karen, and J. J. Wilson. *Women Artists: Recognition and Reappraisal from the Early Middle Ages to the Twentieth Century*. New York: Harper and Row, 1976.

Petteys, Chris. *Dictionary of Women Artists*. Boston: G. K. Hall, 1985.

Recht, Roland. "Le Mythe Romantique d'Erwin de Steinbach." *L'Information de l'Histoire de l'Art* 15, no. 1 (1970): 38–45.

Sheingorn, Pamela. "The Medieval Feminist Art History Project." *Medieval Feminist Newsletter* 12 (1991): 6–19.

Slatkin, Wendy. *Women Artists in History from Antiquity to the Twentieth Century*. Englewood Cliffs, N.J.: Prentice Hall, 1990.

Smith, Lesley, and Jane Taylor, eds. *Women and the Book: Assessing the Visual Evidence*. London: British Library, 1996.

Staniland, Kay. *Embroiderers*. Toronto: University of Toronto Press, 1991.

Willard, Charity Cannon. *Christine de Pizan: Her Life and Works*. New York: Persea Books, 1984.

CHAPTER 10

Artists of the Courts: The Limbourg Brothers and Their Colleagues

Courtly Patrons

A large percentage of the art produced during much of the Middle Ages was religious in nature and was commissioned for or by the church. Previous chapters have discussed, for example, the magnificent objects of metalwork that adorned medieval churches and were used in religious ceremonies. We have also learned about the impressive examples of architectural sculpture which graced the exteriors and interiors of the many splendid medieval monastery churches and cathedrals constructed during the Romanesque and Gothic periods. The painstakingly and lavishly illustrated manuscripts we have previously discussed as well were primarily religious in nature and designed to be used or displayed in churches or monasteries. Apart from being commissioned by religious patrons, a certain number of these works of art were created by artists who were closely associated with the church—who were members of a religious community, like the Benedictine monk, Roger of Helmarshausen, for example.

Of course, it is always dangerous to make sweeping generalizations about entire time periods. Painters, sculptors, architects, weavers, and metalworkers certainly were well employed in various secular (nonreligious) commissions for nonclerical (lay) patrons throughout the early medieval, Romanesque, and Gothic periods as well. However, the construction and decoration of religious structures and the overwhelming amount of art created for, or commissioned by, the church during these centuries certainly explains why the Middle Ages has so often been called "The Age of Faith."

This situation of church patronage undergoes a gradual shift as we progress into the later medieval period—the fourteenth and fifteenth centuries, especially. There are a number of social and economic explanations for this shift in

patronage. The mid-fourteenth century witnessed the dramatic and devastating epidemic of the Black Death (Bubonic Plaque) which wiped out a huge percentage of the population of Europe. This event, combined "with the shifts and losses in population caused by multiple wars" resulted in a much wider scattering of people throughout Europe, so "artists were active in many countries, working for people whose lives had undergone profound changes that influenced what they wanted to see around them."[1] This later medieval period is also characterized by the establishment and consolidation of great wealth on the part of the nobility and aristocracy in different regions in Europe.

This chapter will focus primarily on a particular type of artwork which became exceedingly popular in the later Middle Ages: the illustrated prayer book, or Book of Hours, and upon the style of art associated with the wealthy royal courts of the late fourteenth and early fifteenth centuries: the International Gothic style. We will also meet some of the major art patrons of the late Middle Ages, such as Jean, the Duke of Berry (1340–1416), and we will discuss the style and contributions of major artists of the time, such as the Limbourg brothers, who were employed by these wealthy late-medieval patrons.

Personal Piety: The Book of Hours

Throughout the Middle Ages, an extremely significant aspect of life in medieval monasteries—a crucial routine which made the "religious life" quite different from the "worldly life"—was the recitation of prayers on a daily basis. At eight specified times every day (really in every twenty-four-hour period), the inhabitants of medieval monasteries, whether men or women, would gather together in the monastery church for a series of prayers which they would recite orally, as a group. This practice, dating back to the early Christian period, changed and developed somewhat through the centuries. The texts to be recited, passages from the Bible which were read, hymns to be sung, and the times of day when these services took place became standardized by the early Middle Ages.[2] This cycle of daily prayer—known as the Divine Office—is still, with some modern variations, an important aspect of the Christian religious life today.

As we have seen already, religion permeated all aspects of life during the Middle Ages, and piety was by no means the exclusive privilege of people who had chosen the monastic lifestyle. Prayer and attendance at church services was generally expected of all members of medieval society, and many lay people wanted to emulate the pious lifestyles of the monastics. This desire on the part of lay people "to imitate the prayer-life of the religious"[3] is traditionally offered as an explanation for the increasingly great popularity of personal prayer books in the Gothic and late medieval period. Known as "Books of Hours" (the "hours" referring to the eight times of day set aside for the Divine Office in monasteries), these manuscripts were produced in copious quantities especially from the thirteenth century onward in all areas of Europe. "From the late thirteenth to the early sixteenth century, the Book of Hours was *the* medieval best-seller. . . . More Books of Hours . . . were produced during this period than any other single type

of book, including the Bible."[4] These personal prayer books, often beautifully illustrated, enabled ordinary people to imitate the clergy in an abbreviated or shortened form of religious devotions according to their own more secular daily schedule. In other words, ordinary people probably used their prayer books at times of the day which suited their own convenience, rather than adhering to the monastic hours.

Ordinary people also doubtless took great delight in the pictures customarily included in Books of Hours and it is rare to find a medieval Book of Hours which does not contain illustrations or decorations of any sort. "They are small and usually prettily decorated books. They were intended to be held in the hand and admired for the delicate illumination rather than put on a library shelf."[5] The number and size of the illustrations varied, of course, according to the cost of the book. Some Books of Hours are more modestly illustrated; others are absolutely deluxe productions.

The texts and pictures included in Books of Hours vary somewhat from place to place and through the centuries of their production, so it is virtually impossible to describe a "standard" Book of Hours. Even so, the core texts and illustrations normally include a series of eight prayers in honor of the Virgin Mary accompanied by a set of scenes illustrating major events in her life, such as the Nativity (Birth of Jesus), the Adoration of the Magi, the Virgin Mary's Coronation in Heaven, and so on. The illustrations are designed as aids to prayer and contemplation, with the scenes chosen to correlate with the texts. These core texts in Books of Hours are customarily preceded by some selected sections (or "lessons") from the Gospels, and the books normally also open with a set of calendar pages listing the major holy days in the church year, month by month. Quite frequently these calendar pages will be illustrated with signs of the zodiac and scenes of secular activities—the "labors of the months"—such as planting, pruning, harvesting, and so on. These monthly activities vary a bit from region to region depending upon climate; scholars can often determine where a Book of Hours was made based on these variations. There are also other clues (different forms of prayers used in different areas; prayers to specific saints) which specialists can study to determine the origin of the manuscripts as well. Many times the owners of Books of Hours had their names, portraits, or family emblems (e.g., coats of arms) included in the decoration. Books of Hours were prized family treasures—passed down from generation to generation. Prayers to and illustrations of various saints may be included in Books of Hours, and a special section of prayers for the dead is fairly common in these manuscripts as well. Other sets of prayers (the Hours of the Holy Cross, Hours of the Holy Spirit) are normally included too.

Again, the size and scope of Books of Hours was influenced quite a bit by how much the purchaser could afford. Based on the massive number of these manuscripts that survive from the medieval period, it appears that many middle-class and certainly upper-class people were able to purchase these books. Although Books of Hours have been described as "Books for Everybody"[6]—"everybody" in this case certainly does not refer to all members of medieval society, especially not the peasants and urban laborers.

The Production of Piety: Supply and Demand

Medieval Books of Hours were designed to be used for religious purposes, for private prayer and devotions, hence we may feel somewhat uncomfortable seeing them described as "status symbols" as well. But there is no doubt at all that these religious manuscripts were also regarded by their medieval owners as indicative of their social standing as well as their personal piety. These books "reflect at the same time lay religious piety and the pride, or possibly conspicuous acquisitiveness, of ownership. It is not too cynical to point out that medieval piety incorporated a substantial element of public display."[7] Indeed, there is much evidence to indicate that Books of Hours were considered as fashionable accessories—"must have" objects that every well-to-do medieval person of any social standing or social aspirations simply should possess. These were portable objects, not huge library or coffee-table books, and could certainly be, and were, carried about in public. Although the comparison may seem shocking—this is really not so unlike people today who wish to be seen in possession of the latest model cell phone or state-of-the-art personal digital assistant or laptop computer. Our desires to impress each other—and the symbolism of material possessions—are impulses that seem to run through all periods of history.

In any case, the increasing demand for Books of Hours in the late medieval period was more than recognized and filled by the scribes and artists and booksellers of the time. In the earlier Middle Ages, most manuscripts were produced in monasteries. In the later medieval period, when Books of Hours became so popular, a majority of manuscripts were produced by non-monastic workshops located in the major European cities like London and Paris. These workshops were staffed not by monks but by lay artisans who specialized in various aspects of manuscript production. In cities where universities were located, the demand of students and teachers for books had also already encouraged the development of such workshops.[8] The books produced for university students were, obviously, of a generally much less fancy caliber than the Books of Hours demanded by the pious lay clientele beginning in the thirteenth century who were eager to imitate the religious life and show off their social standing by owning a state-of-the-art prayer book.

Clearly, this market for prayer books was quickly recognized and filled by a growing number of enterprising business people who established bookstores or book workshops in the developing and major urban centers during the medieval period. "The very great appeal of Books of Hours was understood by the medieval booksellers who manufactured and sold these volumes in immense numbers."[9] A lively business was carried on indeed. Clients wishing to purchase a prayer book could specify their cost parameters and negotiate their specifications with the workshop representative. Scribes were employed to write the texts; artists were employed to paint the pictures; other specialists in the assembly line might be responsible for portions of the page border decorations only; others were employed to write only certain text sections in red or gold.

Some artists were given greater responsibilities for full-page pictures although it was not at all uncommon for artists to collaborate on these as well—the artist who was best at painting people might do all the figures in a scene, whereas the foliage and landscape details might be completed by another artist who was better at these elements.

Medieval Books of Hours were often collaborative ventures by many artists who did not sign their names to their contributions, and this explains why it is often so very difficult to attribute many of the vast number of medieval Books of Hours to specific artists. The important exceptions to this are, of course, the Books of Hours that were not made for everybody or by just anybody. The fanciest and most costly Books of Hours produced during the late Middle Ages— and the ones that are the most well documented—are those books that were produced by the most respected artists of the time for the wealthiest patrons. Such is certainly the case with the very famous manuscript known as the *Très Riches Heures* ("Very Rich Hours") of Jean, the Duke of Berry (Chantilly, Musée Condé, MS 65).

The Patron, the Book, and the Brothers

The January calendar page from the *Très Riches Heures* shows a grand scene indeed. Jean (or John), the Duke of Berry, the brother of the French king Charles V, is hosting a dinner party. This is one of the most often reproduced images from medieval manuscripts and can be seen in all its colorful glory in a variety of other sources ranging from art books to greeting cards and gift wrapping paper. At first, the image seems a little hard to read as it is so full of detail. But once the eye adjusts to all the richness and complexity of the scene, one perceives that a banquet is taking place. The duke, wearing a great fur hat, is seated at a table laden with splendid dishes of food. Two servants in very fancy dress are standing in front of the table, carving and serving for the duke and his guest. Other servants crowd around the table and more people appear to be arriving. On the left side of the picture some people are busy retrieving dishes and cups from a great sideboard which is piled with golden tableware. Indeed, a good many of the cups, plates, and vessels depicted in this scene appear to be made of gold. One's eye may be especially attracted to the rather strange looking golden ship-shaped vessel (or *nef*) on the right side of the table that appears to be full of gold plates. A servant at the lower right of the scene is giving a dog a table scrap and two other tiny little dogs appear to be on the table helping themselves to the evident excess of the meal. The duke is seated in front of a fireplace and is protected by a fire screen; other figures are warming their hands at the fire. The words "aproche, aproche" (approach) are written in gold above a figure who has been identified as the duke's steward or chief servant. Perhaps more dishes are being brought to the table or the steward is welcoming further guests to this party. The standing figures in the middle and left of the composition blend rather oddly into a background scene that shows horses and warriors in a landscape.

Look more carefully and you will see that this is actually a tapestry hung upon the back wall of the room. There is writing upon this tapestry also, which has led scholars to identify this as a scene of ancient battles from the classical period: the Trojan War. All in all, this is a fabulous depiction of aristocratic opulence: the fancy costumes of the figures, the expense of the tableware, the extravagance of the meal, and the lavish furnishings make this a truly splendid image of courtly life in the late medieval period.

This scene is only one of more than sixty full-page pictures painted in this manuscript. There are also more than sixty smaller scenes—about one-fourth-page size. The banquet scene is one of twelve full-page illustrations for the calendar section that begins this lavish Book of Hours. As discussed above, calendars were customarily included in medieval prayer books and so this manuscript follows in that tradition. The full-page scenes accompanying the calendar are rather unique, however, and there are other unusual aspects to this manuscript as well. This scene accompanies the calendar page for January and in the semicircular-shaped section above the banquet scene, we can see a figure holding the sun riding in a chariot pulled by winged horses. The sun is moving through the sky and we can see the signs of the zodiac above: Sagittarius (the archer) is giving way to Capricorn (the goat).

Just studying this one picture in this extensively illustrated prayer book gives one the impression that Jean de Berry was an extremely wealthy and important figure in late medieval French society, a man of refined and discerning taste who appreciated the finer things in life. This pictorial impression is certainly supported by what information we have about Jean from other sources such as historical documents, chronicles, household records, and inventories of his possessions. Apart from the many manuscripts (about 300 total) which he collected or commissioned during his life, he "also possessed at least ten castles, fifty swans, fifteen hundred dogs, a monkey, an ostrich, and a camel."[10] Many of these other possessions of the duke are illustrated elsewhere in the manuscript—especially the fabulous castles which he traveled between and the exotic animals in his private menagerie.

The lavishness and opulence of the *Très Riches Heures* has attracted attention through the ages. Doubtless it must have been one of the duke's most prized possessions during his lifetime. But it may be so "famous precisely because it is such a freak. It is far bigger and far richer than any normal Book of Hours"[11]— certainly well beyond the reach of the ordinary upper-middle-class people purchasing private prayer books in the fourteenth and fifteenth centuries. The pages of the manuscript measure about eight by eleven inches; this is much larger than an "ordinary" size medieval prayer book. The *Très Riches Heures* of Jean de Berry thus has an especially stellar position in the history of late medieval manuscript illustration and a great deal of scholarly attention has been devoted to study and analysis of this work. Apart from studying the many, many illustrations in the book in terms of their subject matter, the scenes depicted, and the traditions and innovations represented in the picture cycles, scholars have, of course, been

extremely interested in the different styles of the illustrations and in potentially identifying the gifted artists who painted this very rich prayer book for the duke.

In answering the questions regarding artistic authorship for the manuscript, scholars have been greatly assisted by the fact that a significant number of documents and records survive from around the time when the manuscript was created in the early fifteenth century. In the household records and especially in the detailed inventories of the duke's possessions at the time of his death in 1416, the names of several artists are frequently mentioned. In particular, the names of the artists Paul, Jean, and Herman de Limbourg recur often (with divergent spellings). These documents record various gifts made by the duke to the three artists over a period of years and—combined with other records from other households of the duke's noble relations—the artistic career of the Limbourg brothers has been worked out. Much of this research was initially begun in the late nineteenth century—especially when one scholar identified an entry in the ducal inventory listing a "very rich book of hours" painted by Paul and his brothers with the manuscript now known as the *Très Riches Heures*. "Thus, the Limbourgs came upon the stage of the history of art."[12]

Originally from Flanders, the brothers Jean and Herman were apprenticed briefly to a Parisian goldsmith in the late fourteenth century. Their father (who died around 1399) was a sculptor, and their mother was the sister of the painter Jean Malouel (fl. 1396–1415), who worked for Duke Philippe le Hardi of Burgundy. Perhaps their uncle (Jean Malouel) assisted the brothers in their initial career stages and networked on their behalf. In any case, in 1402 a document notes that Paul and Jean de Limbourg had been hired for a good salary by their uncle's patron, Duke Philippe. The documents specify that the brothers were hired to paint the scenes in a big Bible manuscript that the duke had commissioned. Duke Philippe died in 1402, however, and the brothers appear in documents later in the decade but now in the employ of Philippe's brother Jean, the Duke of Berry. It appears that all three brothers were employed by the Duke of Berry on a number of manuscript painting projects for almost a decade. Scholars have identified their work in several manuscripts commissioned by Jean de Berry during these years—notably, of course, the *Très Riches Heures,* which was begun around 1413. All three of the brothers and their patron, Jean de Berry, died in 1416. It has been speculated that this was due to another outbreak of the plague. The manuscript today known as the *Très Riches Heures* (we have no idea what the manuscript was "called" during the duke's lifetime) was left unfinished when they all died. It appears—and is generally agreed—that another artist finished the manuscript after the deaths of the Limbourg brothers and the duke. There are a number of illustrations in the book which appear to be by a different hand than the original pictures painted by the Limbourg brothers. This later painting style is different from the styles that many scholars have attributed to Paul, Jean, and Herman.

Trying to differentiate the work of this later artist (identified as Jean Colombe[13]) from the styles of the three Limbourg brothers, who initially col-

laborated on painting the illustrations in the manuscript (if indeed, the manuscript now known as the *Très Riches Heures* is the "very rich" one listed in the duke's possessions as having been painted by all three brothers), has proven to be no small task indeed for the many scholars who have engaged in this research. The inventory entry simply states that a "very rich" (or "splendid") Book of Hours was created for the duke by Paul and his brothers. The fact that Paul is specifically named here—combined with the fact that Paul appears elsewhere in the duke's household documents as having received especially nice gifts from the duke—has led many scholars to believe that Paul was the favorite or most highly esteemed artist of the three brothers. On the basis of the surviving documents, Paul seems to have received better and more frequent gifts from the duke than either Jean or Herman. For example, in 1411, the duke gave Paul a fancy house in the city of Bourges, which had previously been the residence of the duke's treasurer. Perhaps this favoritism or esteem for Paul on the part of the duke indicates that he considered Paul to be a better painter than either Jean or Herman? But, what criteria would have been used in the early fifteenth century to judge one artist "better" than another? Perhaps the duke favored Paul because he worked faster than either Jean or Herman and thus was a more productive painter? Perhaps Paul pleased his patron by having more finished work to show to the duke more frequently than either of his slower-working brothers? Perhaps the duke favored Paul because he liked his personality—perhaps Paul was more jovial than either of his brothers? We really can not know why the duke gave Paul more frequent and better gifts than his brothers. It may, of course, be the case that the duke was especially pleased with Paul's painting style no matter how slow or fast the artist worked. Perhaps the duke appreciated the innovations of this artist (Paul) in particular versus the more traditional approach and style of either Jean or Herman. But, what would have been considered innovative in artistic style in France in the early fifteenth century? Can we assume that innovation was considered to be desirable and important then?

Many scholars have indeed thought so—and the illustrations of the *Très Riches Heures* do seem to include many new or at least up-to-date ideas. In the general history of art, the time period when the *Très Riches Heures* was created is usually seen as an important transitional period between medieval and Renaissance art styles. In broadest and most general terms, the art of the Renaissance is characterized by an increasing interest in realism, in showing people and scenes as they naturally and actually look in reality. The people and scenes painted by Renaissance artists are the right size and scale. There is a believable sense of space and depth in Renaissance paintings, versus many medieval paintings, which seem far less realistic and far more symbolic. People and objects depicted in Renaissance paintings appear to be three-dimensional; they have volume, and they cast shadows. Renaissance artists studied classical art, which is generally very realistic in style, and overall worked to make their scenes look natural. During the period of time when the Limbourg brothers were painting their magnificent prayer book for Jean de Berry, many of the most innovative artists (in these terms) were working in Italy and had been for several decades

already. Perhaps the three brothers, as is generally agreed, had been able to travel to Italy and see some of these Italian artworks? Perhaps Jean de Berry especially appreciated the paintings of Paul de Limbourg because his works best showed the current trends in realistic painting style and thus validated the duke's perceptions of himself as a man of the finest taste and discernment?

Again, it is hard to know—but the assumption that Paul was considered the best (the most Renaissance-like) artist has greatly colored much modern scholarship on the *Très Riches Heures*. Some especially monumental studies of this manuscript in the later twentieth century have concentrated especially on identifying the hands of the three brothers. The favored Paul has been credited with the most innovative and realistic scenes. The brothers Jean and Herman are also appreciated and well recognized too, but their more traditional styles pale in comparison to Paul's. For example, in 1974, the important scholar Millard Meiss concluded about the three brothers: "Paul was the most perceptive, the most thoughtful, and the most deeply ambitious. Jean was the most lyrical, the most elegant, and the greatest opportunist. Herman was the most demonstrative; he can even be melodramatic."[14] However, such scholarly attempts to pin down and differentiate the individual styles of the three Limbourg brothers who worked together on this one manuscript are challenged by the fact that the manuscript *was* a collaborative venture—in other words, the brothers may have shared the painting of specific illustrations as well. It is possible that more than one hand was responsible for individual sections in many of the pictures. The naturalism of the January page in the *Très Riches Heures,* for example (the portrait-like qualities of the figures, especially the believable visage of the duke himself), combined with the overall decorative quality of the scene and attention to lavish detail, may reflect the work of both Paul and Jean. If Paul was in fact the more innovative artist, he may have done the realistic parts, and if Jean's style was characterized by attention to colors and fancy details, was he responsible for the more decorative elements of the scene?

The assumption of several scholars that Paul was the more favored artist because of his up-to-date and forward-looking "vision"[15] may give one the impression that authors who adopt such an approach may be especially interested in championing a particular style and associating a particular artist with these innovations. Not unlike the early art history scholar Giorgio Vasari (see the Introduction) whose ideal was the art of Michelangelo, the focus on Paul de Limbourg as the leader of even better things to come seems to concentrate attention on one individual as a particular model of genius. Paul has been described as "a great painter, and therefore far more readily distinguishable."[16] Thus, the painstaking analysis—based on identification of specific artistic personalities—even amongst "by far the best-documented illuminators and painters in France in the fourteenth and early fifteenth centuries,"[17] exhibits the challenges as well as possible pitfalls of scholarship focused on the "search for the artist." Such an approach "seems to be connected with the values ascribed in our present Western society to individualism, and consequently with the need to ascribe achievement to a single, individual talent."[18]

Masters with Many Names

The thrills and challenges involved with the study of late medieval manuscript illustration are certainly stimulated by the incredible beauty and luxury of the lavish productions (such as the *Très Riches Heures*) created for the aristocratic patrons of the time. Many, many other artists apart from the Limbourg brothers are known from this period, and these named artists of the fourteenth and fifteenth centuries hold important positions in the history of art along with the many other artists of the period whose names have been invented by art historians.

The Parisian painter Jean Pucelle (1300–1350), who worked for French royal patrons in the first half of the fourteenth century, is generally considered to be one of the great contributors to the art of manuscript illustration. The works attributed to Pucelle exhibit not only a great delicacy in his celebrated use of *grisaille* (monochrome tones of black/gray with occasional touches of color) but also a remarkable sense of depth and volume. Pucelle's spatial constructions and interior scenes have also been credited to his awareness of contemporary developments in Italian art. He was also a great master of border design and decoration, using the margins of his pages for not only amusing scenes and elements of fantasy but for additional and sometimes complex illustrations pictorially commenting upon and adding to the scenes shown in the main pictures.

Several manuscripts by Pucelle were passed down through the French royalty and were treasured possessions of the great book collector King Charles V (1338–1380) (the brother of Jean de Berry). The names of artists such as Jean Bondol (or John of Bruges) (fl. c1368–1381), who worked for Charles V and whose style shows the influence of Pucelle, and the Flemish artists André Beauneveu (c1330–1402/16) and Jacquemart de Hesdin (fl. 1384–1413) appear frequently in studies of later fourteenth- and early fifteenth-century manuscript illumination in France. In some cases we know more information about particular artists than is usually the case. We know that Beauneveu, for example, was born in the city of Valenciennes, and that he was a sculptor and an architect as well as an esteemed painter. His painting style looks very "sculptural." Jean Bondol designed a magnificent set of tapestries depicting scenes from the Apocalypse for Louis, the Duke of Anjou (1377–1417), a younger brother of Charles V.

Many of these artists appear to have been in charge of workshops, to have had other artists working for them, or to have themselves worked for, or collaborated with, other artists. We should also note that "it is not at all certain that the one habitually referred to as the 'head of the workshop' was necessarily the most gifted artist of a team organized like students around a great master."[19] The manuscripts which have been attributed to the workshop of Jacquemart de Hesdin, to Jacquemart himself, his assistants, and to another artist known to scholars as the "Pseudo-Jacquemart" are an especially complicated case. Indeed, "after noting all the complex types of collaboration . . . within a workshop, one ends up by asking what is a shop anyway."[20]

When names of specific artists aren't known from this period, sometimes scholars have named them after their patrons. Thus, we have the "Boucicaut

Master," who is named after a Book of Hours he created for Jean II de Bouci-
caut, an important French politician and soldier in the early fifteenth century.
Described as "one of the great progressive artists of his generation,"[21] the Bouci-
caut Master appears to have been in charge of a very large and extremely pro-
lific workshop. Several manuscripts have been attributed to his hand, while
several pictures in manuscripts, which were mostly painted by other artists, have
been credited to him as well. The Boucicaut Master is one of the most exten-
sively studied artists from this period and his relationship to and possible in-
fluence on many other artists, including the Limbourg brothers, has received
much scholarly attention.[22]

Many more names could be added to this list. The "Bedford Master" (so
named for his work for John of Lancaster, the Duke of Bedford, who served as
regent of France in the 1420s and 1430s) appears to have run his own work-
shop and also occasionally worked with the Boucicaut Master. In the Bedford
Master's style, scholars have noted "a close affinity with the Boucicaut Master
. . . and also some relationship to the Limbourg brothers."[23]

Other artists, whose real names are not known and who have not been named
after their patrons, have been identified by scholars in other ways. The "Master
of the Paremont de Narbonne," for example, is named after a specific and rather
uniquely surviving painted (in *grisaille*) silk altar frontal made for Charles V
about 1380. The quite distinctive "Rohan Master" is named after a manuscript
he painted in the early fifteenth century not *for* the Rohan family but later *owned*
by them.

The complexities involved with attempting to disentangle individual artists'
styles in the giant jigsaw puzzle of artistic production, even in one region of Eu-
rope during the late medieval period, are also augmented by other factors. Many
artists traveled, worked for a variety of patrons, were shared by different pa-
trons, and works of art (especially highly portable manuscripts) traveled or were
borrowed too. Also, pattern or model books containing designs for figures,
scenes, and decorative details became more widely available and popular dur-
ing this period for artists seeking guidelines or inspiration or to assist employ-
ees in the busy manuscript-producing workshops. In fact, although many named
artists are certainly identifiable for their individual styles during the time, the
late fourteenth and early fifteenth century is also characterized by much larger
and more general style trends which cut across regional or national boundaries.

Unity in Diversity?: The International Gothic Style

Returning to Jean de Berry's dinner party depicted on the January page in the
Très Riches Heures, a number of factors certainly stand out about the illustration.
This is a courtly and aristocratic scene and the artist (or artists) who painted this
picture devoted utmost energy to showing all the splendid details of this event.
Whether this records an actual event—a specific dinner party given by Jean de

Berry for his guest (perhaps his friend Bishop Martin Gouge)—or is rather an idealized illustration of the general lifestyle of this major figure in French royal society in the early fifteenth century, are questions which remain open. Without doubt, however, the lavishness and luxury of the duke's (real or ideal) household and hospitality are portrayed with no expenses spared. The vibrant colors and the attention to detail in costume, tableware, and furnishings are extremely impressive.

This taste for opulence actually characterizes a great deal of art produced in Europe around the year 1400. Scholars have given various names to this pervasive style movement: "International Style" or "International Gothic." And although this chapter has largely concentrated on manuscript illumination associated with the Valois royal family in France (Charles V and his brothers, such as Jean de Berry), it is extremely important to realize that quite similar works of art (manuscripts, frescoes, panel paintings, and metalwork objects) were being produced for wealthy aristocratic patrons all across Europe at this time. All of these patrons seemed to appreciate the same kind of art. The artworks associated with King Wenceslaus IV of Bohemia (1361–1419); Gian Galeazzo Visconti, the Duke of Milan (1351–1402); and King Richard II of England (1367–1400) all display a certain and "rare homogeneity"[24] characterized by a taste for elegance, refinement, and sumptuous as well as naturalistic detail.

Of course, there are regional variations and distinctive style features that can be associated with different countries and different patrons. There are changes and developments in style that can be traced in the last several decades of the fourteenth century and first several decades of the fifteenth century. Nevertheless, the style "was an international phenomenon in western Europe, best understood as a consequence of changing social and economic circumstances of which the kaleidoscopically changing political scene was also a part."[25]

We have already discussed the development and growing popularity of the Book of Hours—the personal prayer book for the laity—as a reflection of significant changes in religious attitudes and practices during the late medieval period. "The traditional forms of religious life began to fall into disrepute. . . . It was on a personal and private level that religion found a new motive force."[26] The rising middle class of merchants, shopkeepers, and businesspeople, who were the primary clientele for Books of Hours, represented a significant shift in the structure of late medieval society, a period which has sometimes (although not without scholarly disagreement) been called the "waning of the Middle Ages."[27]

The opulence and extravagance of the art produced for the aristocratic classes during this time may be seen as reflecting "the natural tendency of the class whose prerogatives are challenged to stress those concepts and institutions peculiar to it and to emphasize the characteristics that distinguish it from the challenging class or group."[28] Thus, the absolute heights of luxury are represented by manuscripts such as the *Très Riches Heures,* and the preciousness and exclusivity of this stellar example of late-medieval manuscript illumination is more than demonstrated still today with the restricted access to this work of art. Housed in the vaults of the Musée Condé in Chantilly, France, the manuscript is never on actual display for the general public to view.[29]

Notes

1. Anne Shaver-Crandell, *The Middle Ages* (Cambridge: Cambridge University Press, 1982), 94.

2. The eight canonical hours are (times approximate): Matins (2:30 a.m.), Lauds (5:00 a.m.), Prime (6:00 a.m.), Terce (9:00 a.m.), Sext (12:00 noon), None (3:00 p.m.), Vespers (4:30 p.m.), and Compline (6:00 p.m.).

3. Michelle Brown, *Understanding Medieval Manuscripts: A Guide to Technical Terms* (Malibu, Calif.: J. Paul Getty Museum, 1994), 24.

4. Roger Wieck, *Time Sanctified: The Book of Hours in Medieval Art and Life* (New York: George Braziller, 1988), 27.

5. Christopher de Hamel, *A History of Illuminated Manuscripts* (Oxford: Phaidon, 1986), 159.

6. De Hamel, in *A History of Illuminated Manuscripts*, titles his chapter (six) on Books of Hours as "Books for Everybody," though quickly clarifies his topic as the "typical manuscripts which any well-to-do medieval family might have purchased," 159.

7. Lawrence Poos, "Social History and the Book of Hours," in Wieck, *Time Sanctified,* 34.

8. For the history and development of medieval universities, the classic source is still Charles Homer Haskins, *The Rise of Universities* (Ithaca, N.Y.: Cornell University Press, 1967), first published in 1923. See also De Hamel's chapter four: "Books for Students," in *A History of Illuminated Manuscripts*.

9. De Hamel, 159.

10. De Hamel, 159.

11. De Hamel, 159.

12. Millard Meiss, *French Painting in the Time of Jean de Berry; The Limbourgs and Their Contemporaries* (New York: George Braziller, 1974), 3.

13. The artist Jean Columbe worked for the Dukes of Savoy in the late fifteenth century. His style has been identified in other works produced for them. The Dukes of Savoy presumably inherited the *Très Riches Heures* after the death of Jean de Berry. See David Robb, *The Art of the Illuminated Manuscript* (Cranbury, N.J.: A.S. Barnes, 1973), 287; also John Harthan, *The Book of Hours* (New York: Park Lane, 1977), 68–69 for a discussion of the successive owners of the manuscript.

14. Meiss, *Limbourgs,* 112.

15. Meiss in *Limbourgs* includes a special section on "Paul's New Vision," 195–201.

16. Meiss, *Limbourgs,* 111.

17. Meiss, *Limbourgs,* 66.

18. Jonathan Alexander, *Medieval Illuminators and Their Methods of Work* (New Haven, Conn.: Yale University Press, 1992), 140.

19. Marcel Thomas, *The Golden Age: Manuscript Painting at the Time of Jean, Duc de Berry* (London: Chatto and Windus, 1979), 14.

20. L.M.J. Delaissé, review of *French Painting in the Time of Jean de Berry; The Late Fourteenth Century and the Patronage of the Duke* by Millard Meiss, *Art Bulletin* LII, no. 2 (1970): 112.

21. Robb, 292.

22. Millard Meiss, *French Painting in the Time of Jean de Berry; The Boucicaut Master* (London: Phaidon, 1968).

23. Robb, 296.

24. Anna Eörsi, *International Gothic Style in Painting* (Budapest: Corvina, 1984), 5.

25. Robb, 294.

26. Eörsi, 13.

27. Johan Huizinga, *The Waning of the Middle Ages* (Garden City, N.Y.: Doubleday Anchor, 1954); first published in 1924.

28. Robb, 295–96.

29. Michael Camille, "The *Très Riches Heures:* An Illuminated Manuscript in the Age of Mechanical Reproduction," *Critical Inquiry* 17 (1990): 72–107.

Bibliography

Alexander, Jonathan. *Medieval Illuminators and Their Methods of Work.* New Haven, Conn.: Yale University Press, 1992.

Avril, François. *Manuscript Painting at the Court of France: The Fourteenth Century.* New York: George Braziller, 1978.

Backhouse, Janet. *Books of Hours.* London: British Library, 1985.

Brown, Michelle. *Understanding Illuminated Manuscripts: A Guide to Technical Terms.* Malibu, Calif.: J. Paul Getty Museum, 1994.

Camille, Michael. "The *Très Riches Heures:* An Illuminated Manuscript in the Age of Mechanical Reproduction." *Critical Inquiry* 17 (1990): 72–107.

De Hamel, Christopher. *A History of Illuminated Manuscripts.* Oxford: Phaidon, 1986.

Delaissé, L.M.J. Review of *French Painting in the Time of Jean de Berry; The Late Fourteenth Century and the Patronage of the Duke,* by Millard Meiss. *Art Bulletin* LII, no. 2 (1970): 106–112.

Eörsi, Anna. *International Gothic Style in Painting.* Budapest: Corvina, 1984.

Harthan, John. *The Book of Hours.* New York: Park Lane, 1977.

Huizinga, Johan. *The Waning of the Middle Ages.* 1924. Reprint, Garden City, N.Y.: Doubleday Anchor, 1954.

Longnon, Jean, Raymond Cazelles, and Millard Meiss. *The Très Riches Heures of Jean, Duke of Berry.* Secaucus, N.J.: Wellfleet Press, 1969.

———. *French Painting in the Time of Jean de Berry; The Boucicaut Master.* London: Phaidon, 1968.

Meiss, Millard. *French Painting in the Time of Jean de Berry; The Late Fourteenth Century and the Patronage of the Duke.* London: Phaidon, 1967.

———. *French Painting in the Time of Jean de Berry; The Limbourgs and Their Contemporaries.* New York: George Braziller, 1974.

Shaver-Crandell, Anne. *The Middle Ages.* Cambridge: Cambridge University Press, 1982.

Thomas, Marcel. *The Golden Age: Manuscript Painting at the Time of Jean, Duc de Berry.* London: Chatto and Windus, 1979.

Wieck, Roger. *Painted Prayers: The Book of Hours in Medieval and Renaissance Art.* New York: George Braziller, 1997.

———. *Time Sanctified: The Book of Hours in Medieval Art and Life.* New York: George Braziller, 1988.

Additional Resources and Selected Bibliography

Please consult individual chapter bibliographies for further sources.

General Sources on Medieval Art

Barral I. Altet, Xavier. *Artistes, Artisans et Production Artistique au Moyen Age*. 3 vols. Paris: Picard, 1986–90.

Camille, Michael. *Gothic Art: Glorious Visions*. New York: Harry N. Abrams, 1996.

———. *The Gothic Idol: Ideology and Image-making in Medieval Art*. Cambridge: Cambridge University Press, 1989.

———. *Image on the Edge: The Margins of Medieval Art*. London: Reaktion Books, 1992.

Cennini, Cennino. *The Craftsman's Handbook: "Il Libro dell'Arte."* Translated by Daniel V. Thompson. New York: Dover, 1960.

Cormack, Robin. *Byzantine Art*. Oxford: Oxford University Press, 2000.

———. *Writing in Gold: Byzantine Society and Its Icons*. New York: Oxford University Press, 1985.

Crosby, S., J. Hayward, C. Little, and W. Wixom. *The Royal Abbey of Saint Denis in the Time of Suger (1122–1151)*. New York: Metropolitan Museum of Art, 1981.

Davis-Weyer, Caecilia. *Early Medieval Art 300–1150*. Toronto: University of Toronto Press, 1986.

Dodwell, C. R., ed. and trans. *Theophilus: The Various Arts: De Diversis Artibus*. Oxford: Clarendon Press, 1986.

Eco, Umberto. *Art and Beauty in the Middle Ages*. New Haven, Conn.: Yale University Press, 1986.

Egbert, Virginia Wylie. *The Medieval Artist at Work*. Princeton, N.J.: Princeton University Press, 1967.

Evans, Joan. *The Flowering of the Middle Ages*. London: Thames and Hudson, 1966.

Frankl, Paul. *The Gothic: Literary Sources and Interpretations through Eight Centuries.* Princeton, N.J.: Princeton University Press, 1960.

Frisch, Teresa. *Gothic Art 1140-c1450.* Toronto: University of Toronto Press, 1987.

Hamburger, Jeffrey. *Nuns as Artists: The Visual Culture of a Medieval Convent.* Berkeley: University of California Press, 1997.

————. *The Visual and the Visionary: Art and Female Spirituality in Late Medieval Germany.* New York: Zone Books, 1998.

Kraus, Henry. *The Living Theatre of Medieval Art.* Philadelphia: University of Pennsylvania Press, 1967.

Lowden, John. *Early Christian and Byzantine Art.* London: Phaidon, 1997.

Mâle, Emile. *The Gothic Image.* New York: Harper and Row, 1958.

Martindale, Andrew. *The Rise of the Artist in the Middle Ages and Early Renaissance.* New York: McGraw-Hill, 1972.

McCash, June Hall, ed. *The Cultural Patronage of Medieval Women.* Athens: University of Georgia Press, 1993.

Miner, Dorothy. *Anastaise and Her Sisters.* Baltimore, Md.: Walters Art Gallery, 1974.

Panofsky, Erwin. *Abbot Suger on the Abbey Church of Saint Denis and Its Art Treasures.* Princeton: Princeton University Press, 1979.

Petzold, Andreas. *Romanesque Art.* New York: Harry N. Abrams, 1995.

Rudolph, Conrad. *The "Things of Greater Importance": Bernard of Clairvaux's "Apologia and the Medieval Attitude Toward Art.* Philadelphia: University of Pennsylvania Press, 1990.

Sekules, Veronica. *Medieval Art.* Oxford: Oxford University Press, 2001.

Shaver-Crandell, Anne. *The Middle Ages.* Cambridge: Cambridge University Press, 1982.

Smith, Lesley, and Jane Taylor, eds. *Women and the Book: Assessing the Visual Evidence.* Toronto: University of Toronto Press, 1996.

Snyder, James. *Medieval Art: Painting, Sculpture, Architecture, Fourth through Fourteenth Century.* New York: Harry N. Abrams, 1989.

Stokstad, Marilyn. *Medieval Art.* New York: Harper and Row, 1986.

Weitzmann, Kurt. *The Icon: Holy Images—Sixth to Fourteenth Century.* New York: George Braziller, 1978.

Zarnecki, George. *Art of the Medieval World.* New York: Harry N. Abrams, 1975.

Sources on Medieval Architecture

Bony, Jean. *French Gothic Architecture of the Twelfth and Thirteenth Centuries.* Berkeley: University of California Press, 1983.

Bucher, Francois. *Architector: The Lodge Books and Sketchbooks of Medieval Architects.* New York: Abaris Books, 1979.

Calkins, Robert. *Medieval Architecture in Western Europe from A.D. 300 to 1500.* New York: Oxford University Press, 1998.

Coldstream, Nicola. *Masons and Sculptors.* Toronto: University of Toronto Press, 1991.

Conant, Kenneth. *Carolingian and Romanesque Architecture, 800–1200.* Harmondsworth: Penguin, 1978.

Gimpel, Jean. *The Cathedral Builders.* New York: Harper and Row, 1984.

Harvey, John. *The Master Builders: Architecture in the Middle Ages.* London: Thames and Hudson, 1971.

————. *The Mediaeval Architect.* London: Wayland, 1972.

James, John. *Chartres: The Masons Who Built a Legend.* London: Routledge and Kegan Paul, 1982.

———. *The Template-Makers of the Paris Basin.* Leura, Australia: West Grinstead Publishing, 1989.

Macaulay, David. *Cathedral: The Story of Its Construction.* Boston: Houghton Mifflin, 1973.

Sources on Medieval Painting

Alexander, Jonathan. *Medieval Illuminators and Their Methods of Work.* New Haven, Conn.: Yale University Press, 1992.

Avril, Francois. *Manuscript Painting at the Court of France: The Fourteenth Century.* New York: George Braziller, 1978.

Backhouse, Janet. *Books of Hours.* London: British Library, 1985.

———. *The Illuminated Manuscript.* London: Phaidon, 1979.

———. *The Illuminated Page: Ten Centuries of Manuscript Painting in the British Library.* London: British Library, 1997.

Binski, Paul. *Painters.* Toronto: University of Toronto Press, 1991.

Bomford, David, Jill Dunkerton, Dillian Gordon, and Ashok Roy. *Art in the Making: Italian Painting before 1400.* London: National Gallery, 1989.

Brown, Michelle. *Understanding Illuminated Manuscripts: A Guide to Technical Terms.* Malibu, Calif.: J. Paul Getty Museum, 1994.

Cahn, Walter. *Romanesque Bible Illumination.* Ithaca, N.Y.: Cornell University Press, 1982.

Calkins, Robert. *Illuminated Books of the Middle Ages.* Ithaca, N.Y.: Cornell University Press, 1983.

Cole, Bruce. *Sienese Painting From Its Origins to the Fifteenth Century.* New York: Harper and Row, 1980.

De Hamel, Christopher. *A History of Illuminated Manuscripts.* Oxford: Phaidon, 1986.

———. *Scribes and Illuminators.* Toronto: University of Toronto Press, 1992.

Demus, Otto. *Romanesque Mural Painting.* New York: Thames and Hudson, 1970.

Dodwell, C. R. *The Pictorial Arts of the West: 800–1200.* New Haven, Conn.: Yale University Press, 1993.

Eörsi, Anna. *International Gothic Style in Painting.* Budapest: Corvina, 1984.

Evans, Michael. *Medieval Drawings.* London: Paul Hamlyn, 1969.

Gibson, Margaret, T. A. Heslop, and Richard Pfaff, eds. *The Eadwine Psalter: Text, Image, and Monastic Culture in Twelfth-Century Canterbury.* University Park: Pennsylvania State University Press, 1992.

Grabar, Andre, and Carl Nordenfalk. *Romanesque Painting.* Lausanne: Skira, 1958.

Lewis, Suzanne. *The Art of Matthew Paris in the Chronica Majora.* Berkeley: University of California Press, 1987.

Meiss, Millard. *French Painting in the Time of Jean de Berry: The Boucicaut Master.* London: Phaidon, 1968.

———. *French Painting in the Time of Jean de Berry: The Late Fourteenth Century and the Patronage of the Duke.* London: Phaidon, 1967.

———. *French Painting in the Time of Jean de Berry: The Limbourgs and Their Contemporaries.* New York: George Braziller, 1974.

Pächt, Otto. *Book Illumination in the Middle Ages.* London: Harvey Miller, 1986.

Robb, David. *The Art of the Illuminated Manuscript.* Cranbury, N.J.: A.S. Barnes, 1973.

Thomas, Marcel. *The Golden Age: Manuscript Painting at the Time of Jean, Duc de Berry.* London: Chatto and Windus, 1979.

Thompson, Daniel. *The Materials of Medieval Painting.* New York: Dover, 1956.

Wieck, Roger. *Painted Prayers: The Book of Hours in Medieval and Renaissance Art.* New York: George Braziller, 1997.

————. *Time Sanctified: The Book of Hours in Medieval Art and Life.* New York: George Braziller, 1988.

Sources on Medieval Sculpture and Metalwork

Armi, C. Edson. *The "Headmaster" of Chartres and the Origins of "Gothic" Sculpture.* University Park: Pennsylvania State University Press, 1994.

————. *Masons and Sculptors in Romanesque Burgundy: The New Aesthetic of Cluny III.* University Park: Pennsylvania State University Press, 1983.

Grivot, Denis, and George Zarnecki. *Gislebertus, Sculptor of Autun.* New York: Orion Press, 1961.

Hearn, Millard. *Romanesque Sculpture: The Revival of Monumental Stone Sculpture in the Eleventh and Twelfth Centuries.* Ithaca, N.Y.: Cornell University Press, 1981.

Kahn, Deborah, ed. *The Romanesque Frieze and Its Spectator: The Lincoln Symposium Papers.* London: Harvey Miller, 1992.

Kendell, Calvin. *The Allegory of the Church: Romanesque Portals and their Verse Inscriptions.* Toronto: University of Toronto Press, 1998.

Lasko, Peter. *Ars Sacra 800–1200.* New Haven, Conn.: Yale University Press, 1994.

Seidel, Linda. *Legends in Limestone: Lazarus, Gislebertus and the Cathedral of Autun.* Chicago: University of Chicago Press, 1999.

Stoddard, Whitney. *The Sculptors of the West Portals of Chartres Cathedral.* New York: Norton, 1987.

Swarzenski, Hanns. *Monuments of Romanesque Art: The Art of Church Treasures in Northwestern Europe.* Chicago: University of Chicago Press, 1967.

Sources on Medieval Textiles

Bernstein, David. *The Mystery of the Bayeux Tapestry.* London: Weidenfeld and Nicolson, 1986.

Dodwell, C. R. *The Pictorial Arts of the West: 800–1200.* New Haven, Conn.: Yale University Press, 1993.

Staniland, Kay. *Embroiderers.* Toronto: University of Toronto Press, 1991.

Wilson, David. *The Bayeux Tapestry.* New York: Alfred A. Knopf, 1985.

Sources on Subjects and Symbols

Biedermann, Hans. *Dictionary of Symbolism: Cultural Icons and the Meanings behind Them.* New York: Meridian, 1994.

Duchet-Suchaux, Gaston, and Michel Pastoureau. *The Bible and the Saints.* Paris: Flammarion, 1994.

Farmer, David. *The Oxford Dictionary of Saints.* Oxford: Oxford University Press, 1982.

Ferguson, George. *Signs and Symbols in Christian Art.* New York: Oxford University Press, 1967.

Hall, James. *Dictionary of Subjects and Symbols in Art.* New York: Harper and Row, 1974.

Ross, Leslie. *Medieval Art: A Topical Dictionary.* Westport, Conn.: Greenwood Press, 1996.

Web Sites

There are a great number of excellent resources for medieval studies and medieval art available on the Internet. Many museums with collections of medieval art maintain informative Web sites, and a number of individual scholars have posted sites specific to their research areas and teaching interests in medieval art. Persons searching the Internet for information on medieval art generally, or for information on specific fields or particular works of art, are well advised to begin with the "meta-sites" listed below. These provide a great number of links to other sites and thus provide the most useful starting points.

Art History Resources on the Web. http://witcombe.sbc.edu/ARTHLinks.html

The Art History Research Centre. http://art-history.concordia.ca/AHRC/splash.htm

The International Center of Medieval Art. http://www.medievalart.org/

The Labyrinth: Resources for Medieval Studies. http://www.georgetown.edu/labyrinth/

NETSERF: The Internet Connection for Medieval Resources. http://www.netserf.org/

The Voice of the Shuttle. http://vos.ucsb.edu/

Yahoo! Directory of Art History. http://dir.yahoo.com/Arts/art_history/

The additional sites listed below are also extremely useful.

The Album of Villard de Honnecourt. http://www.newcastle.edu.au/discipline/fine-art/pubs/villard/index.htm

The Bodleian Library, Oxford. Western manuscripts to c1500. http://www.bodley.ox.ac.uk/dept/scwmss/medieval/medieval.htm

A Digital Archive of Architecture. http://www.bc.edu/bc_org/avp/cas/fnart/arch/default.html

DScriptorium. http://www.byu.edu/~hurlbut/dscriptorium/

The Metropolitan Museum of Art, New York (follow links also to The Cloisters and the Timeline of Art History). http://www.metmuseum.org/home.asp

Mother of All Art and Art History Links Pages. http://www.art-design.umich.edu/mother

Notre Dame Cathedral of Amiens: An Orderly Vision. Digital Image Access Project. http://www.cc.columbia.edu/imaging/html/marc/amiens-marc.html

The Research Centre for Illuminated Manuscripts. http://www.courtauld.ac.uk/Pages/rcims.html

WebMuseum, Paris. http://sunsite.icm.edu.pl/wm/

General Index

Abraham, 132–33
Adam and Eve, 96
Agnes, Saint, 117
Altars and altarpieces, forms and function of, 30–31, 38–39, 98, 109, 116–18, 129, 167
Amiens, Cathedral of Notre Dame, 71
Angels, 16–18, 109, 117, 131, 133
Apocalypse, Beatus commentary on, 140; as subject in art, 98, 140, 166. *See also* Last Judgment
Architect, medieval definition of, 65–66
Architecture, medieval styles of, 66–69, 73, 97–98, 101, 103
Art, medieval attitudes about, 8, 85–90, 125
Artist, use of term in the medieval period, 8, 112
Artists, biographies of, 4–9, 72–73; itinerant, 21, 56, 63, 95, 106, 112, 118, 165, 167; roles in medieval society, 7–8, 83–84, 90–91, 112, 166–67. *See also* Vasari, Giorgio; Workshops
Augustine, Saint, 48, 54
Autun, 7–8, 13, 15–25, 141–42

Baptism, 35–36
Bayeux Tapestry, 96, 152–53
Beatus of Liébana, 140
Beauvais, Cathedral of Saint Pierre, 105
Becket, Thomas, Saint, 14
Benedict of Nursia, Saint, 85
Benedictine order, 84, 90
Bernard of Clairvaux, Saint, 85–90, 142
Black Death. *See* Bubonic Plague
Boccaccio, Giovanni, 151
Books of Hours, 158–62, 168
Bubonic Plague, 120, 158, 163
Byzantine art, 10, 32, 38, 68, 88, 95–96, 99, 100–101, 114, 118, 123–25, 127, 130, 132–35, 144. *See also* Icons

Canterbury, 14, 45, 50, 55, 57, 71–72, 84
Chartres, Cathedral of, 63, 103–6
Christine de Pisan, 147–48, 151
Christopher, Saint, 96
Cistercian order, 85, 90
Classicizing style, 36
Cluny, 20
Constantine the Great, Emperor, 14, 38–39, 124

Index of Artists and Architects

ABOUT THE AUTHOR

LESLIE ROSS is Professor and Chair of the Art History program at Dominican University of California. She is the author of *Medieval Art: A Topical Dictionary* (Greenwood Press, 1996) and *Text Image, Message: Saints in Medieval Manuscript Illustrations* (Greenwood Press, 1994).

CPSIA information can be obtained at www.ICGtesting.com
Printed in the USA
BVOW05*1824240713

326684BV00011B/14/P